Meret Oppenheim

From Breakfast in Fur and Back Again

Die Pelztasse war nur der Anfang

Exhibition Catalogue

Meret Oppenheim

From Breakfast in Fur and Back Again

The Conflation of Images, Language, and Objects in Meret Oppenheim's Applied Poetry

Die Pelztasse war nur der Anfang

Verschmelzung von Bildern, Sprache, Gegenständen
in Meret Oppenheims angewandter Poesie

Edited by – herausgegeben von
Thomas Levy
With contributions by – mit Beiträgen von
Belinda Grace Gardner

KERBER VERLAG

Colophon – Impressum

© Kerber Verlag, Bielefeld, 2003
the Artists, the Photographers and the Authors
der Künstler, Fotografen und die Autoren

© for the reproduced works from/
für die abgebildeten Werke von
Meret Oppenheim, Man Ray, Daniel Spoerri
VG Bild-Kunst, Bonn 2003

Editor – Herausgeber:
Thomas Levy, Hamburg

Designed – gestaltet:
Baltus Mediendesign, Bielefeld

Texts – Textbeiträge:
Belinda Grace Gardner

Photographs – Fotografien:
Jürgen Aick, Hamburg; Meret Oppenheim Archives /
Levy, Hamburg; Daniel Spoerri Archives, Schweizer
Landesbibliothek, Bern; Christian Baur, Basel; Galerie de France,
Paris; Galerie 1900 – 2000 – Marcel Fleiss, Paris;
Galerie Ziegler, Zürich; Brigitte Hellgoth, Düsseldorf;
Thomas Kaiser, Hamburg; Dora Maar; Dirk Masbaum,
Hamburg; Roman März; Man Ray; Rüdiger Trautsch,
Hamburg; Karin Székessy, Hamburg

Biography translated by – Biografie übersetzt von:
Eileen Laurie

Production – Gesamtherstellung:
Kerber Verlag, Bielefeld

Front Cover – Titel:
Portrait of Meret Oppenheim:
Rüdiger Trautsch, Hamburg, 1982
Ring: Dirk Masbaum, Hamburg
Back Cover – Rückseite:
Portrait of Meret Oppenheim
Re-Photo by Albert Winkler of the Stockholm
television feature, 1967

Realization Fashion, Jewelry, Furniture, and Objects:
Theaterkunst, Hamburg
Constanze Schuster, Hamburg
Ortrun Heinrich, Hamburg
Thomas Börner, Hamburg
Helmut Sasse, Hamburg
Organized by Barbara Kloth, Hamburg
Edited by Martin Bühler, Basle and Thomas Levy, Hamburg

Printed and published by
Kerber Verlag, Bielefeld
Windelsbleicher Str. 166-170
D-33659 Bielefeld
Tel. +49 (0) 5 21/9 50 08 10
Fax +49 (0) 5 21/9 50 08 88
e-mail: info@kerber-verlag.de
www.kerber-verlag.de

ISBN 3-936646-29-5

Printed in Germany

US Distribution
D.A.P., Distributed Art Publishers Inc.
155 Sixth Avenue 2nd Floor
New York, N. Y. 10013
Tel. 001 212 6 27 19 99
Fax 001 212 6 27 94 84

Published in conjunction with an exhibition
at the Museum für Kunst und Gewerbe, Hamburg,
and Thomas Levy Gallery, Hamburg

Die Publikation erscheint anlässlich der Ausstellung
im Museum für Kunst und Gewerbe, Hamburg,
sowie in der Thomas Levy Galerie, Hamburg

Contents – Inhalt

7 **From 'Breakfast in Fur' and Back Again**
The Conflation of Images, Language, and Objects
in Meret Oppenheim's 'Applied Poetry'
Belinda Grace Gardner

25 **Die „Pelztasse" war nur der Anfang**
Verschmelzung von Bildern, Sprache, Gegenständen
in Meret Oppenheims „angewandter Poesie"
Belinda Grace Gardner

42 **"She was incredibly open for everything"**
Interview with Daniel Spoerri

53 **„Sie war wahnsinnig offen für alles"**
Interview mit Daniel Spoerri

65 **Jewelry – Schmuck**

89 **Fashion – Mode**

117 **Furniture and other Objects –
Möbel und andere Objekte**

143 **Plates – Abbildungen**

226 **Biography – Biografie**

 Appendix – Anhang
237 Solo Exhibitions – Einzelausstellungen
238 Catalogues of Solo Exhibitions – Kataloge von Einzelausstellungen
239 Group Exhibitions – Gruppenausstellungen
242 Publications by Meret Oppenheim – Publikationen von Meret Oppenheim
244 Bibliography – Bibliographie
247 Filmography – Filmographie

248 **Index of Works – Abbildungsverzeichnis**

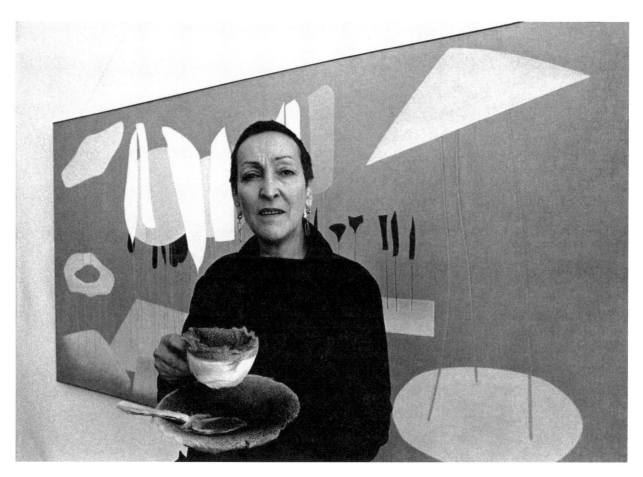

M.O. Duisburg, 1975; Photo: Brigitte Hellgoth

From 'Breakfast in Fur' and Back Again

The Conflation of Images, Language, and Objects in Meret Oppenheim's 'Applied Poetry'

Belinda Grace Gardner

Those who perceive her white fingers are willing to transform themselves. All shed their skins to abandon themselves to the new world. All know that no ship will bring them back, but the horn of plenty is beckoning. It unfurls its array and lets its fragrance stream out. The green birds rend the sails and the great sun falls into the sea. Yet as long as someone stirs the drum, night cannot go down.

From: Meret Oppenheim, "Wer ihre weißen Finger sieht," 1940[1]

since Meret Oppenheim does not add up colors shapes and things or simply string together miscellaneous matters or relate objects to one another but merges ideas thus she can use the vocabulary and the syntax of language in the same manner as the vocabulary and the syntax of colors and shapes as well as the vocabulary and the syntax of objects and things because the vocabulary and syntax of language are used in the same manner for the merging of ideas as the vocabulary and syntax of colors shapes and things

From: Helmut Heissenbüttel, "Kleiner Klappentext für Meret Oppenheim," 7, 1974[2]

x = Rabbit

"Freedom is not given to you – you have to take it"[3]: In her much-acclaimed speech on receiving the Basle Art Award in 1975 Meret Oppenheim stood up against the limitation and debasement of women in society. She declared the traditional role model obsolete and opened up new perspectives for the "female artist." Her conviction that changes could only be brought about through the self-determined action of women was vehemently enforced by her own lifestyle. Born in 1913 in Berlin and deceased in 1985 in Basle, Meret Oppenheim in over fifty years of artistic practice presented a multi-layered, tension-infused, and enigmatic body of work that has proved resistant against monopolization and restriction. She survived being played down as model, muse, and "fairy princess of the Surrealists,"[4] as well as being persistently reduced to the "fur cup," her ingenious object from the beginning of her career as an artist in Paris. Meret Oppenheim proved equally resistant to attempts at formal categorizations of her work, devoting herself instead to a diversity of style, content, and artistic media – "stylistic refusal as an act of rebellion."[5] In Meret Oppenheim's poetic diction: "Here no caste spirit reigns./Here everyone can freely express himself."[6] There

7

was method behind the "discontinuity" in the artist's œuvre. It was a creative path which, according to Jean-Christophe Ammann, allowed her subject-matter to take its own course: "With Meret Oppenheim everything is possible – in seemingly exclusionary juxtaposition and succession. Every time you deem yourself on her trail, it becomes obscured, reappearing where you least expect it."[7]

Her "things," as Meret Oppenheim casually called her multi-faceted creations, oscillate between the different aesthetic domains, encompassing the visual arts and literature as well as the applied arts. Paintings, drawings, objects, poetry, fashion and furniture design, merge in the free flow of an unrestricted creative energy, drawing from the states of both waking and dreaming. "Meret Oppenheim's poetry," as Christiane Meyer-Thoss claims, who, apart from the 'Book of Ideas' also published the artist's poems and dreams, "is the skilled balancing of moods - perfection and completion are not the objective. When the essence of the matter has been touched, she quits the field, trusting in the fragmentary to let the concept of the whole flash up more vitally."[8] A precarious principle that gives momentary expression to the fleeting nature of things in the process of transformation. And still these are powerful moments that Meret Oppenheim captures in the fragile equilibrium of a permanent temporariness, as if recording in her images the ephemeral iridescence of butterflies or rainbows. Again, one should not misread the artist's approach. "In her hand her sensitivity and intuition are sharp instruments, which she knows how to employ precisely," as Bice Curiger, author of the first monograph on Meret Oppenheim, emphasizes, "even if her creative energy is focussed on the tentative, the light, the sparing, the delicately balanced."[9]

Life and work of Meret Oppenheim are intertwined like the weaving of roots spreading out underground, finding their hold. The artist has continuously given shape in her work to the *Secret of Vegetation*, as one of her paintings from 1972 is entitled, and to the phenomena of nature in general, with extension into cosmic space. Metamorphoses, transmogrifications, disguises, and alternating roles are her metier. Bizarre streaks of humor and macabre nuances pervade her keenly fine-spun art, which she extracts from the subconscious images of her imagination and gathers "from a vast mental space."[10] As Christiane Meyer-Thoss maintains, Meret Oppenheim considers it her purpose as an artist to serve as a medium "to bring the images into the world,"[11] which, in a sense, are freely floating in the ocean of thought like collective aesthetic driftwood. "Every idea is born with its own shape. I realize the ideas, as they enter my mind. No one knows from where the ideas burst in; they bring their shape with them; like Athena who sprang from Zeus' head in helmet and armor, the ideas come in their garments."[12]

Meret Oppenheim's journey through life proceeds in syncopes, with breathtaking flights, melancholy abysses, shattering collapses, and a glowing artistic resurrection in her later years. She grows up in an artistically inclined environment as the daughter of a Swiss mother and German father, who is a medical doctor. Through him Meret Oppenheim becomes acquainted already as a young girl with the writings of C. G. Jung. At the age of fourteen she begins to note down her dreams, a source of inspiration throughout her career, generating a number of works. An important role model is her Swiss grandmother Lisa Wenger, once

a student at the Düsseldorf Art Academy, a feminist and a writer. Meret Oppenheim spends her childhood in Southern Germany and in Switzerland, where her grandparents reside. Already as a schoolgirl she decides to become a painter. "X = rabbit": In her mathematics exercise book she collages this phantasmagoric equation, her first "surrealist" work, which is reproduced in 1957 in the periodical *Le Surréalisme, même* and published as a multiple in 1973 in an edition of one hundred copies.

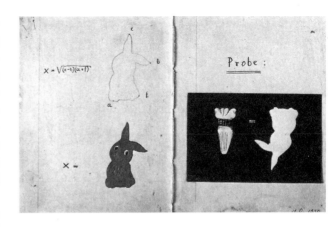

The School Note Book – Das Schulheft, 1930

Meret Oppenheim drops out of school, goes to Paris, and in the briefest time participates in all the important Surrealist exhibitions. She produces paintings, drawings, writes poetry, and creates objects – the "fur cup," among others – figurative, absurd, dark, lyrical, and cooly abstract works in rapid alternation.

Then, around 1936, the onset of a long creative crisis, the culmination of an already latent depressive state of mind. In 1937 she returns to Switzerland and attends the arts and crafts school in Basle, where she studies painting and drawing techniques, qualifying herself as an art restorer on the side. The Second World War, financial difficulties, a feeling of creative powerlessness, resulting from questioning herself as a – female – artist: "It was as if the discrimination of women was weighing heavily on my shoulders as an inherent feeling of inferiority."[13] The crisis lasts for eighteen years, until 1954. Like a phoenix Meret Oppenheim soars up from the shadows. She enriches the lively art scene in Bern, where she takes a studio, creating a wide spectrum of new works. An extensive retrospective in Stockholm in 1967 marks her breakthrough, the second and decisive one as an artist. Numerous exhibitions and awards follow. In 1982 she participates in *documenta 7* in Kassel. In the 1970's and 1980's she is finally appreciated and understood in her complexity, particularly by the younger generation of artists.

Bern, Carona in Ticino, the location of the enchanting fairytale house of her grandparents, and again Paris are the places where, in the last decades of her life, Meret Oppenheim progresses with her "settled wandering."[14] When in 1985 she dies at the age of seventy-two in Basle, she leaves as her legacy a copious body of work, which to this day retains its mystery. In her obliquely humorous artistic scheme involving paradoxes, imponderables, and surprises Meret Oppenheim continuously put to the test her early equation "x = rabbit," renewing it in the process, and keeping it afloat. "Not least, it is this art of a 'state of suspension in the center,'" Bruno Steiger asserts, "that arouses the very humor iridescently vacillating between elegance and panic characteristic of her 'things', even before the enigma."[15] The intermediate realm where phenomena are inverted and take on other guises, where the "great sun falls into the sea" and the "horn of plenty" beckons, is both the artist's point of departure and place of arrival. To borrow a phrase of the poet Hilde Domin, Meret Oppenheim "set her foot in the air, and the air sustained."[16]

"And let the walls go..."

With her departure for Paris in 1932 at the age of eighteen, accompanied by the Swiss painter Irène Zurkinden, who is a few years her senior, Meret Oppenheim launches her first meteoric career as a young artist among the Surrealists. Alberto Giacometti and Hans Arp introduce her to the group that has come together to rip down all barriers and taboos of society. "Poésie," "amour," "liberté" are the keywords of a subversion flowering in wild array. In this cultural revolution the pivotal artistic formula is Lautréamont's "unexpected encounter between a sewing machine and an umbrella on a dissecting table"[17]: the wondrous collusion of things that by no means belong together. Surrealist chief programmist André Breton, as is known, deduces from the violent clash of divergent denotative elements his consciously cryptic definition of a new aesthetics: "Convulsive beauty will be erotically veiled, erruptively rigid, magical, and determined by circumstance, or it will not be."[18]

In the person of Meret Oppenheim the "convulsive beauty," often invoked by Breton, obtains a legendary presence. *Erotique-voilée* – 'Veiled Erotic' is the telling title of Man Ray's famous nude photograph of the artist behind the wheel of a printing press, taken in 1933 in the Paris studio of the Cubist painter Louis Marcoussis and published in 1934 in the journal *Minotaure*: in direct proximity to Breton's essay on "la beauté convulsive." Meret Oppenheim mutates abruptly into a symbolic figure of Surrealism. Streaks of printer's ink on the raised left arm and palm of the portrayed artist additionally draw attention to the contrast between naked female body and massive machine, "an erotic dream image par excellence."[19] The enigmatic nude representation of the graceful young woman with the androgynous garçon hairstyle causes – in total accordance with the Surrealist agenda – a scandal. And Meret Oppenheim herself in the course of her elevation to a mystical erotic icon is "colonized as a Surrealist object."[20] Concerning her own artistic output, in it the Surrealist dynamics – as her rabbit equation shows, which she executed in her school exercise book as a sixteen-year-old student – have long been pre-molded. Not as a theoretical concept, but rather as an essential characteristic of the artist, these dynamics find resonance and are intensified in the sphere of Surrealism.

Initially Meret Oppenheim feels recognized as an artist among the champions of "convulsive beauty." She begins one of her poems from 1933 with the exuberant words, "Finally!/Freedom![21]." It is the very year in which the newcomer participates for the first time in a Surrealist exhibition in Paris, together with well-known artists such as Alberto Giacometti, Max Ernst, Man Ray, and René Magritte.[22] More shows follow, among others, the *International Kunstudstilling Kubisme = surrealisme* in 1935 in Copenhagen, where Meret

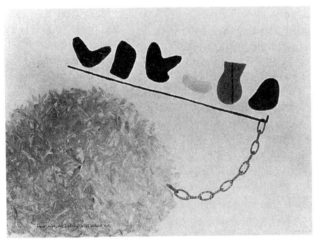

Quick, Quick, the Most Beautiful Vowel is Becoming Void
Husch, Husch der schönste Vokal entleert sich, 1934

Oppenheim presents the painting *Husch-husch, der schönste Vokal entleert sich* ('Quick, Quick, the Most Beautiful Vowel is Becoming Void') from 1934. It is dedicated to the Dada-stimulated Surrealist Max Ernst, with whom from 1934 to 1935 she has a passionate relationship, and also manifests itself in lines of verse: "From berries you thrive/With the shoe you connive/Quick, quick, the most beautiful vowel is becoming void."[23] In her oil painting for Max Ernst Meret Oppenheim confronts a diffuse, furry entity with colorful, semi-geometrical, semi-organic shapes bearing sharply contoured outlines. They are balancing, almost dancing, above a narrow black line suspended in the air, connected by a chain to the tangled ball-like shape – on the verge of taking off. A tightrope walk, aiming towards liberation. In a poem written at the same time, the artist incites whomever it may concern to give freedom a chance: "For you – against you/Throw all stones behind you/And let the walls go."[24]

The Masked Cup

The exhibition of Surrealist objects at the Charles Ratton gallery in Paris is open for only a few days – from May 22 to May 29, 1936. And yet it marks a climax and turning point in Meret Oppenheim's lightning career among the Surrealists. André Breton organizes the show that catapults the artist more or less overnight into the limelight – or at least the object she presents there: the "fur cup," which under the title *Déjeuner en fourrure* gains mythical status. Breton stages the exhibition as an amazing confrontation of art, flea market articles, ritual objects from distant cultures, stuffed exotic animals, crystals, birds' eggs, carnivorous plants, and other marvels.[25] In this curio cabinet of the avant-garde, predecessor of quite a few contemporary exhibition events, Meret Oppenheim's "fur cup" is displayed - almost en passant – in the lower shelf of a glass-fronted vitrine, surrounded by non-European artifacts, Marcel Duchamp's *Bottle Dryer*, and sculptures by Max Ernst and other artists. Here, "where the attack on normative aesthetics is ostentatiously articulated,"[26] the "fur cup" is discovered by Alfred H. Barr, at the time director of the Museum of Modern Art in New York, and, according to the record, purchased for the sum of 200 Swiss francs. Just barely created, the *Déjeuner en fourrure* enters "the soon most significant collection of art [of the twentieth] century."[27]

Meret Oppenheim has unceremoniously recounted where the "fur cup" originated: a bracelet she designed herself, a metal ring covered with ocelot fur, which in early summer of 1936 she showed to her friends Dora Maar and Picasso at the Parisian Café de Flore. Picasso's remark that one can coat anything with fur. Her retort, "also this plate and cup right here."[28] When André Breton invites her to submit work to the *Exposition surréaliste d'objets* at the Charles Ratton gallery, she allegedly recalls the idea at the café. She buys a cup, saucer, and spoon from the department store, covers everything with Chinese gazelle fur and, voilà, finished is the piece of art, which the artist laconically entitles *Tasse, soucoupe et cuillère revêtus de fourrure* ('Cup, Saucer, and Spoon, Covered with Fur'). It is noteworthy that the idea for the object, the trigger of Meret Oppenheim's early fame, is inspired by a piece of jewelry.[29]

She sells her idea for the bracelet covered with fur to fashion designer Elsa Schiaparelli[30], considered the "Surrealist" among the couturiers, who introduced "shocking pink" into the world of clothing and devised a whole range of eccentric wear, such as a hat in the shape of a shoe. Already in the case of the "fur cup" the interplay between art, fashion, design, and the poetic (and Surrealist) stylistic device of the oxymoron, the combination of opposing elements, becomes apparent, which is a decisive feature of Meret Oppenheim's artistic endeavor.

The "fur cup" – a result of chance, inspiration, and the translation of a concept for a decorative accessoire into a piece of art – is a big success in Paris. The title that Breton concocts for the object, *Déjeuner en fourrure*, which evokes Edouard Manet's scandalous painting *Le déjeuner sur l'herbe* (1863) as well as Leopold Sacher-Masoch's no less scandalous novel *Venus in Furs* (1870)[31], still enhances its erotic aura. The commodity item transformed into an animal state not only brings to a head the Surrealist passion for clashing disparates, in this sense "functioning" perfectly in Breton's exotically staged show. But as a "veiled" body (or "érotique-voilée") it also serves as a projection surface for manifold speculation. In the eroticizing context of Surrealism the "fur cup" becomes a fetish, a symbol of female sexuality. And, as such, as its presentation in the Graz exhibition *Phantom der Lust – Visionen des Masochismus* ('Phantom of Lust – Visions of Masochism'), 2003, confirms, has undauntedly sustained itself to this day.[32]

In Ursula Sinnreich's opinion, however, Meret Oppenheim's particular challenge consists in "covering her object seamlessly with a precious garment of fur, thus denying the view on its 'naked' surface." She believes that the artist, "through the material that she chooses for this camouflage" sparks off "a double-pronged desire – to see what is hidden from the gaze, but above all to touch what is being displayed." In the "total refusal" of this desire "the actual explosive force of this work" would lie.[33] The "masked cup," which remains impervious, fits in with Meret Oppenheim's evasive, mutable aesthetics, and, in addition, points to a central theme in her œuvre, as Thomas McEvilley declares: the dichotomy between nature and culture she seeks to resolve. He states that in conjoining "a cultural object with a natural condition – the condition of furry beasts" she is referring precisely to this contradiction between nature and culture, while at the same time threatening to "sink" culture ultimately into nature: "The fur grows over the teacup like fur growing on a werewolf in a horror movie."[34]

Sensuality and warmth versus smooth coolness, animal wildness versus civilized tameness: "The attraction/repulsion" of the "fur cup" is rooted in the material contrast between porcelain and fur, Walo von Fellenberg and Jonathan Rousseau assume, a "tactile eroticism" aiming at the associated "region in the mind."[35] The spectrum of possible interpretations makes clear the potential of Meret Oppenheim's "fur cup," but also reveals that, ultimately, it cannot be pinned down. With the exhibition *Fantastic Art, Dada, Surrealism* in 1936 at the New York Museum of Modern Art Meret Oppenheim's "fur cup" attains international cult status. "Few works of art," MoMA director Alfred H. Barr recapitulates a bit later, "have so captured the popular imagination as has Meret Oppenheim's Surrealist object, the 'fur-lined cup, plate and spoon'. Like Lautréamont's

renowned image, like Dalí's limp watches, the 'fur-lined tea set' makes concretely real the most extreme, the most bizarre improbability. The tension and excitement caused by this object in the minds of tens of thousands of Americans have been expressed in rage, laughter, disgust or delight."[36]

For Meret Oppenheim, who in 1936 becomes the shooting star of the Surrealist scene, the "delight" her object arouses is a double-edged sword. The enthusiastic reception of the "fur cup" eclipses its author and blots her out. More zombie than werewolf, the fur-covered creature takes on an independent existence. Behind it for a long period the rest of the artist's production disappears, literally overwhelmed by this object. The reduction of Meret Oppenheim to one work, "which stuck to her like an all-distorting label," as Josef Helfenstein remarks, had an effect equal to "mummification."[37] Jacqueline Burckhardt and Bice Curiger phrase the effects of this narrowed perception even more sharply: "The work and its creator have been stored away on the shelves of art like Siamese twins preserved in formaldehyde – here the erotic, Surrealist protoproject, there the beautiful, enraptured muse – and treated as historical givens, incapable of mutual communication."[38]

One is impelled to connect the onset of Meret Oppenheim's crisis in 1936 - in the very year of her great success – with this experience of massive usurpation.[39] However, emotionally she has been treading on thin ice already for some time, a circumstance that the partially rather somber paintings and drawings from her Paris years imply. The surreal jewelry and fashion, which from around 1934 onward she designs parallel to her art, is not merely a means to earn money in a financially difficult situation (a number of artists in the Surrealist milieu, among those Giacometti, work for Parisian fashion houses[40]), but a strategy of survival, as Christiane Meyer-Thoss reports. According to her, Meret Oppenheim had looked upon her fashion sketches as "desperate attempts" to "'stay grounded, to at least do something useful.'" What she finds characteristic of the artist is her endeavor "even under the most problematic conditions to come down to earth by means of the eccentric and off-beat."[41]

In fact, Meret Oppenheim's ideas for accessoires are inseparably intertwined with the rest of her artistic creation. As the "fur cup" demonstrates, impulses pass from one field to the other. Her sketches for fur sandals and gloves, from which the toes or fingertips respectively protrude, also go back to the year 1936. The gloves were realized by the artist, who placed wooden fingers with red lacquered nails into them as elegant female protheses. A slightly uncanny variation on the notion that anything might be covered with fur. Behind the disguises and the camouflage the energies of dark humor implicitly stir.

Aside from participating in the large shows in New York and London, "in which Surrealism reached the peak of its public impact,"[42] Meret Oppenheim in 1936 has her first solo-exhibition at the Marguerite Schulthess gallery in Basle. Particularly her object *Ma Gouvernante – My Nurse – Mein Kindermädchen*, which already had been represented at the *Exposition surréaliste d'objets* in Paris, attracts the attention of the Swiss audience. "Whether we are witnessing abysses, frivolity, or something that is intended to incense the bourgeois, we dare not judge," a critic wrote. "Possibly in a hundred years we will humbly kneel down before it."[43] The

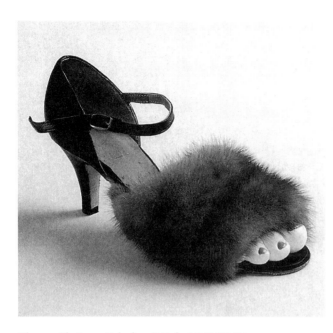

Shoe with Fur – Schuh mit Pelz 1936/2003

object, consisting of a pair of high-heeled women's shoes, bound together and crowned by paper cuffs, contains prototypical motifs, which recur in the artist's work. Again Meret Oppenheim resorts to material from the world of fashion to transfer it into another form.

Ma gouvernante, described by Bice Curiger as "a violent connection between roast goose, maids' bonnet, and woman in bondage,"[44] can also be regarded as a precursor of the shoe object *Le couple* from 1956 (created on the occasion of an exhibition in the context of Daniel Spoerri's Picasso production in Bern). In the latter case lace-up booties are joined at the tips as if engrossed in a fervent kiss. The partly loosened lacing evokes associations of a "state of abandon,"[45] which are underpinned by Meret Oppenheim's own comments on *Le couple* – in her words the "peculiar unisexual pair; two shoes pursuing forbidden pleasures in the cover of night."[46]. The text on the invitation card for the Basle exhibition, where *Ma gouvernante* provokes perplexity, but also sharp criticism[47], was written by Max Ernst. The Dadaist prose piece ends with a rhetorical question-and-answer game: "Who covers the soup spoons with precious fur? Meretlein. Who has risen above our heads? Meretlein."[48]

Disguises, Transformations, Metamorphoses

The lovely, untamable elfin child "Meretlein" in Gottfried Keller's classic German Bildungsroman, *Der grüne Heinrich* (1854/55), supposedly inspired the artist's name.[49] Keller's episode about "Meretlein," who possesses magical powers, once even awakening from death, in any case offers enough material for forming all kinds of legends, which particularly applies to the Surrealist circle, where the overlapping of fiction and reality is a prominent artistic concept. The literary model is also implicit in Max Ernst's burlesque lines for Meret Oppenheim's Basle exhibition in 1936.[50] But for the artist herself as well the figure of "Meretlein" is a source of inspiration in experimenting with various roles and identities. Accordingly, when later residing in Bern, she appears at the farewell celebration for the director of the Bern Art Gallery, Arnold Rüdlinger, as the tombstone of "Meretlein" from Keller's novel. Her costume is made of oxidized brocade, her face shimmers in metallic green, and she is adorned with tendrils of tin ivy from the graveyard.[51] In a text on Meret Oppenheim from 1960 Rüdlinger had warmly recommended that one read *Der grüne Heinrich* for a better comprehension of the artist: "There hardly exists anybody who has been more strongly molded by his name than Meret Oppenheim," Rüdlinger surmises.[52] The

disguise becomes the vehicle for an ambivalent performance: in acting out the "resurrected" or "undead" persona of "Meretlein," the artist ironically undermines the myth, while at the same time living the legend. On another occasion she costumes herself as "Meretlein on the deathbed," assuming a corpse-like paleness and wearing a pillow fastened behind her head.[53]

Yellow Mask – Gelbe Maske, 1936

The intrepidity with which Meret Oppenheim brings to light the darker, precipitous sides of existence, mingling these with ambiguities and awry humor as latent factors of tension and disruption, has a carnivalesque quality. As a time of transformation and masquerade, of demons and fools, of exuberance and excess, carnival is a dialectical consolidation of all subversive forces. Christiane Meyer-Thoss has pointed out Meret Oppenheim's "particularly ardent relationship" to the customary Basle Fasnacht ceremonies and her enthusiasm for costume parties. The artist wore self-constructed masks – from the emulation of a butterfly up to the nightmarishly grotesque countenance of a ghoul – to the masquerades she visited together with her artist friends.[54] The privately staged *Spring Banquet* in 1959 in Bern, where Meret Oppenheim prepared an evening dinner for a few, selected guests on the naked body of a young woman, decorated with gold bronze and fresh blossoms, includes, aside from the impetus of bacchanalian and matriarchal fertility rites,[55] a touch of the carnivalesque as well. Observing Meret Oppenheim's concepts for fashion and jewelry before this backdrop, the "Fasnacht" spirit also becomes tangible, which subliminally informs the artist's work as a whole.

A golden bird's nest with an enamel egg as an adornment for the crevice in the ear, "where a part of the human body becomes an accommodation for wild animals."[56] A hat for three people, which is to be presented by black and white mannequins. A golden cord for the neck embracing "bones" of ivory. A pair of female hands, bound together as a belt clasp, and absurdly frivolous 'Variété Undergarments' with vividly highlighted feminine charms. An evening jacket with a trim of buttons in the shape of small white plates surrounded by embroidered knives and forks. A table with bronze bird's legs and a surface, on which smaller birds have apparently left their footprints (shown in 1939 at an exhibition of fantastic furniture in the newly opened Paris gallery of Leo Castelli and René Drouin). Consistently nature, the energies of animal life, creep into the sphere of the decorative as an unpredictable force, creating reverberating disturbances. Meret Oppenheim lets a large lizard tail grow out of a cape; from a cap in the shape of a dog's head with gaping jaws she drapes a red velvet tongue flapping into the potential wearer's face. A motif that the artist varies in her

15

Läbchuechegluschti chair: In this monstrous piece of furniture from 1967 the back rest has mutated into a bestial grimace, from which a gigantic cloth tongue dangles down, futilely lusting after a seat cushion designed as a piece of traditional Bern gingerbread.

The 'Template for White Skeleton Hand on Black Leather Gloves' (1936) – according to Christiane Meyer-Thoss a reinterpretation of the fragmentary black printer's ink on Meret Oppenheim's palm in the famous Man Ray photo[57] – and the gloves with red, piped veins (1942-45)[58] draw the attention to another kind of secret life: by transcending, as a revealing cover, the boundaries between inside

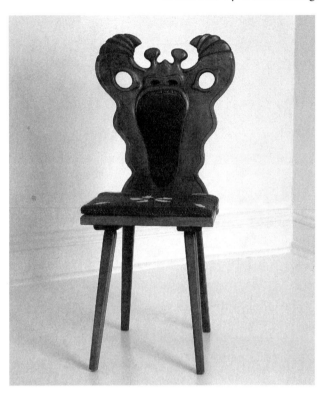

Läbchuechegluschti, 1967

and outside. The artist's "poetical X-ray eye" makes the contours of the bone structure or the delicate, plant-like ramifications of the veins visible, and also wearable, "as a wild ornament of beauty."[59] Bice Curiger further elaborates this notion: "Meret Oppenheim demonstrates her keen sense of little horrors by means of subtle traps. She lets the nocturnal side of things, their movements and our relationships to them, spark up in a casual way."[60]

The template for the rendering of a skeletal hand on a leather glove, where the "vanitas" theme intrudes into the terrain of fashion, anticipates the later self-portrait of the artist, *X-Ray of M.O.'s Skull* from 1964. In both cases – albeit in a slightly shifted manner – the decorative aspect of the fashion accessoire figures as a vehicle for profounder implications. While in the first instance the transience of worldly beauty is addressed in the deceptive form of a decorative object (gloves), in the self-portrait the jewelry portentously prevails after the exterior shell of the body has disappeared, being thus posited as "that which endures and survives."[61] As Josef Helfenstein stresses: "The artist's head, illuminated in profile, is turned into a skull," – an image of death – "whereas the vanitas attributes, the rings on ears and fingers, manifest themselves in a particularly conspicuous and ambiguous manner."[62]

The interaction between the artistically charged fashion and furniture design concepts (of which during the artist's lifetime only a small number were realized) and the artistic production of Meret Oppenheim cannot be emphasized enough. While in her painting she repeatedly returns to earlier works and sketches, she continuously transforms motifs and sujets from all of her creative domains, clothing them in new garments. This also applies to the drawing *Giacometti's Ear* from 1933 – a combination of stylized female body and clenched fist, from which an arched flower blossoms, together forming the shape of an ear. The physical attribute of the artist Meret Oppenheim revered in earlier days, which is trans-

lated into an ornament of symbolic content, again almost appears like "a piece of jewelry."[63] In 1958 the sketch is rendered as a slate relief and in 1959 is transposed into a bronze object, which in turn serves as the model for a multiple in 1977. The sketch for a *Chapeau de Plage* from 1960 – a mutable hat for the beach, which in wind is intended to billow like a "wandering white cloud"[64] and is reminiscent of the surreal drawing *Girl, Carrying on Her Head a Cloud with Rabbit* (1941) – corresponds with Meret Oppenheim's increased focus on "sky" images and cloud motifs in her work in the early 1960's.[65] The above-mentioned work dedicated to Max Ernst, *Quick, Quick, the Most Beautiful Vowel is Becoming Void* from 1934, on the other hand, is converted from a painting into a necklace: In the piece of jewelry realized in 1985 the precariously poised colorful elements from the painting are transmuted into semi-precious stone pendants.[66]

Finally, the notorious "fur cup" from 1936, which so profoundly determined Meret Oppenheim's image as an artist, also undergoes a metamorphosis in various re-formulations. In a derivative form the "fur cup" reverberates in the objet trouvé *Bicycle Seat Covered with Bees* from 1952, a photo the artist discovered in a magazine and passed on to André Breton. "At the sight of the bicycle seat covered with a swarm of bees, I immediately thought of the fur-covered tea set," the creation of which in turn had been prompted "by the joy in the paradox, the aggressive,"[67] as the artist explains in a letter to Jean-Christophe Ammann in 1982. In a television recording of her first major retrospective at the Moderna Museet, Stockholm, in 1967 she subverts the myth surrounding the "fur cup" by leading the cup to her mouth in the gesture of drinking, thus "in a certain sense reinstating its original purpose," as Josef Helfenstein remarks.[68]

In Meret Oppenheim's demonstrative rejection of her "Surrealist origins" Bruno Steiger perceives an expression of her very own aesthetic concept. The "simulation of a usability of the object in an everyday context," he claims, transfers "the first poetical inversion onto a plane, where art and life are no longer separable." Steiger believes that as a "document of the indecisiveness and bivalency of the artistic invention" the Stockholm ruse "directly links up with the general theme concerning the identity of illusion and certainty, evidence and counter-evidence, which had already been anticipated in the Basle 'Exercise Book'."[69] With her *Souvenir du déjeuner en fourrure* from 1970, a kitsch memento of her massively charged-up work from Surrealist days, the artist beats her fur-clad zombie creature with the weapon of "eternal" preservation in the "living dead"-mode of the multifold fake: Under a tightly sealed glass cover the "cup" now rests, adorned with false edelweiss, as an artificial fur appliqué on imitation damask.

The kitsch object reproduced as a multiple not only attacks the sublime claim to the "uniqueness and non-repeatability" of the work of art as such and her cult work in particular.[70] It is also an ironical re-appropriation of the "fur cup," snatched away from Meret Oppenheim in the course of its reception (the Swiss artist Thomas Hirschhorn carries this still further in his *Meret-Oppenheim-Kiosk* from the year 2000, lined from top to bottom with a patchwork of various fur patterns, where the "fur cup" myth literally explodes in the overkill of sampled, visual allusions to the hide of wild beasts[71]). In 1971 Meret Oppenheim publishes a poster edition after Man Ray's photograph of the "fur cup" from 1936 in

three colors: "red/brownish, yellow/greenish, and bluish/pink."[72] She once more draws upon the idea of "animalizing" a commodity item through the use of fur in 1968 in her wonderfully absurd object *Squirrel*: a beer glass, topped with artificial foam, from which a bushy tail sprouts. In 1978 she returns with a fur-covered brass ring to the origins of the "fur cup," thus coming full circle.

While Meret Oppenheim in later years further developed earlier artistic ideas, partially duplicating and distributing them as multiples, only in a few exceptional cases was she able to launch her sketches for fashion and jewelry commercially, selling only single design concepts, for instance, to the fashion houses Schiaparelli (the fur-covered bracelet) or Rochas (a *Silk Carée*, from around 1936, "with black braids coiled around the head" and cherry trimmings).[73] In 1967 she is commissioned by the paper mill Feldmühle AG in Düsseldorf to design models for a planned assortment of paper dresses. The artist outlines a whole range of garments, extending from "extreme" to "norm" dresses, including "fantasy accessoires."[74] Some of these models she realizes as samples for the firm, among them a shaggy paper jacket, appearing like a hybrid of ostrich plumes, long-haired fur, and grass growing profusely. However, the Feldmühle AG, probably due to economic reasons, puts the production "on ice."[75]

Even here, on her short-term excursion into the world of industry, Meret Oppenheim lets the "wild signal"[76] from the animal and plant spheres of nature, which pervade her art, flare up in her sketches. In the interplay of transformation processes, mimicry, and metamorphoses, inspiring her to a whole variety of "disguises," the artist continues to reinvent herself anew – a fact, which also expresses itself in her "pleasure in displaying the instability of prescribed identities," as Nancy Spector points out – "gender roles were worn and discarded like used costumes."[77] In the *Portrait (Photo) with Tattoo* from 1980 Meret Oppenheim applies to her frontally photographed face an ornamental design, resembling the ornamental scars or totemic symbols in the tribal rites of archaic nature cults. Her metamorphosis into another outward manifestation results in the "mask" being virtually inscribed into the skin: Face and "tattoo" merge in the portrait of the artist, becoming as one – "a veil that both conceals and reveals her purposely ambiguous identity."[78]

Just Another State

In her life and work Meret Oppenheim often shed her skin like *Old Snake Nature* (as one of her objects from 1970 is entitled), which – in conjunction with Eve – she conceived of as the catalyst of human cognition and recurrently focussed upon in her work as a positive symbol, according to Bice Curiger, "for the reevaluation of femininity per se."[79] Her development as an artist becomes palpable in the shifts and fluctuations of her imagery, specifically in relation to the manner in which the female figure is represented. Meret Oppenheim's pictures, objects, sketches, and poems encompass the critical questioning of her role as an artist in the male-dominated Surrealist circle as well as an affirmative self-assertion after

having overcome her crisis. Archetypal femininity, tangibly demonstrated in the model of the *Primeval Venus* from 1933, joins figures waiting in faceless anonymity (*Sitting Figure with Folded Hands*,1933), reclining in semi-immobilized petrifaction (*Stone Woman*, 1938), or floating through nothingness with amputated limbs (*The Suffering of Genevieve*, 1939) as signifiers of unreleased (female) existence in the shadow realms of individual and collective creative restriction. These persona emancipate themselves with their creator, who in her later work catapults the act of liberation into a "grounded" state of suspension rooted within herself. "For me personally art is defined in the image of an oyster which forms its pearl around a foreign body; the occasion is of little concern," as Meret Oppenheim states in a conversation with Rudolf Schmitz in the context of her touring retrospective in 1984/85. "A crisis, also an artistic crisis, always indicates: You can go further; you haven't gone far enough; you haven't reached your limits."[80] Life itself – to which in her case the spheres of the subconscious and of dreams belong as well as an "integration into zones of extensive spatial, temporal, and mythical dimensions"[81] – provides the material, which she incorporates into her art, relying on the method of "letting herself drift, wide open, in a state of alert, expectant concentration,"[82] and forming her "pearls" around it. The fact that the "foreign body" is contained and bears fruit within herself, is only seemingly a contradiction.

Old Snake Nature – Die alte Schlange Natur, 1970

In her often quoted speech in 1975 in Basle Meret Oppenheim formulates her central notion of a "spiritual androgyny,"[83] according to which in the creative act the "spiritually feminine" and the "spiritually masculine" are both equally involved.[84] Androgyny here becomes a "metaphor for the unification and equivalence of opposites, the holistic coupling of equal parts,"[85] in the coarse of which the "polarity of the sexes" can be resolved "on the individual level as well as in the social domain."[86] However, in the process, as Jean-Christophe Ammann differentiates, Meret Oppenheim does not entirely neutralize the dialectical tension between male and female: "The male world projected onto the female – and vice versa – is acknowledged and extracted in her work as both congruent and incongruent." What he finds decisive, is that "both of these worlds reveal themselves *within herself* or, respectively, in her work," rendering the specific "keenness" of her aesthetic production, which is independent "of ideology or fixed attitudes."[87] Her refusal to be tied down – concerning artistic forms of expression as well as gender roles – finds correspondence in her "androgynous" concept of the mind.

As can be seen, despite the "discontinuity" characteristic of Meret Oppen-

19

Primeval Venus, model – Urzeitvenus, Modell, 1933

heim, consistent strands reveal themselves, meandering through her œuvre like the cathartic symbol of the snake. The *Primeval Venus* is turned in 1962 into a terracotta sculpture filled with straw, and, in 1977, into a bronze multiple. In variation the figure is perceivable in the top-heavy object *A Distant Relative* from 1966, which with subtle humor implies that Venus, after all, is the "distant relative" of every woman. From the "fur cup" to the fountain in Bern, inaugurated in 1983 and meanwhile taken over by the natural "specter of the mask,"[88] which Meret Oppenheim deliberately entrusted to the rampant, veiling forces of vegetation, the artistic idea is rooted in the already incorporated processes of mutation and transformation. In the artist's view, death as well is "just another state."[89] Uroboros, the snake that sires itself and bites its own tail, is inscribed as an emblem of the eternal cycle of life on her gravestone in Carona, where the grandparents' house retains the creative handwriting of the artist up to this day. Nothing is lost, as Meret Oppenheim in her prospective *Self-portrait Since the Year 50,000 B.C. to X* envisages: "All the thoughts that were ever thought roll around the earth in the vast mind sphere. The world shatters; the mind sphere bursts; the thoughts disperse into the universe, where they continue to live on other stars."[90]

Notes:

[Unless otherwise indicated, quotations in the assay generally author's translation]

1 From: Meret Oppenheim: Husch, husch, der schönste Vokal entleert sich, Gedichte, Zeichnungen, edited and with an epilogue by Christiane Meyer-Thoss, Frankfurt/Main, 1984, p. 51.

2 Helmut Heissenbüttel: "Kleiner Klappentext für Meret Oppenheim," 7, in: Meret Oppenheim, exh.cat. (Museum of the City of Solothurn and other venues), Solothurn, 1974 (w/o p.).

3 Cf. Meret Oppenheim, "Rede anlässlich der Übergabe des Kunstpreises der Stadt Basel 1974, am 16. Januar 1975," (Acceptance Speech for the 1974 Art Award of the City of Basle, January 16, 1975), in: Bice Curiger: Spuren durchstandener Freiheit, Zurich, 1989 (1982), p. 130.

4 Cf. Josef Helfenstein: Meret Oppenheim und der Surrealismus, Stuttgart, 1993, p. 48.

5 Cf. Christiane Meyer-Thoss: Meret Oppenheim – Buch der Ideen, Frühe Zeichnungen, Skizzen und Entwürfe für Mode, Schmuck und Design (with photographs by Heinrich Helfenstein), Bern, 1996, p. 63. With the publication 'Buch der Ideen' ('Book of Ideas') Christiane Meyer-Thoss presented the first extensive survey of Meret Oppenheim's sketches for fashion, jewelry, and furniture design and examined the intertwining of the genres in the artist's work.

6 From: Meret Oppenheim: Husch, husch, der schönste Vokal entleert sich, p. 17.

7 Cf. Jean-Christophe Ammann, "Für Meret Oppenheim," in: Curiger, 1989, p. 116.

8 Cf. Meyer-Thoss, 1996, p. 88.

9 Cf. Curiger, 1989, p. 52.

10 Cf. Meyer-Thoss, 1996, p. 17.

11 Cf. ibid.

12 Cf. quote in Meyer-Thoss, 1996, ibid.

13 Cf. quote in Curiger, 1989, p. 43.

14 Cf. ibid., p. 89.

15 Cf. Bruno Steiger, "...Man könnte sagen, etwas stimme nicht," in: Du - Die Zeitschrift für Kultur, Meret Oppenheim – Kunst von Sinnen, February 2001, No. 713, p. 44.

16 From: Hilde Domin: Nur eine Rose als Stütze, Frankfurt/Main, 1977 (1959), p. 53.

17 Cf. Lautréamont (Isidore-Lucien Ducasse): Die Gesänge des Maldoror (translated from French into German by Ré Soupault), Reinbek/ Hamburg, 1990 (1963), p. 223.

18 From: André Breton, "L'Amour fou" (translated from French into German by Friedhelm Kemp), in: Surrealismus in Paris 1919-1939, edited and with an essay by Karlheinz Barck, Leipzig, 1990, p. 515.

19 Cf. Curiger, 1989, p. 23.

20 Cf. Nancy Spector, "Meret Oppenheim – Performing Identities," in: Beyond the Teacup, exh.cat. (Guggenheim Museum, New York, and other venues, 1996-97, guest curators: Jacqueline Burckhardt and Bice Curiger), ed. by Independent Curators Inc. (ICI), New York, 1996, p. 37.

21 From: Meret Oppenheim: Husch, husch, der schönste Vokal entleert sich, p. 15.

22 Cf. Helfenstein, 1993, p. 20ff.

23 Cf. Meret Oppenheim: Husch, husch, der schönste Vokal entleert sich, p. 23.

24 Ibid., p. 31.

25 Cf. Helfenstein 1993, p. 70ff.

26 Cf. ibid., p. 72.

27 Cf. ibid., p. 73.

28 Cf. Interview (June 6, 2003) with Daniel Spoerri in this catalogue, p. 44.

29 Cf. Meyer-Thoss, 1996, p. 34. In her sketches of rings and bracelets, 1935, Meret Oppenheim under "Sept.35." comments on a sketch of a brass bracelet covered with fur: "This bracelet gave me the idea for the fur cup, plate, and spoon!".

30 Cf. ibid., p. 33ff.

31 Cf. Helfenstein, 1993, p. 69f., and footnote 3, p. 185, as well as Ursula Sinnreich, "Wenn die Harpunen fliegen," in: Du, February 2001, No. 713, p. 29.

32 "Phantom der Lust – Visionen des Masochismus in der Kunst," Neue Galerie Graz at Landesmusuem Joanneum (April 26-August 24, 2003), accompanying publication (2 vols.), Munich, 2003. In the catalogue (vol. 2, ed. by Peter Weibel) Meret Oppenheim's 'Déjeuner en fourrure' and her 'Fur Gloves with

Wooden Fingers' from 1936 are reproduced in direct vicinity to Hans Bellmer's prosthetic doll creatures and works by Salvador Dalí, Adolf Loos, and Victor Brauner.

33 Cf. Ursula Sinnreich, in: Du, February 2001, No. 713, p. 29.

34 Cf. Thomas McEvilley: "Basic Dichotomies in Meret Oppenheim's Work," in: Beyond the Teacup, New York, 1996, p. 46.

35 Cf. Walo von Fellenberg and Jonathan Rousseau, "Taktile Region im Kopf," in: Du, February 2001, No. 713, p. 75.

36 Cited from Joachim Helfenstein, "Against the Intolerability of Fame – Meret Oppenheim and Surrealism," in: Beyond the Teacup, New York, 1996, p. 27.

37 Cf. ibid., p. 29.

38 Cf. Jacqueline Burckhardt und Bice Curiger, "With an Enormously Tiny Bit of a Lot," in: Meret Oppenheim – Eine andere Retrospektive – A Different Retrospective, exh.cat. (traveled to Museum voor Moderne Kunst Arnhem, Holland, and other venues), Galerie Krinzinger (ed.), Vienna, 1997, p. 12 [translation of Burckhardt/Curiger from the German by Catherine Schelbert].

39 Cf. Helfenstein, 1993, p. 73.

40 Cf. ibid., p. 151.

41 Cf. Meyer-Thoss, 1996, p. 33.

42 Cf. Helfenstein, 1993, p. 24.

43 Cf. quote in ibid., p. 95f.

44 Cf. Curiger, 1989, p. 29, and Jacqueline Burckhardt and Bice Curiger, in: Meret Oppenheim – A Different Retrospective, Vienna, 1997, p. 12. Here one finds further elaboration on Meret Oppenheim's "second-most-famous object": "Tied together and served up on a silver platter, the shoes present the culinary, erotic image of a single being or a fatally intertwined unisexual couple with firm, solid thighs ready for consumption at a formal repast."

45 Cf. Jacqueline Burckhardt and Bice Curiger, in: Meret Oppenheim – A Different Retrospective, Vienna, 1997, ibid.

46 Cf. Jean-Christophe Ammann, in: Curiger, 1989, p. 116; cited from a letter to Jean-Christophe Ammann, dating from June 8, 1982; cf. also p. 117.

47 Cf. Helfenstein, 1993, p. 96.

48 Cf. ibid., p. 39f.

49 Cf. "Meret Oppenheim - Spuren zu einer Biographie, gesichert durch Hans Christoph von Tavel," in: Meret Oppenheim, Solothurn, 1974 (w/o p.).

50 Helfenstein, 1993, p. 40ff.

51 Cf. Curiger, 1989, note in the index of works, p. 261.

52 Cf. citation in Helfenstein, 1993, p. 40.

53 Cf. Meyer-Thoss, 1996, p. 100.

54 Cf. ibid. and Curiger, 1989, p. 261.

55 Cf. Meyer-Thoss 1996, p. 56ff., and Peter Gorsen, "Meret Oppenheim's Banquets – A Theory of Androgyne Creativity," in: Meret Oppenheim – A Different Retrospective, Vienna, 1997, p. 35, and Helfenstein, 1993, p. 25. On André Breton's insistance the 'Spring Banquet was repeated at Galerie Cordier, Paris, in the context of the 'Exposition inteRnatiOnal du Surréalisme' (EROS) in 1959. Unhappy about the distorting 'happening'-character of the second event, Meret Oppenheim subsequently did not again participate in any activities of the Surrealists.

56 Cf. Meyer-Thoss, 1996, p. 38.

57 Cf. ibid., p. 26.

58 In 1985 these gloves were manufactured in an edition of 150 copies (in light blue, piped goat suede leather with silk-screen print) and enclosed as a supplement in the de-luxe-edition of the journal Parkett, No. 4, 1985. Cf. Meret Oppenheim – A Different Retrospective, Vienna, 1997, appendix, p. 215.

59 Cf. Meyer-Thoss, 1996, p. 66f.

60 Cf. Curiger, 1989, p. 31f.

61 Cf. Jacqueline Burckhardt and Bice Curiger, in: Meret Oppenheim – A Different Retrospective, Vienna, 1997, p. 12.

62 Cf. Helfenstein, 1993, p. 125.

63 Cf. Meyer-Thoss, 1996, p. 68f., and Helfenstein, 1993, p. 148ff.

64 Cf. Meyer-Thoss, 1996, p. 42.

65 Cf. Curiger, 1989, p. 75, and index of works, p. 186ff.

66 Cf. ibid., index of works, p. 260.

67 Cf. letter to Jean-Christophe Ammann from June 8, 1982, in: Jean-Christophe Ammann, in: Curiger, 1989, p. 117.

68 Cf. Helfenstein, 1993, p. 76.

69 Cf. Bruno Steiger, in: Du, February 2001, No. 713, p. 45.

70 Cf. Helfenstein, 1993, p. 78, and Meyer-Thoss 1996, p. 32. Both Helfenstein and Meyer-Thoss conclude that the 'Souvenir du déjeuner en fourrure' also points to the "entertainment value" of the original object.

71 Thomas Hirschhorn installed his 'Meret-Oppenheim-Kiosk' in 2000 at University Irchel, Zurich. Cf. Walo von Fellenberg and Jonathan Rousseau, in: Du, February 2001, No. 713, p. 75.

72 Cf. ibid. and Curiger, 1989, index of works, p. 204.

73 Cf. Meyer-Thoss, 1996, p. 38f.

74 Cf. ibid., p. 74ff.

75 Cf. ibid., p. 76.

76 Cf. ibid., p. 80.

77 Cf. Nancy Spector, in: Beyond the Teacup, New York, 1996, p. 41.

78 Cf. ibid., p. 42.

79 Cf. Curiger, 1989, p. 85.

80 Cf. "Meret Oppenheim im Gespräch mit Rudolf Schmitz," in: Meyer-Thoss, 1996, p. 131. The interview took place on the occasion of Meret Oppenheim's touring exhibition in 1984/85, prior to the opening of the show at Frankfurt Kunstverein. First published in an abridged version in: Wolkenkratzer Art Journal, No. 5., November/December, Frankfurt, 1984.

81 Cf. Curiger, 1989, p. 75.

82 Cf. Jacqueline Burckhardt and Bice Curiger, in: Beyond the Teacup, New York, 1996, p. 17 [texts by Jacqueline Burckhardt and Bice Curiger translated from the German by Catherine Schelbert].

83 Cf. Helfenstein, 1993, p. 164ff.

84 Cf. Meret Oppenheim, "Rede anlässlich der Übergabe des Kunstpreises der Stadt Basel 1974, am 16. Januar 1975," in: Curiger, 1989, p. 130f.

85 Cf. Nancy Spector, in: Beyond the Teacup, New York, 1996, p. 40.

86 Cf. Helfenstein, 1993, p. 165.

87 Cf. Jean-Christophe Ammann, in: Curiger, 1989, p. 117.

88 Cf. Meyer-Thoss, 1996, p. 101.

89 Cf. "Meret Oppenheim im Gespräch mit Rudolf Schmitz," in: ibid., p. 137.

90 From: Meret Oppenheim: Husch, husch, der schönste Vokal entleert sich, Frankfurt/Main, 1984, p. 85.

Die „Pelztasse" war nur der Anfang

**Verschmelzung von Bildern, Sprache, Gegenständen
in Meret Oppenheims „angewandter Poesie"**

Belinda Grace Gardner

*Wer ihre weißen Finger sieht, ist bereit, sich zu verwandeln. Alle entsteigen ihrer
Haut, um sich der neuen Welt hinzugeben. Alle wissen, dass kein Schiff sie zurück-
bringt, aber das Füllhorn winkt. Es öffnet seine Fächer und lässt seinen Duft aus-
strömen. Die grünen Vögel zerreißen die Segel, und die große Sonne fällt ins Wasser.
Aber solange einer die Trommel rührt, kann die Nacht nicht sinken.*

<div align="right">

Aus: Meret Oppenheim: „Wer ihre weißen Finger sieht", 1940[1]

</div>

*da Meret Oppenheim nicht Farben Formen oder Sachen addiert oder einfach
Verschiedenes aneinander reiht oder Objekte zueinander in Beziehung setzt sondern
Vorstellungen verschmilzt kann sie das Vokabular und die Syntax der Sprache in der
gleichen Weise gebrauchen wie das Vokabular und die Syntax der Farben und
Formen wie auch das Vokabular und die Syntax der Dinge und Gegenstände denn
Vokabular und Syntax der Sprache werden auf die gleiche Weise als Vorstellung zur
Verschmelzung von Vorstellung benutzt wie Vokabular und Syntax von Farben
Formen und Gegenständen*

<div align="right">

Aus: Helmut Heissenbüttel: „Kleiner Klappentext für Meret Oppenheim", 7, 1974[2]

</div>

x = Hase

„Die Freiheit wird einem nicht gegeben, man muss sie nehmen"[3]: In ihrer viel
beachteten Rede 1975 zur Verleihung des Kunstpreises der Stadt Basel trat Meret
Oppenheim gegen jegliche Einschränkung und Abwertung von Frauen in der
Gesellschaft an. Sie erklärte das tradierte Rollenbild für obsolet und eröffnete
dem „weiblichen Künstler" neue Perspektiven. Ihre Überzeugung, dass Änderun-
gen erst durch ein radikal selbstbestimmtes Handeln von Frauen herbeigeführt
werden, hat sie vehement gelebt. Meret Oppenheim, 1913 in Berlin geboren und
1985 in Basel gestorben, legte in mehr als fünfzig Schaffensjahren ein vielschich-
tiges, spannungsvolles und rätselhaftes Werk vor, das sich als resistent erwiesen
hat gegen frühe Vereinnahmung und Festlegung. Sie überstand die Verharmlo-
sung als Modell, Muse und „Fee der Surrealisten"[4]. Ebenso wie die zugespitzte
Reduktion auf die „Pelztasse", das geniale Objekt aus ihrer Pariser Anfangszeit als
Künstlerin. Als resistent hat sich Meret Oppenheim auch gegenüber stilistischen
Einordnungsversuchen erwiesen, stattdessen auf formale, inhaltliche und media-
le Mannigfaltigkeit gesetzt – „stilistische Verweigerung als Widerstand"[5]. In Me-
ret Oppenheims poetischer Diktion: „Hier herrscht kein Kastengeist. / Hier darf
sich jeder ungehindert äußern."[6] Die „Diskontinuität" im Œuvre der Künstlerin

hatte System. Es war ein schöpferischer Weg, der nach Jean-Christophe Ammann ihren „Inhalten freien Lauf" ließ: „Bei Meret Oppenheim ist alles möglich: im sich scheinbar ausschließenden Nebeneinander und Nacheinander. Immer wenn man glaubt, ihr auf der Spur zu sein, verwischt sich diese und taucht dort wieder auf, wo man sie nicht erwartet."[7]

Ihre „Sachen", wie Meret Oppenheim selbst ihre vieldeutigen Schöpfungen beiläufig bezeichnete, oszillieren genreübergreifend zwischen bildenden, literarischen und angewandten Künsten. Malerei, Zeichnungen, Objekte, Dichtung, Entwürfe für Mode, Schmuck, Mobiliar verschmelzen im freien Fluss einer uneingeschränkten kreativen Energie, die sich aus Wach- und Traumzuständen gleichermaßen speist. „Meret Oppenheims Poesie", so Christiane Meyer-Thoss, die neben dem „Buch der Ideen" auch die Gedichte und Träume der Künstlerin herausgegeben hat, „ist handwerkliches Ausbalancieren von Stimmungen – die Perfektion und Vollendung wird nicht angestrebt. Wenn der Geist der Sache berührt ist, verlässt sie das Feld im Vertrauen auf das Fragmentarische, das die Idee des Ganzen lebendiger aufscheinen lässt."[8] Ein prekäres Prinzip, das dem Flüchtigen, im Wandel Begriffenen momenthaft Ausdruck verleiht. Und doch sind es starke Momente, die Meret Oppenheim im fragilen Gleichgewicht eines dauerhaften Provisoriums festhält, als banne sie im Bild das ephemere Schillern von Schmetterlingen oder Regenbögen. Man soll sich aber auch hier nicht in der Künstlerin täuschen: „Ihre Sensibilität und Intuition sind in ihrer Hand scharfe Instrumente, die sie präzise einzusetzen weiß", betont Bice Curiger, Verfasserin der ersten Monographie über Meret Oppenheim, „selbst wenn ihre schöpferische Energie sich auf das Tastende, das Leichte, das Sparsame und das zart Äquilibrierende richtet."[9]

Leben und Werk sind bei Meret Oppenheim ineinander verwoben wie das Geflecht von Wurzeln, die sich untergründig ausbreiten, Fuß fassen. Die Künstlerin hat dem „Geheimnis der Vegetation", so der Titel eines ihrer Gemälde von 1972, überhaupt den Erscheinungen der Natur mit Erweiterung ins Kosmische hinein, durchgängig Gestalt gegeben. Metamorphosen, Verwandlungen, Maskierungen, Rollenwechsel sind ihr Metier. Eine bisweilen bizarre Komik und makabre Nuancen durchströmen ihre zum Feinstofflichen tendierende Kunst, die sie aus ihren inneren Bildern emporfördert und „aus einem weiten geistigen Raum"[10] in Empfang nimmt. Laut Christiane Meyer-Thoss begreift Meret Oppenheim ihre Aufgabe als Künstlerin darin, einem Medium gleich „den Bildern auf die Welt"[11] zu helfen, die gewissermaßen als kollektives ästhetisches Treibgut frei flottierend in der Luft liegen. „Jeder Einfall wird geboren mit seiner Form. Ich realisiere die Ideen, wie sie mir in den Kopf kommen. Man weiß

The Secret of Vegetation –
Das Geheimnis der Vegetation, 1972

nicht, woher die Einfälle einfallen; sie bringen ihre Form mit sich, so wie Athene behelmt und gepanzert dem Haupt des Zeus entsprungen ist, kommen die Ideen mit ihrem Kleid."[12]

Meret Oppenheims Pfad verläuft synkopisch, mit atemberaubenden Höhenflügen, melancholischen Untiefen, niederschmetternden Einbrüchen und einer fulminanten künstlerischen Auferstehung in späteren Jahren. Sie wächst in einem musischen Umfeld als Tochter einer Schweizerin und eines Deutschen auf. Durch den Vater, der Arzt ist, kommt Meret Oppenheim früh mit den Schriften C. G. Jungs in Berührung. Mit vierzehn Jahren beginnt sie, ihre Träume zu notieren, zeitlebens eine Inspirationsquelle, aus der etliche Werke hervorgehen. Ein wichtiges Vorbild ist die Schweizer Großmutter Lisa Wenger-Ruutz, einst Studentin an der Kunstakademie Düsseldorf, Frauenrechtlerin und Schriftstellerin. Meret Oppenheim verbringt ihre Kindheit in Süddeutschland und der Schweiz, wo die Großeltern leben. Schon als Schülerin beschließt sie, Malerin zu werden. „X = Hase": Ins Mathematikheft collagiert sie diese phantasmagorische Gleichung, ihr erstes „surrealistisches" Werk, das 1957 in der Zeitschrift „Le Surréalisme même" abgebildet und 1973 in einer Auflage von hundert Exemplaren als Multiple herausgegeben wird.

Sie bricht die Schule ab, geht nach Paris, nimmt innerhalb kürzester Zeit an allen wesentlichen Surrealisten-Ausstellungen teil. Sie malt, zeichnet, schreibt Gedichte, macht Objekte. Die „Pelztasse", unter anderem. Figürliches, Skurriles, Dunkles, Poetisches, Kühl-Abstraktes im schnellen Wechsel.

Dann um 1936, Ausbruch einer langen Schaffenskrise, die Kulmination einer bereits latenten depressiven Verfassung. 1937 Rückkehr in die Schweiz, Besuch der Kunstgewerbeschule in Basel, wo sie Mal- und Zeichentechniken studiert und nebenher eine Ausbildung als Bilderrestauratorin absolviert. Zweiter Weltkrieg, Geldnot, ein Gefühl kreativer Ohnmacht, resultierend aus der eigenen Infragestellung als Künstlerin: „Es war mir [...], als würde die jahrtausendealte Diskriminierung der Frau auf meinen Schultern lasten, als ein in mir steckendes Gefühl der Minderwertigkeit."[13] Die Krise dauert achtzehn Jahre an, bis 1954. Phoenixgleich steigt Meret Oppenheim aus den Schatten empor. Sie bereichert die damals rege Künstlerszene in Bern, wo sie ein Atelier bezieht und ein weites Spektrum neuer Werke schafft. Eine große Retrospektive in Stockholm 1967 bringt ihr den Durchbruch, den zweiten und eigentlichen, als Künstlerin. Zahlreiche Ausstellungen und Auszeichnungen folgen. 1982 nimmt sie an der documenta 7 in Kassel teil. In den siebziger und achtziger Jahren wird sie in ihrer Komplexität, gerade auch von der jüngeren Künstlergeneration, schließlich begriffen und anerkannt.

Bern, Carona im Tessin, wo das märchenhaft-verwunschene Haus der Großeltern steht, und auch wieder Paris sind die Orte, wo Meret Oppenheim ihr „sesshaftes Unterwegssein"[14] in den letzten Jahrzehnten ihres Lebens vorantreibt. Als sie 1985 mit 72 Jahren in Basel stirbt, hinterlässt sie ein reiches Œuvre, das bis heute sein Geheimnis wahrt. Im hintergründig-humorvollen Spiel mit Paradoxien, Unwägbarkeiten und Überraschungen hat Meret Oppenheim ihr frühes Rechenexempel „x = Hase" immer wieder frisch auf die Probe gestellt und stets in der Schwebe gehalten. „Auf dieser Kunst des 'Schwebens in der Mitte'", erkennt Bruno Steiger, „beruht wohl nicht zuletzt jener zwischen Eleganz und

Panik irisierende Witz, der ihren 'Sachen' eignet, noch vor aller Enigmatik."[15] Das Zwischenreich, wo die Dinge sich umkehren und andere Formen annehmen, wo die „große Sonne" ins Wasser fällt und „das Füllhorn winkt", ist zugleich Ausgangs- und Ankunftspunkt der Künstlerin. Um mit einer Zeile der Dichterin Hilde Domin zu sprechen, Meret Oppenheim „setzte den Fuß in die Luft, und sie trug"[16].

„Und lass die Wände los ..."

Mit ihrem Aufbruch nach Paris 1932 als 18-Jährige in Begleitung der um ein paar Jahre älteren Schweizer Malerin Irène Zurkinden beginnt Meret Oppenheims erste, kometenhafte Karriere als junge Künstlerin im Kreis der Surrealisten. Alberto Giacometti und Hans Arp führen sie ein in die Gruppe, die angetreten ist, jegliche Grenzen und Tabus der Gesellschaft aufzusprengen. „Poésie", „amour", „liberté" lauten die Schlagworte der Subversion, die wilde Blüten treibt. Zentrale künstlerische Formel beim kulturellen Umsturz ist Lautréamonts „unvermutete Begegnung einer Nähmaschine und eines Regenschirms auf einem Seziertisch"[17]: das wundersame Zusammentreffen von Dingen, die keinesfalls zusammengehören. Surrealisten-Chef-Programmatiker André Breton leitet vom heftigen Aufeinanderprallen divergierender Sinn-Elemente bekanntlich seine bewusst kryptische Definition einer neuen Ästhetik ab: „Die konvulsivische Schönheit wird erotisch-verhüllt, berstend-starr, magisch und umstandsbedingt sein, oder sie wird nicht sein."[18]

In Gestalt von Meret Oppenheim erhält die von Breton viel beschworene „konvulsivische Schönheit" legendäre Präsenz. „Erotique-voilée' – 'Verhüllte Erotik', so lautet der Titel von Man Rays berühmtem Aktfoto der Künstlerin hinter dem Rad einer Kupferdruckpresse, aufgenommen 1933 im Pariser Atelier des kubistischen Malers Louis Marcoussis und 1934 in der Zeitschrift „Minotaure" veröffentlicht: in unmittelbarer Nachbarschaft zu Bretons Aufsatz über „La beauté convulsive". Schlagartig mutiert Meret Oppenheim zur surrealistischen Symbolfigur. Druckerschwärze auf dem erhobenem linken Arm und der Handfläche der Porträtierten lenkt den Blick zusätzlich auf den Kontrast zwischen nacktem, weiblichem Körper und wuchtiger Maschine, „ein erotisches Traumbild par excellence"[19]. Die enigmatische Aktaufnahme der anmutigen, jungen Frau mit dem androgynen Garçon-Schnitt wird – ganz im Sinne der Surrealisten – zum Skandal. Und Meret Oppenheim selbst im Zuge ihrer Erhöhung zur mystischen Erotik-Ikone als „surrealistisches Objekt kolonisiert"[20]. Was ihre eigene Kunstproduktion anbelangt, ist darin die surrealistische Dynamik – wie ihre Hasen-Gleichung zeigt, die sie als 16-Jährige im Schulheft ausführte – längst vorgeprägt. Nicht als theoretisches Konstrukt, sondern als innewohnender Wesenszug der Künstlerin, der im Surrealismus einen Resonanzboden findet und sich noch intensiviert.

Zunächst fühlt sich Meret Oppenheim unter den Verfechtern der „konvulsivischen Schönheit" als Künstlerin verstanden. „Endlich!/Die Freiheit!"[21], so beginnt ein Gedicht aus dem Jahr 1933 – dem Jahr, in dem die Newcomerin erst-

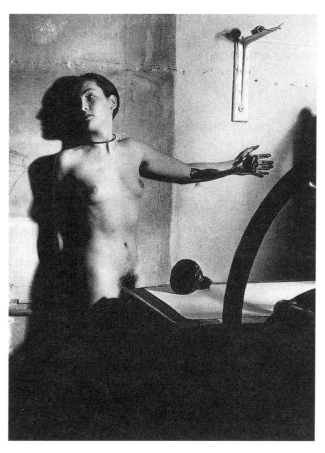

M.O., Paris, 1933; Photo: Man Ray

malig bei einer Surrealisten-Ausstellung in Paris gemeinsam mit bekannten Künstlern wie Alberto Giacometti, Max Ernst, Man Ray und René Magritte vertreten ist.[22] Weitere Teilnahmen folgen, unter anderem an der Schau „International Kunstudstilling Kubisme = surrealisme" 1935 in Kopenhagen, wo Meret Oppenheim das Gemälde „Husch-husch, der schönste Vokal entleert sich" von 1934 zeigt. Es ist dem Dada-bewegten Surrealisten Max Ernst gewidmet, mit dem sie 1934-35 eine leidenschaftliche Beziehung hat, und schlägt sich auch lyrisch nieder: „Von Beeren nährt man sich/Mit dem Schuh verehrt man sich /Husch, husch, der schönste Vokal entleert sich."[23] In ihrem Ölbild für Max Ernst konfrontiert Meret Oppenheim ein pelzig-diffuses Gebilde mit bunten, halb geometrischen, halb organischen Formen, die wie ausgestanzt wirken. Sie balancieren, tanzen fast, über einer schmalen schwarzen Linie in der Luft, die durch eine Kette mit dem knäuelartigen Körper verbunden ist, kurz vor dem Abheben. Eine Gratwanderung, die in Richtung Befreiung zielt. Wie es in einem zeitgleich geschriebenen Gedicht der Künstlerin heißt: „Für dich – wider dich/Wirf alle Steine hinter dich/Und lass die Wände los."[24]

Die Maskierte Tasse

Ein paar Tage nur – vom 22. bis 29. Mai 1936 – dauert die Ausstellung surrealistischer Objekte in der Pariser Galerie Charles Ratton. Und doch markiert sie einen Höhe- und Wendepunkt in Meret Oppenheims rasanter Laufbahn im Dunstkreis der Surrealisten. André Breton organisiert die Schau, die die Künstlerin gleichsam über Nacht ins Schlaglicht katapultiert. Oder zumindest das Objekt, das sie dort präsentiert: die als „Déjeuner en fourrure" zum Mythos gewordene „Pelztasse". Breton konzipiert die Ausstellung als verblüffende Gegenüberstellung von Kunst, Flohmarktfundstücken, Kultgegenständen aus fernen Ländern, ausgestopften exotischen Tieren, Kristallen, Vogeleiern, fleischfressenden Pflanzen und weiteren Kuriositäten.[25] In dieser Wunderkammer der Avantgarde, Vorreiter so manch heutiger Ausstellungsinszenierung, wird Meret Oppenheims „Pelztasse" – fast en passant – im untersten Regal einer Glasvitrine dargeboten: umgeben von außereuropäischen Objekten, Marcel Duchamps „Flaschentrockner" und Skulpturen, unter anderem, von Max Ernst. Hier, „wo der Angriff auf eine normative Ästhetik mit aller Deutlichkeit zum Ausdruck kommt"[26], wird die „Pelztasse" von Alfred H. Barr, dem damaligen Leiter des Museum of Modern

Art in New York, entdeckt und, laut Überlieferung, für die Summe von 200 Schweizerfranken gekauft. Kaum geschaffen, landet das „Déjeuner en fourrure" in „der schon bald bedeutendsten Sammlung der Kunst [des zwanzigsten] Jahrhunderts".[27]

Wie die „Pelztasse" entstanden ist, hat Meret Oppenheim in aller Nüchternheit erzählt: Der selbst entworfene Armreif, ein mit Ozelotfell bekleideter Metallring, den sie im Frühsommer 1936 im Pariser Café de Flore ihrer Freundin Dora Maar und Picasso vorführte. Die Bemerkung Picassos, dass man mit Pelz alles überziehen könne. Ihre Erwiderung, „auch diesen Teller und diese Tasse dort".[28] Als André Breton sie zur „Exposition surréaliste d'objets" in der Galerie Charles Ratton einlädt, besinnt sie sich angeblich auf den Einfall im Café. Sie besorgt aus dem Kaufhaus eine Tasse mit Untertasse sowie einen Löffel, bezieht alles mit chinesischem Gazellenfell, und, voilà, fertig ist das „Pelzgedeck", das die Künstlerin lakonisch „Tasse, soucoupe et cuillère revêtus de fourrure" ('Tasse, Untertasse und Löffel, mit Fell verkleidet') nennt. Bemerkenswert ist, dass die Idee zu dem Objekt, das Meret Oppenheims frühen Ruhm begründet, durch einen Schmuckentwurf inspiriert wird.[29]

Den Entwurf für einen mit Pelz überzogenen Armreif verkauft die Künstlerin an die als „Surrealistin" unter den Couturiers geltende Modedesignerin Elsa Schiaparelli[30], die „Shocking Pink" als Knall-Farbe für Bekleidung einführte und exzentrische Kreationen wie einen Hut in Schuh-Form auf den Markt brachte. Schon bei der „Pelztasse" wird das Zusammenspiel von Kunst, Mode, Design und dem lyrischen (und surrealistischen) Stilmittel des Oxymorons, der Verbindung von Widersprüchen, ersichtlich, das für Meret Oppenheims künstlerische Praxis maßgeblich ist.

Die „Pelztasse" – ein Resultat aus Zufall, Eingebung und Übertragung des Konzepts für ein dekoratives Accessoire auf einen zweckfreien Kunstgegenstand – wird in Paris ein großer Erfolg. Der von Breton nachträglich verliehene Titel „Déjeuner en fourrure", der Edouard Manets Skandal-Gemälde „Le déjeuner sur l'herbe" (1863) ebenso evoziert wie Leopold Sacher-Masochs nicht minder skandalöse Novelle „Venus im Pelz" (1870)[31], verstärkt noch die erotische Aura des Objekts. Der zum Tier gewordene Gebrauchsgegenstand treibt nicht nur die surrealistische Passion für Zusammenstöße des Disparaten auf die Spitze – und „funktioniert" in diesem Sinne bestens in Bretons exotischer Inszenierung. Sondern er bietet als „verhüllter" Körper (oder „Erotique-voilée") eine Projektionsfläche für Spekulationen jeglicher Art. Im erotisierenden Kontext des Surrealismus wird die „Pelztasse" zum Fetisch, zum Symbol weiblicher Sexualität. Und als solche bis heute, wie ihre Präsentation in der Grazer Ausstellung „Phantom der Lust – Visionen des Masochismus" 2003 belegt, unverdrossen hochgehalten.[32]

Aus Ursula Sinnreichs Sicht besteht indes die besondere Herausforderung Meret Oppenheims darin, „ihr Objekt nahtlos mit einem kostbaren Gewand aus Fell zu überziehen und damit den Blick auf seine 'nackte' Oberfläche zu verweigern". Die Künstlerin entzünde „durch das Material, das sie für diese Camouflage wählt, gleich ein doppeltes Begehren; zu schauen, was dem Blick verborgen ist, vor allem aber das zu berühren, was da ausgestellt ist." Gerade in der „totalen Verweigerung" dieses Begehrens bestehe „die eigentliche Sprengkraft dieses Wer-

kes".[33] Die „maskierte Tasse", die sich nicht durchschauen lässt, fügt sich in Meret Oppenheims flirrende, sich entziehende Bildwelten ein. Und bringt zudem ein Grundthema ihres Œuvres zur Anschauung, wie Thomas McEvilley meint: den Konflikt zwischen Natur und Kultur, den sie zu überwinden sucht. Durch ihre Verknüpfung eines Gegenstands aus der Kultur mit dem naturgegebenen Zustand von Pelztieren, verweise sie auf eben jene Natur/Kultur-Dichotomie. Zugleich aber drohe sie, die Kultur endgültig in die Natur zu versenken: „Das Fell überwuchert die Tasse wie der Pelz, der einem Werwolf in einem Horror-Film wächst."[34]

Sinnlichkeit und Wärme versus glatter Kühle, Wild-Animalisches versus Gezähmt-Zivilisiertem: „Der Anziehung/Abstossung" der „Pelztasse" liege der stoffliche „Kontrast von Porzellan und Pelz zugrunde", glauben Walo von Fellenberg und Jonathan Rousseau, eine „taktile Erotik", die auf eine ebensolche „Region im Kopf" ziele[35]. Die Bandbreite möglicher Interpretationen macht das Potential von Meret Oppenheims „Pelztasse" deutlich, zeigt aber auch, dass diese eben nicht abschließend dingfest zu machen ist. Mit der Schau „Fantastic Art, Dada, Surrealism" 1936 im New Yorker Museum of Modern Art erlangt Meret Oppenheims „Pelztasse" internationalen Kultstatus. „Wenige Kunstwerke", resümiert MoMA-Direktor Alfred H. Barr kurze Zeit später, „haben in den letzten Jahren derart die Phantasie des Volkes angeregt wie Meret Oppenheims surrealistisches Objekt, die mit Fell überzogene Tasse, der Teller und der Löffel. Wie Lautréamonts berühmte Metapher, wie Dalís weiche Uhren macht die Pelztasse die bizarrste Unwahrscheinlichkeit auf konkrete Weise real. Die Spannung und Erregung, die dieses Objekt bei Zehntausenden von Amerikanern auslösten, drückten sich in Wutausbrüchen, Gelächter, Ekel und Entzücken aus."[36]

Für Meret Oppenheim, die 1936 zum Shootingstar der Surrealisten-Szene wird, ist das „Entzücken" über ihr Objekt ein zweischneidiges Schwert. Die begeisterte Rezeption der „Pelztasse" überlagert die Verfasserin, blendet sie aus. Eher Zombie als Werwolf, verselbstständigt sich die fellverkleidete Kreatur und führt ein Eigenleben. Dahinter verschwindet für geraume Zeit der übrige Output der Künstlerin, wird förmlich erdrückt. Die Reduktion Meret Oppenheims auf das „zum alles verstellenden Identifikationsaufhänger verkommenen [...] einen Werkes", so Josef Helfenstein, sei „einer Mumifizierung" gleichgekommen.[37] Jacqueline Burckhardt und Bice Curiger bringen die Folgen dieser Sichtverengung noch schärfer auf den Punkt: „Werk und Schöpferin standen allzu lange wie in Formalin aufbewahrte siamesische Zwillinge – hier das surrealistisch-erotische Proto-Objekt, dort die schöne entrückte Muse – zur Ansicht in die Regale abgelegt als nicht weiter kommunizierende Grundgegebenheiten des historischen Weichbilds."[38]

Es liegt nahe, den Ausbruch von Meret Oppenheims Krise 1936 – ausgerechnet im Jahr ihres großen Erfolgs – mit dieser Vereinnahmung in Zusammenhang zu bringen.[39] Allerdings wandelt sie seelisch bereits seit längerem auf dünnem Eis, was die teils recht düsteren Gemälde und Zeichnungen aus der Pariser Zeit andeuten. Die surrealen Schmuck- und Modeentwürfe, die sie ab etwa 1934 parallel zu ihrer Kunst entwickelt, sind nicht nur Mittel zum Geldverdienen in finanziell angespannter Situation (diverse Künstler aus dem Umfeld der Sur-

realisten, darunter Giacometti, sind für Pariser Modehäuser tätig[40]), sondern eine Überlebensstrategie, wie Christiane Meyer-Thoss berichtet. Meret Oppenheim habe die Modeentwürfe selbst als „verzweifelte Versuche" betrachtet, „‚auf dem Teppich zu bleiben, um wenigstens etwas Nützliches zu machen'". Bezeichnend für die Künstlerin sei das Bestreben, „noch in den schwierigsten Lebensumständen [...] ausgerechnet mit dem Eigenwilligen und Abwegigen auf die Erde zu kommen".[41]

Tatsächlich sind Meret Oppenheims Ideen für Accessoires mit ihrem übrigen künstlerischen Schaffen untrennbar verstrickt. Wie die „Pelztasse" zeigt, gehen Impulse von einem Feld zu anderen über. Aus dem Jahr 1936 stammen auch Entwürfe für Fellsandalen und -handschuhe, bei denen die Zehen oder Fingerspitzen jeweils aus dem Pelz hervorlugen. Die Handschuhe hat die Künstlerin realisiert und hölzerne Finger mit rotlackierten Nägeln als elegante weibliche Prothesen hineingesteckt. Eine etwas unheimliche Variante der Vorstellung, alles ließe sich mit Pelz beziehen. Hinter Maskierung und Camouflage regen sich die Energien eines dunklen Humors.

Neben Beteiligungen an den großen Ausstellungen in New York und London, „in denen der Surrealismus den Höhepunkt seiner öffentlichen Wirksamkeit"[42] erreicht, hat Meret Oppenheim 1936 ihre erste Einzelausstellung in der Galerie Marguerite Schulthess in Basel. Insbesondere ihr Objekt „Ma gouvernante – My Nurse – Mein Kindermädchen", das bereits in der Pariser „Exposition surréaliste

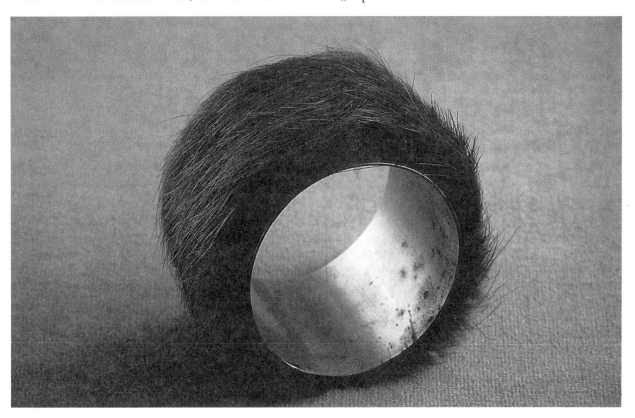

Bracelet – Armband, 1935

d'objets" vertreten war, zieht die Aufmerksamkeit des Schweizer Publikums auf sich. „Ob es sich um Abgründe, um Spielerei, um das, was den Bourgeois epatieren soll, handle, wagen wir nicht zu entscheiden", schreibt ein Rezensent. „Möglich, dass wir in hundert Jahren devot davor niederknien."[43] Das Objekt, bestehend aus einem Paar zusammengebundenen, mit Papierkrausen gekrönten, hochhackigen weißen Damenschuhen, birgt prototypische Motive, die sich im Werk der Künstlerin wiederholen. Erneut nutzt Meret Oppenheim hier ein Material aus der Modewelt, um es in einen anderen Zustand zu überführen.

„Ma gouvernante", von Bice Curiger als „eine heftige Verbindung [...] zwischen Gänsebraten, Bedienstetenhäubchen und gefesselter Frau"[44] bezeichnet, kann auch als ein Vorläufer des Schuhobjekts „Le couple" von 1956 gesehen werden (entstanden anlässlich einer Ausstellung im Rahmen von Daniel Spoerris Picasso-Inszenierung in Bern). In letzterem Fall sind zwei Schnürstiefel an den Spitzen wie in einem innigen Kuss vereint. Die halb geöffnete Schnürung weckt Assoziationen zu einem „Zustand sinnlichen Sich-gehen-Lassens"[45], die von Meret Oppenheims eigenem Kommentar zu „Le couple" unterfüttert werden – in ihren Worten, jenem „seltsamen eingeschlechtlichen Paar: zwei Schuhe, die, unbeobachtet in der Nacht, ‚Verbotenes' treiben"[46]. Den Text auf der Einladungskarte für die Baseler Ausstellung, wo „Ma gouvernante" Ratlosigkeit, aber auch scharfe Kritik erregt[47], verfasst Max Ernst. Das dadaistische Prosa-Stück endet mit einem rhetorischen Frage- und Antwortspiel: „Wer überzieht die Suppenlöffel mit kostbarem Pelzwerk? Das Meretlein. Wer ist uns über den Kopf gewachsen? Das Meretlein."[48]

Verkleidungen, Verwandlungen, Metamorphosen

Nach dem liebreizenden, unbezähmbaren Hexenkind „Meretlein" aus Gottfried Kellers Bildungsroman-Klassiker „Der Grüne Heinrich" (1854/55) soll die Künstlerin benannt worden sein.[49] Kellers Episode vom „Meretlein", das über magische Kräfte verfügt und sogar einmal aus dem Tod erwacht, bietet jedenfalls Stoff genug für allerlei Legendenbildung – gerade im Kreis der Surrealisten, wo das Ineinanderfließen von Fiktion und Wirklichkeit künstlerisches Konzept ist. Die literarische Folie klingt bei Max Ernsts burlesken Zeilen zu Meret Oppenheims Baseler Ausstellung 1936 ebenfalls an.[50] Aber auch für die Künstlerin selbst ist die „Meretlein"-Figur eine Quelle für Identifikations- und Rollenspiele. So tritt sie in ihrer Berner Zeit beim Künstlerfest zum Abschied des Leiters der Kunsthalle Bern, Arnold Rüdlinger, als Grabstein von „Meretlein" aus Kellers Roman auf. Ihr Gewand besteht aus oxydiertem Brokat, ihr Gesicht schimmert metallisch grün, und als Schmuck trägt sie blecherne Efeuranken vom Friedhof.[51] Rüdlinger hatte in einem Text über Meret Oppenheim 1960 empfohlen, man möge zum besseren Verständnis der Künstlerin den „Grünen Heinrich" lesen: „Kaum jemand ist von seinem Namen stärker geprägt worden", befand er, „als Meret Oppenheim."[52] Die Verkleidung gerät zur doppelbödigen Performance: Als „Auferstandene" oder „Untote" rückt die Künstlerin der Legende ironisch zu Leibe und lebt sie zugleich aus. Bei anderer Gelegenheit kostümiert sie sich als

„Meretlein auf dem Totenbett" mit aufgeschminkter Leichenblässe und festgebundenem Kissen hinter dem Kopf.[53]

Die Unerschrockenheit, mit der Meret Oppenheim Abgründiges ans Licht holt, mit schräger Komik versetzt und Ambiguitäten als latente Spannungs- oder Störfaktoren mitschwingen lässt, hat eine karnevaleske Qualität. Als Zeit der Wandlungen und Maskeraden, der Dämonen und Narren, der Ausgelassenheit und der Ausschweifungen ist Karneval eine dialektische Bündelung aller subversiven Kräfte. Christiane Meyer-Thoss hat auf Meret Oppenheims „besonders innige Beziehung" zur Basler Fasnacht und ihre Begeisterung für Kostümbälle hingewiesen. Selbst kreierte Masken – vom Schmetterling bis hin zur alptraumhaft-grotesken Gespenster-Visage – kamen bei gemeinsam mit Künstlerfreunden besuchten Kostümfesten zum Einsatz.[54] Auch das privat inszenierte „Frühlingsfest" 1959 in Bern, bei dem die Künstlerin im engsten Kreis ein nächtliches Mahl auf dem nackten, mit Goldbronze und frischen Blüten geschmückten Körper einer jungen Frau bereitete, birgt neben dem Impetus bacchantischer und matriarchaler Fruchtbarkeitsriten[55] eine karnevalistische Note. Betrachtet man vor diesem Hintergrund Meret Oppenheims Mode- und Schmuckentwürfe aus der Pariser Zeit und danach, wird darin jener Fasnachtsgeist spürbar, der unterschwellig das gesamte Werk der Künstlerin durchzieht.

Ein goldenes Vogelnest mit emailliertem Ei als Zierde für die Ohrmuschel, „wo ein Körperteil des Menschen zur Behausung von wild lebenden Tieren wird"[56]. Ein Hut für drei Personen, der von schwarzen und weißen Mannequins vorzuführen ist. Eine Goldschnur für den Hals, die „Knochen" aus Elfenbein umfasst. Gefesselte Frauenhände als Gürtelschließe und frivol-aberwitzige „Variété-Unterwäsche" mit plastisch hervorgehobenen weiblichen Reizen. Eine Abendjacke mit einer Knopfleiste aus weißen Tellern und aufgesticktem Besteck. Ein Tisch mit bronzenen Vogelbeinen und einer Platte, auf der kleinere Vögel scheinbar ihre Fußabdrücke hinterlassen haben (er wird 1939 bei einer Ausstellung phantastischer Möbel in der damals gerade eröffneten Pariser Galerie von Leo Castelli und René Drouin gezeigt). Immer wieder schleicht sich ins Dekorative die Natur, das Animalische, als unberechenbare Kraft ein und bringt einiges ins Wanken. Aus einem Cape lässt Meret Oppenheim einen Echsenschwanz herauswachsen, aus einer Kappe in Form eines Hundekopfs mit aufgerissenem Maul eine rote Samtzunge der potentiellen Trägerin ins Gesicht wedeln. Ein Motiv, das die Künstlerin in ihrem „Läbchuechegluschti"-Sessel variiert: In diesem Monster-Möbelstück von 1967 ist die Lehne zur ungeheuerlichen Fratze mutiert, von der eine riesige Stoffzunge herabhängt, die vergeblich nach

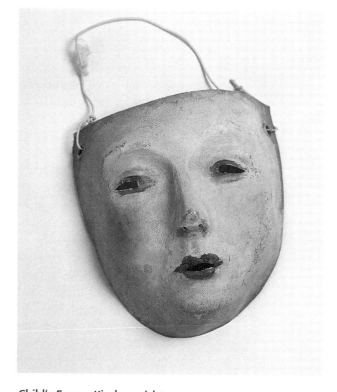

Child's Face – Kindergesicht

33

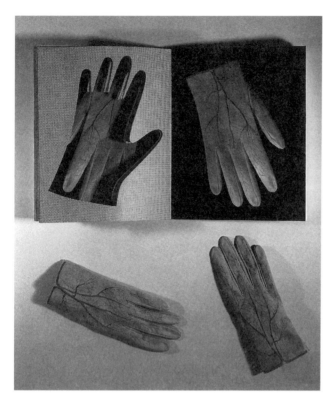

Pair of Gloves with Veins
Handschuhe mit Adern (Paar), 1985

einem als „Berner Lebkuchen" gestalteten Sitz-kissen giert.

Auch die „Schablone für weiße Knochenhand auf schwarzem Lederhandschuh" (1936) – nach Christiane Meyer-Thoss eine umdeutende Fort-führung der fragmentarischen Schwarzfärbung von Meret Oppenheims Handfläche im berühmten Man-Ray-Foto[57] – und die Handschuhe mit roten, paspelierten Adern (1942-45)[58] lenken den Blick auf das Verborgene, indem sie als enthüllende Ver-hüllung die Grenzen zwischen Innen und Außen transzendieren. Das „poetische Röntgenauge" der Künstlerin macht die Umrisse des Skeletts oder die pflanzenartigen Verzweigungen der Adern „als wildes Ornament der Schönheit" sicht- und auch tragbar[59]. „Meret Oppenheim", so Bice Curiger, „zeigt ihren entwickelten Sinn für die kleinen Schrecknisse mittels subtiler Fallen. Sie lässt die Nachtseite der Dinge, ihrer Bewegungen und unserer Beziehungen zu ihnen wie im Spiel her-vorblitzen."[60]

Die „Schablone für weiße Knochenhand auf schwarzem Lederhandschuh", bei welcher die Vanitas-Thematik in das Gebiet der Mode ein-bricht, ist ein Vorgriff auf das spätere Selbstporträt der Künstlerin „Röntgenaufnahme des Schädels M.O." von 1964. In beiden Fällen – wenngleich auf leicht verschobene Weise – figuriert der Aspekt des schmückenden Beiwerks, das üblicherweise das Accessoire kennzeichnet, als Träger einer tiefer gehenden Bedeutung. Während bei Ersterem die Vergänglichkeit irdischer Schönheit in der trügerischen Gestalt eines dekorativen Gegenstands (Handschuhen) angesprochen wird, bleibt im Selbstbildnis der Schmuck signalhaft bestehen, nachdem die äußere Hülle des Körpers verschwunden ist, somit zum „eigentlich Überdauernden und Beständigen"[61] erklärt: „Der im Profil beleuchtete Kopf der Künstlerin", stellt Josef Helfenstein fest, „wird zum Totenschädel, wobei Vanitas-Attribute, die Ohr- und Fingerringe [...] besonders auffällig und vieldeutig in Erscheinung treten."[62]

Die Wechselwirkung zwischen den kunstträchtigen Mode- und Design-Ideen (von denen zu Lebzeiten der Künstlerin nur wenige realisiert wurden) und der künstlerischen Produktion Meret Oppenheims kann nicht oft genug betont wer-den. Während sie in ihrem Werk wiederholt auf frühere Arbeiten oder Skizzen zurückgeht, wandelt sie Motive und Sujets aus allen Schaffensbereichen stetig um und bringt sie in neuen Gewändern auf die Bildfläche. So auch bei der Zeichnung „Das Ohr von Giacometti" von 1933 – halb stilisierter Frauenkörper, halb Faust, aus der eine Blüte bogenförmig erwächst, die zusammen die Form eines Ohrs ergeben. Der in ein symbolhaltiges Ornament übertragene Körperteil des von Meret Oppenheim verehrten Künstlers wirkt fast wieder wie „eine Art Schmuck-

stück"[63]. Die Skizze wird 1958 als Schieferrelief umgesetzt und 1959 in eine Bronzeplastik transformiert, die ihrerseits 1977 als Vorlage für ein Multiple dient. Der Entwurf für einen „Chapeau de Plage" von 1960 – einem wandlungsfähigen Strandhut, der sich bei Wind zu einer „wandernden weißen Wolke"[64] blähen soll, und an die surreale Zeichnung „Mädchen, auf dem Kopf eine Wolke mit Hasen tragend" (1941) anknüpft – korrespondiert mit Meret Oppenheims Hinwendung zu „Himmelsbildern" und Wolkenmotiven Anfang der 1960er-Jahre[65]. Den Weg vom Gemälde zur Halskette wiederum legt das erwähnte, Max Ernst gewidmete Werk „Husch-husch, der schönste Vokal entleert sich" von 1934 zurück: Im 1985 realisierten Schmuckstück sind die gratwandernden bunten Elemente aus dem Gemälde in Halbedelstein-Anhänger umdekliniert.[66]

Nicht zuletzt durchläuft auch die berühmt-berüchtigte „Pelztasse" von 1936, die Meret Oppenheims Image als Künstlerin so nachhaltig prägte, in Um- und Neuformulierungen eine Metamorphose. In abgeleiteter Form hallt sie nach im Fundstück „Fahrradsattel von Bienen bedeckt" von 1952, einem Foto, das die Künstlerin in einer Illustrierten entdeckte und an André Breton weitergab. „Beim Anblick des von einem Bienenschwarm umhüllten Fahrradsattels dachte ich gleich an das pelzübergezogene Gedeck", schreibt die Künstlerin 1982 in einem Brief an Jean-Christophe Ammann, das seinerseits „aus der Freude am Paradoxen, am Aggressiven", entstanden sei.[67] Bei einer Fernsehaufzeichnung ihrer ersten großen Retrospektive im Moderna Museet Stockholm 1967 unterwandert sie den Mythos um die „Pelztasse", indem sie diese in der Geste des Trinkens an den Mund und damit „in gewisser Weise wieder ihrem ursprünglichen Gebrauch" zurückführt, wie Josef Helfenstein bemerkt.[68]

Diese Absage Meret Oppenheims an ihre „surrealistische Herkunft" begreift Bruno Steiger als Ausdruck ihres ureigenen ästhetischen Konzepts. Die „Simulation einer alltagstauglichen Anwendbarkeit des Gegenstands" transponiere „jene erste poetische Inversion auf eine Ebene [...], in der sich Kunst und Leben nicht mehr trennen" ließen: „Als Dokument der Unentschiedenheit und Doppelwertigkeit der künstlerischen Invention knüpft die Stockholmer 'Neunerprobe' unmittelbar an das Generalthema der Identität von Trug und Gewissheit, von Beweis und Gegenbeweis an, das sich bereits im Basler 'Schulheft' angekündigt hatte."[69] Mit ihrem „Souvenir du déjeuner en fourrure" 1970, einem Kitsch-Andenken an ihr heftig aufgeladenes Werk aus Surrealisten-Tagen, schlägt die Künstlerin ihre pelzverkleidete Zombie-Kreatur mit der Waffe „ewiger" Konservierung im Wiedergänger-Modus eines mehrfachen Fake: Unter bombiertem Glas ruht, von falschem Edelweiß verziert, die Tasse nun als Kunstpelz-Applikation auf Damast-Imitat.

Das als Multiple vervielfältigte Kitsch-Objekt attackiert nicht nur den hehren Anspruch auf „Einzigkeit und Unwiederholbarkeit"[70] des Kunstwerks als solchem und ihres Kult-Werks im Besonderen. Es ist auch eine ironische Wiederaneignung der „Pelztasse", die Meret Oppenheim im Zuge der Rezeptionsgeschichte entrissen worden war (ein Sachverhalt, den der Schweizer Künstler Thomas Hirschhorn noch eine Umdrehung weitertreibt in seinem patchworkartig mit verschiedenen Fell-Mustern verkleideten „Meret-Oppenheim-Kiosk" von 2000, wo der „Pelztassen"-Mythos im Overkill einer gesampelten Raubtier-Optik

förmlich explodiert[71]). 1971 legt Meret Oppenheim eine Poster-Edition nach Man Rays Foto der „Pelztasse" von 1936 in drei Farben auf: „rot/bräunlich, gelb/grünlich und bläulich/rosa"[72]. Die Idee, einen Gebrauchsgegenstand mit Fell zu „animalisieren", setzt sie nochmals 1968 in ihrem wunderbar absurden Objekt „Eichhörnchen" um: einem von künstlichem Schaum gekrönten Bierglas, aus dem ein buschiger Eichhörnchen-Schwanz wächst. 1978 kehrt sie mit einem fellbesetzten Messingring an den Ursprung der „Pelztasse" zurück und schließt damit den Kreis.

Während Meret Oppenheim in späteren Jahren frühere Konzepte künstlerisch weiterentwickelte und teils als Multiples auflegte, so gelang es ihr nur in wenigen Ausnahmen, ihre Mode- und Schmuckentwürfe kommerziell unterzubringen. Sie verkaufte lediglich Einzelstücke, so an die Modehäuser Schiaparelli (den pelzbesetzten Armreif) und Rochas (ein „Seidencarée", um 1936, „mit schwarzen, um den Kopf gelegten Zöpfen" und Kirsch-Garnitur).[73] 1967 erhält sie von der Papierfabrik Feldmühle AG, Düsseldorf, den Auftrag, Modelle für eine geplante Kollektion von Papier-Kleidern zu entwerfen. Die Künstlerin skizziert ein ganzes Konzept, das vom „extremen" bis zum „Norm-Kleid" reicht, inklusive „Phantasie-Accessoires".[74] Einige Modelle realisiert sie als Anschauungsobjekte für die Firma, darunter ein zotteliges Papier-Gewand, von der Anmutung her eine Kreuzung aus Straußengefieder, langhaarigem Fell und wucherndem Gras. Die Feldmühle AG legt jedoch, vermutlich aus Kostengründen, die Produktion „auf Eis".[75]

Sogar hier noch, beim kurzfristigen Ausflug in die Welt der Industrie, lässt sie in ihren Entwürfen das „wilde Signal"[76] aus den Tier- und Pflanzenwelten der Natur, die ihre Kunst durchdringen, aufleuchten. Im Spiel mit Verwandlungsprozessen, Mimikry und Metamorphosen, das sie zu „Verkleidungen" unterschiedlichster Art inspiriert, erfindet sich die Künstlerin immer wieder neu – was sich auch in einer „lustvollen Zurschaustellung der Instabilität reglementierter Identitäten" ausdrücke, so Nancy Spector: „Geschlechterrollen wurden getragen und abgelegt wie gebrauchte Kostüme."[77] Im „Porträt (Photo) mit Tätowierung" von 1980 versieht Meret Oppenheim ihr frontal aufgenommenes Antlitz nachträglich mit einem ornamentalen Muster, das an Schmucknarben oder totemistische Zeichen in den kultischen Ritualen von Naturvölkern erinnert. Bei der Metamorphose in eine andere Erscheinungsform wird die „Maske" der Haut virtuell eingeschrieben: Gesicht und „Tätowierung" verschmelzen im Porträt der Künstlerin zu einer Einheit – „eine Verhüllung, die ihre bewusst ambivalente Identität zugleich verbirgt und offenbart"[78].

Nur ein anderer Zustand

Meret Oppenheim hat in ihrem Leben und Werk Häutungen durchlebt wie „Die alte Schlange Natur" (so der Titel eines Objekts von 1970), die sie im Verbund mit Eva als Katalysatorin menschlicher Erkenntnis begriff und als positiv besetztes Symbol, laut Bice Curiger, „für die Neubewertung des Weiblichen schlechthin"[79] wiederholt in ihr Schaffen einbrachte. Ihre Entwicklung als Künstlerin wird im Wandel der Bildmotive greifbar, speziell in der Art, wie sie die weibliche Figur

repräsentiert. Von der kritischen Hinterfragung ihrer Rolle als Künstlerin im männlich dominierten Kreis der Surrealisten bis hin zur affirmativen Selbstbehauptung nach überstandener Krise spannt sich der Bogen, den Meret Oppenheim in ihren Bildern, Objekten, Entwürfen und Gedichten beschreitet. Archetypische Weiblichkeit, im Modell der „Urzeit-Venus" von 1933 plastisch vor Augen geführt, reiht sich neben gesichtslos wartende („Sitzende Figur mit verschränkten Fingern", 1933), halb immobilisierte („Steinfrau", 1938) oder amputierte, haltlos im Nichts wabernde („Das Leiden der Genoveva", 1939) Figurationen eines unerlösten (Frau-)Seins im Schattenreich individueller und kollektiver kreativer Eingrenzung. Diese Gestalten emanzipieren sich mit ihrer Schöpferin, die im späteren Werk zum Befreiungsschlag eines „geerdeten", in ihr selbst verwurzelten Schwebezustands ansetzt. „Für mich persönlich ist die Kunst definiert im Bild der Muschel, die um einen Fremdkörper ihre Perle bildet; der Anlass scheint mir ziemlich gleichgültig", so Meret Oppenheim in einem Gespräch mit Rudolf Schmitz anlässlich ihrer Retrospektive 1984/85. „Eine Krise, auch eine künstlerische Krise, deutet immer an: Du kannst noch weitergehen; Du bist noch nicht weit genug gegangen. Deine Grenzen sind noch nicht erreicht."[80] Das Leben selbst – wozu in ihrem Fall auch die Sphären des Unbewussten und der Träume sowie „das Eingebundensein in größere Zonen ausgedehnter räumlicher, zeitlicher und mythischer Dimensionen"[81] gehören – bietet den Stoff, den sie durch „ein erwartungsvolles Sich-treiben-lassen, ein Sich-öffnen im Zustand der Konzentration"[82] ihrer Kunst einverleibt, und um den sie ihre „Perlen" bildet. Dass der „Fremdkörper" im eigenen Wesen der Künstlerin enthalten ist und Früchte trägt, ist nur scheinbar ein Widerspruch.

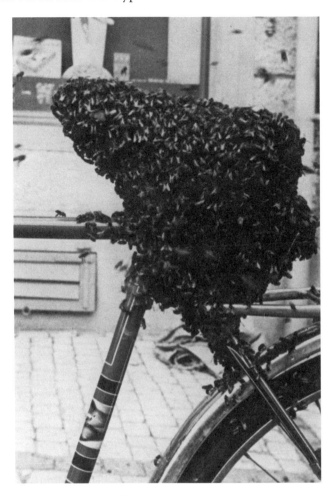

Bicycle Seat Covered with Bees – Fahrradsattel von Bienen bedeckt, 1952

In ihrer oft zitierten Rede 1975 in Basel formuliert Meret Oppenheim ihre zentrale Vorstellung einer „Androgynität des Geistes"[83], nach welcher das „Geistig-Weibliche" und das „Geistig-Männliche" gleichermaßen am schöpferischen Akt beteiligt sind.[84] Androgynität wird hier zur „Metapher für die Vereinigung und Gleichsetzung der Gegensätze, der ganzheitlichen Paarung gleicher Teile"[85], in deren Zuge die „Polarität der Geschlechter [...] sowohl auf der Ebene des Individuums wie im gesellschaftlichen Bereich"[86] überwunden werden kann. Dabei, differenziert Jean-Christophe Ammann, hebe Meret Oppenheim die dialektische Spannung zwischen männlich/weiblich jedoch nicht in Gänze auf: „Die auf das Weibliche projizierte Welt des Männlichen – und umgekehrt – wird in ihrem

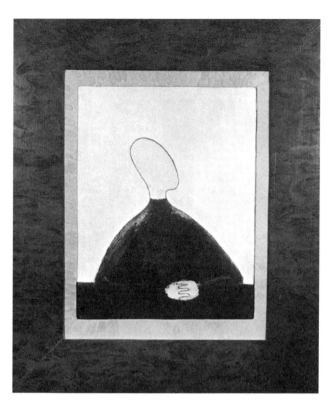

Sitting Figure with Folded Hands –
Sitzende Figur mit verschränkten Fingern, 1933

Schaffen als sowohl kongruent als auch nicht-kongruent erkannt und herausgearbeitet." Entscheidend sei, „dass sich diese beiden Welten in ihr selbst bzw. in ihrem Werk offenbaren." Darin gerade bestehe jene „von Ideologie oder Gesinnungshaltung" unabhängige „Schärfe" ihrer ästhetischen Produktion.[87] Die Weigerung, sich festlegen zu lassen – hinsichtlich ihrer künstlerischen Ausdrucksformen ebenso wie ihrer Geschlechterrolle – finden im „androgynen" Geisteskonzept eine Entsprechung.

Bei aller „Diskontinuität", die Meret Oppenheim zu Eigen ist, sind – wie sich zeigt – Stränge zu erkennen, die durch das Œuvre hindurch mäandern wie das kathartische Sinnbild der Schlange. Die „Urzeit-Venus" verwandelt sich 1962 in eine mit Stroh gefüllte Terrakotta-Skulptur und 1977 in ein Bronze-Multiple. Als Variation lässt sie sich im busenlastigen Objekt „Eine entfernte Verwandte" von 1966 erblicken, das mit hintergründigem Witz darauf verweist, dass Venus schließlich die „entfernte Verwandte" aller Frauen ist. Von der „Pelztasse" bis zum 1983 eingeweihten, mittlerweile vom natürlichen „Spuk der Maske"[88] erfassten Brunnen in Bern, den Meret Oppenheim gezielt der pflanzlichen Überwucherung und Verhüllung anheim stellte, liegen der künstlerischen Idee die mitgedachten Prozesse von Mutation und Transformation zugrunde. Auch der Tod ist aus Sicht der Künstlerin „nur ein anderer Zustand"[89]. Der „Uroboros", die sich selbst zeugende, in den eigenen Schwanz beißende Schlange, steht als Zeichen für den ewigen Kreislauf des Lebens auf ihrem Grabstein in Carona, wo das großelterliche Haus die gestalterische Handschrift der Künstlerin bis heute bewahrt. Nichts geht verloren, wie Meret Oppenheim in ihrem „Selbstporträt seit 50 000 v. Chr. bis X" in Aussicht stellt: „Alle Gedanken, die je gedacht wurden, rollen um die Erde in der großen Geistkugel. Die Erde zerspringt, die Geistkugel platzt, die Gedanken zerstreuen sich im Universum, wo sie auf andern Sternen weiterleben."[90]

Anmerkungen:

1 Aus: Meret Oppenheim: Husch, husch, der schönste Vokal entleert sich, Gedichte, Zeichnungen, hrsg. und mit einem Nachwort von Christiane Meyer-Thoss, Frankfurt/Main 1984, S. 51.

2 Helmut Heissenbüttel: „Kleiner Klappentext für Meret Oppenheim", 7, in: Meret Oppenheim, Ausst.-Kat. (Museum der Stadt Solothurn u.a. Stationen), Solothurn 1974 (o.S.).

3 Vgl. Meret Oppenheim: "Rede anlässlich der Übergabe des Kunstpreises der Stadt Basel 1974, am 16. Januar 1975", in: Bice Curiger: Spuren durchstandener Freiheit, Zürich 1989 (1982), S. 130.

4 Vgl. Josef Helfenstein: Meret Oppenheim und der Surrealismus, Stuttgart 1993, S. 48.

5 Vgl. Christiane Meyer-Thoss, Meret Oppenheim – Buch der Ideen, Frühe Zeichnungen, Skizzen und Entwürfe für Mode, Schmuck und Design (mit Photographien von Heinrich Helfenstein), Bern 1996, S. 39. Mit dem „Buch der Ideen" hat Christiane Meyer-Thoss erstmalig eine umfangreiche Bestandsaufnahme von Meret Oppenheims Entwürfen für Mode, Schmuck und Möbelstücke vorgelegt und das Ineinanderfließen der Genres im Werk der Künstlerin beleuchtet.

6 Aus: Meret Oppenheim: Husch, husch, der schönste Vokal entleert sich, S. 17.

7 Vgl. Jean-Christophe Ammann: „Für Meret Oppenheim", in: Curiger 1989, S. 116.

8 Vgl. Meyer-Thoss 1996, S. 88.

9 Vgl. Curiger 1989, S. 52.

10 Vgl. Meyer-Thoss 1996, S. 17.

11 Vgl. ebd.

12 Zitiert nach Meyer-Thoss 1996, ebd.

13 Zitiert nach Curiger 1989, S. 43.

14 Vgl. ebd., S. 89.

15 Vgl. Bruno Steiger: „…Man könnte sagen, etwas stimme nicht", in: Du - Die Zeitschrift für Kultur, Meret Oppenheim – Kunst von Sinnen, Februar 2001, Nr. 713, S. 44.

16 Aus: Hilde Domin: Nur eine Rose als Stütze, Frankfurt/Main 1977 (1959), S. 53.

17 Vgl. Lautréamont (Isidore-Lucien Ducasse): Die Gesänge des Maldoror (aus dem Französischen von Ré Soupault), Sechster Gesang, Reinbek bei Hamburg, 1990 (1963), S. 223.

18 Aus: André Breton, „L'Amour fou" (aus dem Französischen von Friedhelm Kemp), in: Surrealismus in Paris 1919-1939, hrsg. und mit einem Essay von Karlheinz Barck, Leipzig 1990, S. 515.

19 Vgl. Curiger 1989, S. 23.

20 Vgl. Nancy Spector: „Meret Oppenheim – Performing Identities", in: Beyond the Teacup, Ausst.-Kat. (Guggenheim Museum, New York und weitere Stationen, 1996-97, Gastkuratorinnen: Jacqueline Burckhardt und Bice Curiger), hrsg. von Independent Curators Inc. (ICI), New York 1996, S. 37.

21 Aus: Meret Oppenheim: Husch, husch, der schönste Vokal entleert sich, S. 15.

22 Vgl. Helfenstein 1993, S. 20ff.

23 Aus: Meret Oppenheim: Husch, husch, der schönste Vokal entleert sich, S. 23.

24 Ebd., S. 31.

25 Vgl. Helfenstein 1993, S. 70ff.

26 Vgl. ebd., S. 72.

27 Vgl. ebd., S. 73.

28 Vgl. Interview (Juni 2003) mit Daniel Spoerri im vorliegenden Katalog, S. 56

29 Vgl. Meyer-Thoss 1996, S. 34. In ihren Skizzen und Notizen für Ringe und Armreifen, 1935, merkt Meret Oppenheim unter „Sept. 35." zu einem mit Fell beklebten Armreifen aus Messingrohr an: „Dieses Armband gab mir die Idee für Pelztasse, Teller u. Löffel!"

30 Vgl. ebd., S. 33ff.

31 Vgl. Helfenstein 1993, S. 69f. und Fußnote 3, S. 185 sowie Ursula Sinnreich, „Wenn die Harpunen fliegen", in: Du, Februar 2001, Nr. 713, S. 29.

32 „Phantom der Lust – Visionen des Masochismus in der Kunst", Neue Galerie Graz am Landesmuseum Joanneum (26. April-24. August 2003), Begleitpublikation (2 Bde.), München 2003. Im Katalog (Bd. 2), hrsg. von Peter Weibel, sind Meret Oppenheims „Déjeuner en fourrure" und ihre „Pelzhandschuhe" von 1936 abgebildet, in direkter Nachbarschaft zu Hans Bellmers prothesenhaften Puppenwesen sowie Werken von Salvador Dalí, Adolf Loos und Victor Brauner.

33 Vgl. Ursula Sinnreich, in: Du, Februar 2001, Nr. 713, S. 29

34 Vgl. Thomas McEvilley: „Basic Dichotomies in Meret Oppenheim's Work", in: Beyond the Teacup, New York 1996, S. 46.

35 Vgl. Walo von Fellenberg und Jonathan Rousseau: „Taktile Region im Kopf", in Du, Februar 2001, Nr. 713, S. 75

36 Zitiert nach Helfenstein 1993, S. 73.

37 Vgl. ebd.

38 Vgl. Jacqueline Burckhardt und Bice Curiger, „Mit ganz enorm wenig viel", in: Meret Oppenheim – Eine andere Retrospektive, Ausst.-Kat., hrsg. von Galerie Krinzinger, Wien (mit weiteren Stationen u. a. Museum voor Moderne Kunst Arnhem, Holland), Wien 1997, S. 8.

39 Vgl. Helfenstein 1993, S. 73.

40 Vgl. ebd., S. 151.

41 Vgl. Meyer-Thoss 1996, S. 33.

42 Vgl. Helfenstein 1993, S. 24.

43 Zitiert nach ebd., S. 95f.

44 Vgl. Curiger 1989, S. 29, sowie Jacqueline Burckhardt und Bice Curiger, in: Meret Oppenheim – Eine andere Retrospektive, Wien 1997, S. 9. Hier heißt es zum „zweitberühmtesten Objekt Meret Oppenheims": „Es sind jene zum Sonntagsbraten drapierten, zusammengebundenen weißen Schuhe mit hohen Absätzen, welche mit Papierkrausen versehen sind. Auf dem Silbertablett präsentiert, geben diese das kulinarisch-erotische Bild eines Wesens oder eines fatal verbundenen eingeschlechtlichen Paares mit strammen Schenkeln ab; bereit, in formellem Rahmen verspiesen zu werden."

45 Vgl. Jacqueline Burckhardt und Bice Curiger, in: Meret Oppenheim – Eine andere Retrospektive, Wien 1997, ebd.

46 Zitiert nach Jean-Christophe Ammann, in: Curiger 1989, S. 116. Aus einem Brief der Künstlerin an Jean-Christophe Ammann vom 8. Juni 1982; vgl. auch S. 117.

47 Vgl. Helfenstein 1993, S. 96.

48 Zitiert nach ebd., S. 39f.

49 Vgl. „Meret Oppenheim – Spuren zu einer Biographie, gesichert durch Hans Christoph von Tavel", in: Meret Oppenheim, Solothurn 1974 (o. S.).

50 Helfenstein 1993, S. 40ff.

51 Vgl. Curiger 1989, Anmerkung zum Werkverzeichnis, S. 261.

52 Zitiert nach Helfenstein 1993, S. 40.

53 Vgl. Meyer-Thoss 1996, S. 100.

54 Vgl. ebd. und Curiger 1989, S. 261.

55 Vgl. Meyer-Thoss 1996, S. 56ff. und Peter Gorsen, „Meret Oppenheims Festmähler – Zur Theorie androgyner Kreativität" in: Meret Oppenheim – Eine andere Retrospektive, Wien 1997, S. 32f. sowie Helfenstein 1993, S. 25. Das „Frühlingsfest" wurde auf Drängen von André Breton wenig später in der Galerie Cordier, Paris, anlässlich der „Exposition inteRnatiOnal du Surréalisme" („EROS")1959 wiederholt. Unglücklich über den verfälschenden „Happening"-Charakter der zweiten Inszenierung, hat Meret Oppenheim anschließend an keinen Aktivitäten der Surrealisten mehr teilgenommen.

56 Vgl. Meyer-Thoss 1996, S. 38.

57 Vgl. ebd., S. 26.

58 1985 wurden diese Handschuhe als Edition von 150 Exemplaren (in hellblauem, paspeliertem Ziegenwildleder mit Siebdruck) aufgelegt und der Luxusausgabe von Parkett 4, 1985, beigelegt. Vgl. Meret Oppenheim – Eine andere Retrospektive, Ausst.-Kat., Wien 1997, Anhang, S. 215.

59 Vgl. Meyer-Thoss 1996, S. 66f.

60 Vgl. Curiger 1989, S. 31f.

61 Vgl. Jacqueline Burckhardt und Bice Curiger, in: Meret Oppenheim – Eine andere Retrospektive, Wien 1997, S. 8.

62 Vgl. Helfenstein 1993, S. 125.

63 Vgl. Meyer-Thoss 1996, S. 68f. und Helfenstein 1993, S. 148ff.

64 Vgl. Meyer-Thoss 1996, S. 42.

65 Vgl. Curiger 1989, S. 75, und Werkverzeichnis, S. 186ff.

66 Vgl. ebd., Werkverzeichnis, S. 260.

67 Aus einem Brief der Künstlerin an Jean-Christophe Ammann vom 8. Juni 1982, in: Jean-Christophe Ammann, Curiger 1989, S. 117.

68 Vgl. Helfenstein 1993, S. 76.

69 Vgl. Bruno Steiger, in: Du, Februar 2001, Nr. 713, S. 45.

70 Vgl. Helfenstein 1993, S. 78, und Meyer-Thoss 1996, S. 32. Sowohl Helfenstein als auch Meyer-Thoss resümieren, dass das „Souvenir du déjeuner en fourrure" nicht zuletzt auf den „Unterhaltungswert" des ursprünglichen Objekts verweise.

71 Thomas Hirschhorn hat den „Meret-Oppenheim-Kiosk" 2000 in der Universität Irchel, Zürich, installiert. Vgl. Walo von Fellenberg und Jonathan Rousseau in: Du, Februar 2001, Nr. 713, S. 75.

72 Vgl. ebd. und Curiger 1989, Werkverzeichnis, S. 204.

73 Vgl. Meyer-Thoss 1996, S. 38f.

74 Vgl. ebd., S. 74ff.

75 Vgl. ebd., S. 76.

76 Vgl. ebd., S. 80.

77 Vgl. Nancy Spector, in: Beyond the Teacup, New York 1996, S. 41.

78 Vgl. ebd., S. 42.

79 Vgl. Curiger 1989, S. 85.

80 Zitiert nach „Meret Oppenheim im Gespräch mit Rudolf Schmitz", in: Meyer-Thoss 1996, S. 131. Das Interview fand anlässlich der Vorbereitungen zur retrospektiven Wanderausstellung Meret Oppenheims 1984/85 statt, die kurz darauf im Frankfurter Kunstverein eröffnet wurde. Erstmals abgedruckt in gekürzter Fassung: Wolkenkratzer Art Journal, Nr. 5., November/Dezember, Frankfurt 1984.

81 Vgl. Curiger 1989, S. 75.

82 Vgl. Jacqueline Burckhardt und Bice Curiger, in: Meret Oppenheim – Eine andere Retrospektive, Wien 1997, S. 9.

83 Vgl. Helfenstein 1993, S. 164ff.

84 Vgl. Meret Oppenheim, „Rede anlässlich der Übergabe des Kunstpreises der Stadt Basel 1974, am 16. Januar 1975", in: Curiger 1989, S. 130f.

85 Vgl. Nancy Spector, in: Beyond the Teacup, New York 1996, S. 40.

86 Vgl. Helfenstein 1993, S. 165.

87 Vgl. Jean-Christophe Ammann, in: Curiger 1989, S. 117.

88 Vgl. Meyer-Thoss, S. 101.

89 Zitiert nach „Meret Oppenheim im Gespräch mit Rudolf Schmitz", in ebd., S. 137.

90 Aus: Meret Oppenheim: Husch, husch, der schönste Vokal entleert sich, Frankfurt/Main 1984, S. 85.

"She was incredibly open for everything"

'Trap' Artist Daniel Spoerri Retraces his Friendship with Meret Oppenheim

Daniel Spoerri was born in Rumania in 1930 and grew up in Switzerland. In 1960 he was co-founder of the artists' group Nouveaux Réalistes in Paris, of which Yves Klein and Jean Tinguely, among others, were also members. In the same year Spoerri created his first assemblages of found objects, followed by the 'Tableaux-pièges' – 'Trap Pictures' – which brought the artist international fame: tabletops with dishes and remnants from meals, frozen in time and vertically placed on the wall. Spoerri invented 'Eat Art', was a poet, dancer, stage director, and ran his own restaurant. After having lived in Paris and Italy for many years, he now resides in Ticino, Switzerland. Daniel Spoerri became acquainted with Meret Oppenheim in Bern, when he was still active in dance and theater. He portrays his friend and fellow-artist in a conversation with Belinda Grace Gardner.[1]

Belinda Grace Gardner: You and Meret Oppenheim were friends over many years. When did you first meet?

Daniel Spoerri: We met in Bern in 1954, not long after I had arrived there from Paris. I was engaged as a solo dancer at the City Theater in Bern, which at that time was easy to get around in. All the intellectuals and artists lived in the old part of town – it was a complete milieu. We always got together at the same places, for example at Café Commerce, which incidentally has hardly changed at all. In this context Meret and I became acquainted.

Meret Oppenheim also participated in one of your theater projects.

Indeed. While still a dancer, I began to stage plays at a small theater in Bern, including the first German performance of Ionesco's 'La Cantatrice Chauve' and Picasso's play 'Le Désir Attrapé par la Queue', to which, in fact, Meret contributed in several ways.

Picasso's play was staged in 1956 and was, I believe, a kind of absurd-surreal drama?

Yes, one might say that. If one interprets the play, however, its meaning does come across, which simply amounts to the fact that wishful thinking should not replace life itself. It is an Existentialist play. Desires are wishes projected into the future and not grounded in the here and now, which is where Existentialism of course is rooted. And Picasso expressed this idea in his very own imaginative way. I think

he wrote the whole play in only four days. It contains numerous scenes that are rather hilarious. For example, he called the characters of the girl and her lover 'The Tart' and 'Fat Foot'. The play was translated into German by Paul Celan, which was actually wonderful. Yet we were not so thrilled, because we thought the translation had hardly anything to do with Picasso. Particularly Meret was of the opinion that the play had to be re-translated – in the manner in which Picasso had written it – and not turned into a Celan poem.

The original text probably had more rough edges...

A lot more rough edges than Celan's translation. Celan strongly poeticized Picasso's diction. The part of 'Fat Foot', for instance, which I played myself, involves a long scene, where the character, similar to Samuel Beckett's personae, just babbles on and on. Celan transformed this torrent of words into sentences, which prompted Meret to say, 'come on, let's do a new translation'. The play had been published by the Arche Verlag. And the publisher could not allow us a new translation since Picasso had already authorized Celan's text. He was willing, though, to ignore whatever happened on the stage. So we played Meret Oppenheim's version, without letting on that she had written it. Meret also designed the costumes and masks for the production and played the part of the 'Curtain'. The theater was really tiny – the stage itself was probably no more than six square meters in size. So we performed the Picasso play for a very intimate audience, including a small scandal.

What was the scandal about?

In 1956, when we had our premiere, the Soviet troops had just marched into Hungary. Students protested in front of the theater because they were against our staging a play by a Communist, namely Picasso. Of course our audience was not in the theater because of a Communist, but on account of the artist Picasso. In the end the student's campaign was a complete flop. It's hard to imagine anything like that happening today. In any case Meret, who was seventeen years older than I, became a very good friend of mine during our mutual time in Bern. I still had all kinds of fancy ideas, with all the stuff I was planning and wanted to make happen, but I guess this was what actually fascinated her. She was incredibly open for everything. When I launched my artistic career in 1960 in Paris and became a member of the Nouveaux Réalistes, she was also very supportive. After all, at this point she had been working as an artist for decades and had met me when I was still in dance and theater. She could have also taken the view that I was quickly sneaking my way into the

M.O., Bern, 1956; Photo: Archiv M.O.

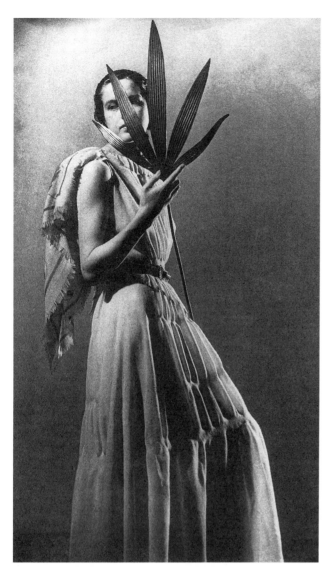

M.O., Paris, 1936; Photo: Dora Maar

art scene – there were such tendencies. Particularly those, who still knew me as a dancer, found it easy to say, 'too bad he's now doing that nonsense. He was okay as a dancer, but now he's simply gluing objects onto surfaces'. Meret never did that. She always showed regard for my artistic work.

How did you experience Meret Oppenheim?

Meret was a very inspired person, highly interested intellectually, and infinitely free. Above that she looked extremely intriguing all her life. When she was still young, she had an almost boyish appearance.

There was something androgynous about her...

She was a garçonne – she really represented that. With her gamin air, her short hair, and exceptional attractiveness she completely corresponded to the beauty ideal of the avant-garde of that time. Meret, you will recall, came to Paris in the early 1930's with the painter Irène Zurkinden. There they immediately dived into the action, visited the famous cafés, the studios, got to know Alberto Giacometti, André Breton, and many other artists from the Surrealist group. This is how Meret met Max Ernst, whom she was together with for a while. She also had an erotic approach to women and had some very close female friends. One of her good friends, for instance, was Dora Maar, at that time the lover of Picasso...

...who gave the impetus to Meret Oppenheim's famous 'fur cup' from 1936.

That's right. Meret of course told me how the idea for 'Breakfast in Fur' came about. She had designed a metal bracelet covered with fur. At the Café de Flore, where she had a rendezvous with Dora Maar and Picasso, she proudly presented it, whereupon Picasso remarked that one can cover anything with fur...

...to which Meret Oppenheim apparently retorted, 'this plate and cup as well'. Shortly thereafter she clothed an ordinary cup, saucer, and spoon from the department store with fur for Breton's show of Surrealist art at the gallery Charles Ratton, thus creating the Surrealist object per se. However, for quite a while the 'fur cup' was more popular than the artist who had invented it. And at

the same time Meret Oppenheim was reduced to this particular work for far too long.

I believe that the 'fur cup', which became so famous, caused her a great deal of harm. For a long time everybody only approached her in connection with the 'cup', or, respectively, didn't even know her name. Many were familiar with the work, without being aware that it had been created by Meret Oppenheim. It was simply the 'fur cup', period. It had no...

...author.

...author, exactly. In this respect I had a striking experience, which goes back to around 1971 – I had already been living in Ticino for two years. A photographer from Stuttgart dropped by to inter-

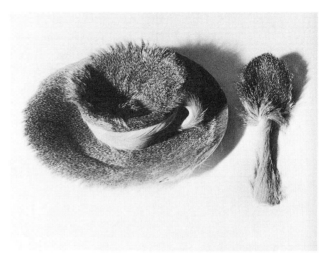

Breakfast in Fur – Die Pelztasse, 1936; Photo: Man Ray

view me. Meret was visiting me at the time, which I mentioned to the photographer. But he only said, Mr. Spoerri, I came here to talk to you, not on account of anybody else. So I asked him if he knew 'Breakfast in Fur.' And then he got all excited and said, 'oh yes, it's a fantastic work, the greatest object there is'. When he realized that the very Meret Oppenheim, who had created this object, was right there in front of him, he, of course, lost interest in me completely and had eyes only for Meret. She, however, wanted to rid herself of the 'fur cup' – and then told the story about Picasso. Who knows whether Picasso ever made any remark to this effect? At some point she downright hated the 'cup.'

It was indeed an enormous constriction, which Meret Oppenheim obviously did not care for at all...

No, being the very opposite – namely, open for everything.

Looking at Meret Oppenheim's work as a whole, it reveals excursions in a variety of directions.

She definitely had her own style, but experimented for a while before finding her own particular form of expression. There is a famous painting of hers of a 'Stone Woman', half lying on solid ground, half disappearing in the water. I'm sure Max Ernst temporarily influenced her, possibly certain Giacometti figures – one discovers all kinds of things in her work.

Her work is very hybrid. Still there are a number of thematic strands running through it. One finds opposites held in precarious suspension; divergent elements merged into surreal syntheses, with regard to form as well as content; transformations, lightness becoming heavy – and vice versa; organic forces tak-

45

ing over rational space, obscuring, covering, and exploding it; clouds, butter-flies, birdlike creatures, which take off into a free-floating sphere. In her works the images themselves evade accessibility, a clearly defined meaning. They contain an enigmatic poetic quality, which in turn Meret Oppenheim in her poetry transforms into images via language...

In my view it's a combination of various, also opposing, elements. Personally, I am particularly impressed by her objects, such as, for example, her wonderful 'Le couple.' She created it on the occasion of our Picasso performance in Bern. Back then we had the idea to invite artists to produce works for the premiere which - as in the case of Picasso and his play – might perhaps deviate slightly from their body of work as a whole. That was basically the approach. A number of Bern artists participated. And Meret contributed this object to the show: a pair of high-lace booties, grown together at the tips. It's absolutely fantastic. In fact I find it almost even more brilliant than the 'fur cup'. With objects like 'Le couple', 'Ma gouvernante', or the 'Squirrel' – a beer glass with a bushy tail – she has indeed lengthily proved that the 'fur cup' was by no means merely a spontaneous idea.

In 1959 Meret Oppenheim staged an event, which she called 'Spring Banquet', a kind of early 'happening' for a very small audience. A rather blurred photograph of the banquet still exists, in which a young woman is roughly discernible, surrounded by blossoms. Those present at the event dined from her naked body. Did you experience the 'Spring Banquet'?

No, I wasn't there. However, shortly afterwards I saw the follow-up event in Paris at the Daniel Cordier gallery, in the context of the famous Surrealist show in 1959. I visited the opening with Tinguely, and there a young girl was lying in a room. She had lobsters in her armpits and so on, and people were eating from her body. What was still required by the law at that time, but struck me negatively, was the fact that the woman was wearing a kind of pink body suit. She wasn't really naked at all. Both of us, Tinguely and I, were disappointed and found it rather silly to eat from a body suit. But at Meret's 'Spring Banquet' in Bern this will certainly have been different. The artist Lilly Keller, a friend of Meret and also of mine in the days when I was still a dancer, described it to me. Indeed, only a handful of people participated in it.

After her extensive retrospective at the Moderna Museet in Stockholm in 1967 Meret Oppenheim was rediscovered as an artist – one might even say, properly acknowledged for the first time. Between her early and later fame she had a long-drawn-out creative crisis, which began around 1936 and lasted until 1954. The outbreak of the crisis coincided with her return to Switzerland. World War Two was looming, Meret Oppenheim's financial situation was also difficult; both things contributed to her decision to leave Paris. Of course this was not an isolated phenomenon, considering that around the same time many artists of the Surrealist group went into exile.

Artists like Meret or Serge Brignoni and Otto Tschumi, the latter both Swiss painters as well and Surrealists in a broader sense, who lived in Paris before the war – that is, between 1932 and 1938 – were confronted with a situation where their career was abruptly cut off, so to speak, by the war. Many at that time were left in limbo, who would otherwise have made their way in Paris. After her return to Switzerland things were quite difficult for Meret for a while. She then qualified herself as a restorer of paintings to earn money, and it took some time until she regained recognition as an artist. At the beginning in Switzerland people didn't really know much about her and were only familiar with her 'fur cup.' Nobody could estimate exactly what she was up to as an artist or, for that matter, if she was still up to anything at all.

Meanwhile one knows that in fact she did continue to work throughout her crisis, albeit with reduced vigor. She also discarded or destroyed many projects during this phase. In the mid-1940's Meret Oppenheim met Wolfgang La Roche, whom she married in 1949. Did you get to know him?

Oh, yes. Wolfgang La Roche belonged to the famous La Roche family from Basle. He initially worked as a production manager or something like that in the movie business. I believe that La Roche and Meret were very much in love for some time. He had a huge motorcycle, a Harley-Davidson. The two of them traveled all over Switzerland on that bike. La Roche didn't think you needed a helmet as long as you didn't have an accident. So they would always be riding around on the Harley with flying hair. Of course you must take into consideration that in those days there was hardly any traffic on the streets. Later on they both led their own lives, but they did stay together until La Roche's death in 1967. At some point Meret plunged into her art again with lots of verve. She took up residence in a small apartment-cum-studio in Bern. People once more began to appreciate and admire her. She was very popular, but she was also a fragile person and quite vulnerable.

I think her works mirror this vulnerability. Even though they sometimes appear burlesque, they always have a delicate or searching quality – in a way, as if a spider were casting its thread into thin air to find a hold somewhere, but maybe there is none. When the two of you met, however, Meret Oppenheim had already overcome her crisis. There are various photos, where she is to be seen

Wolfgang La Roche and M.O.,Bern, 1952
Photo: M.O. Archives

in costumes and jewelry she designed herself. Did you ever witness her appearing at exhibitions or other events in fantastic garments or disguises?

No, not in the extreme sense, at the very most at Fasnacht, the traditional Basle carnival celebrations. She was always exquisite and simply striking as a person. In the circles in which she moved, she was really very prominent – also through her great openness, her immense interest in the world, and her cosmopolitanism. She spoke French fluently, German, of course, and Italian. She also had visitors constantly. When I was still a dancer, she came over to my place once with Elisa Breton. And I cooked for them – I think it was something like boiled potatoes with curd cheese. Until the end Leonor Fini was a very close friend of hers. Meret knew Giacometti, Duchamp, all those people. And she was simply game for anything. For instance, I once had the idea that it would be great to travel with the Trans-Siberia Express. She immediately said, 'if you take the trip, I'll come along' – ten days on the train, via Mongolia to the Japanese border, and back again.

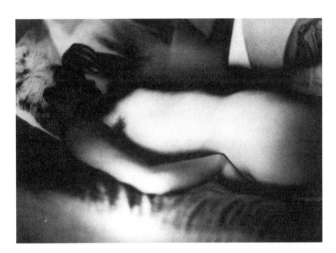

And - did you ever go on the journey?

No, Meret had more courage than I did. I was just thinking out loud how nice it would be to take that train some day. She would have departed right off the bat. She even experimented with drugs once.

Yes, under medical supervision, subsequently capturing her experiences in a gouache entitled 'Psilocybin.'

Of course this had nothing to do with addiction – it was motivated by sheer curiosity. Meret was tremendously curious about life, people, the body, sexuality. She wanted to know about everything, but never in a superficial or sensationalist way – in a very refined, sophisticated manner.

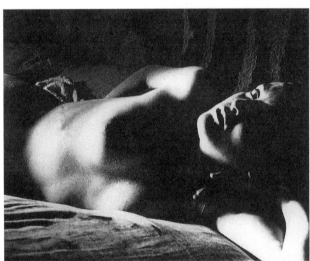

M.O., Paris, 1933/34, Photos: Man Ray

Among others, Meret Oppenheim had a special affinity to female writers of Romanticism such as Bettina Bretano and Karoline von Günderode, both of whom she dedicated paintings to in the late phase of her career. On the other hand, she was very much a woman of the twentieth century and always ahead of her times. She also reminds me to a certain extent of the writer and psychoanalyst Lou Andreas-Salomé, who was closely acquainted with Rilke and

Nietzsche. In the course of Man Ray's famous nude portrait, featuring Meret Oppenheim in conjunction with a printing press, the Surrealists celebrated her as the inspiring 'Érotique-voilée'. Lou Andreas-Salomé as well was stylized as the 'muse' of eminent male artists and consequently blotted out as an artist in her own right. She also stood up at a very early point for the equality of women.

Yes, one can surely find connections there. But Meret is also very much rooted in the avant-garde departure of the 1920's and 1930's, when particularly in Paris things started moving...

...and women began to pursue their own objectives and to liberate themselves from conventions...

...yes, to emancipate themselves, but without dwelling on it like the feminists in later years, who became very hostile towards men. This was not the case with the emancipated women of that time. They were simply in command of their lives, if they had the necessary strength, and asserted themselves and their rights, true to the conviction: 'I have the right, because I say so'. In this context Eva Aeppli also comes to my mind, who is of a younger generation, but is also committed to her art in a very feminine way.

Casa Costanza, Carona, 1980, Photo: Thomas Kaiser

Meret Oppenheim found the energy to get going again. The last two decades of her life were a highly productive phase. Where other artists might have become rigid and have stuck to established paths, she still tried out new concepts, continued to transform herself, and very certainly did not keep quiet – an almost anticyclical conduct.

Because she was under pressure for such a long time – a pressure she already had to endure as a young genius, which possibly manifested itself in her creative crisis. When she realized that she was liberated from this pressure, this released enormous energies in her. Indeed, she became more and more active. In the early 1970's she took an apartment again in Paris – a funny place. It probably had once been a palais, but only remnants of this remained. The apartment itself was virtually split up through little walls and partitions into bits and pieces. A staircase led down into the cellar, where Meret had another odd space. She always had peculiar places.

Her family's house in Carona, where she left her creative traces everywhere, has a very special magic as well. All kinds of accumulated curiosities are to be found there, and scattered among these are her artistic works. The house radiates an enchanted fairy-tale atmosphere.

49

Yes, up to this day it is a very beautiful house. It was built by Ticino craftsmen, who brought into it their entire skills in the art of stucco molding. Meret's grandfather had bought the house, which later belonged to the whole family. But mainly Meret furnished it. She was terribly fussy. In this respect she was a true restorer. She had in fact restored Schwitters, among others. She distributed little notes in the entire house, on which she had written all kinds of rules, since the family members spent time there alternately. The house in Carona was wonderful, as was her studio in the old part of Bern.

The fountain that Meret Oppenheim realized in Bern in 1983, two years before her death, caused quite a stir.

Well, at first, when the fountain still looked very austere. Some complained about it and there was a bit of commotion, but that soon abated. Meanwhile the fountain is as mossy and overgrown as Meret had intended it to be. It's located directly on the central square in Bern, the Waisenhausplatz, in front of the police headquarters, a building which signals: 'We keep order and obey the law'. Architecturally Bern is rather naïve. Facing it cross-wise the Federal Houses of Parliament are situated, flanked on the right and the left by banking houses. On the square itself a charming market takes place regularly, where the farmers from the surrounding countryside sell a few eggs and onions. So this is where Meret placed her fountain. Plants were supposed to spread out on it, but it was constructed with concrete – and it takes a while for anything to grow on that. Since the inauguration of the fountain almost twenty years have passed. Now it's covered with foliage and hanging moss and looks very beautiful. By the way, another fountain Meret designed is located in my artists' park in Tuscany.[2]

Wolfgang Hahn, Daniel Spoerri, Katharina Steffen, and M.O. at the banquet ‚La Faim de CNAC', Paris, 1976

In your sculpture garden, where since 1990 you also install works of your artist friends?

Exactly. When her fountain entered my park, Meret had already died. It's based on an early plaster model from 1967 and is entitled 'Hermes Fountain'. As its main feature two snakes are coiling around a rod with branches, which is crowned with a small golden sphere with spread wings. It definitely evokes erotic connotations. Aesthetically, the fountain suggests the notion of a hermaphrodite, which – knowing Meret – is not really so far-fetched. She never had the fountain cast, though. One day one of her nephews, Martin Bühler, who had also been an assistant of Tinguely, visited me. He asked me, if I wouldn't like to have the fountain sculpture for my park. I was immediately thrilled because the park is also called my 'album souvenir'. All my friends are assembled in

the park – and of course I very much wanted to have a work of Meret's there as well. There were a few complications, since Meret had later painted her sculpture for an exhibition and attached little strings of pearls to the snakes' tongues that streamed down like droplets of water. It was thus an independent work, which the heirs could not give me in this form. A stonemason then manufactured an exact copy of it, of which up to now three casts have been made. I received one of these, another one is with Meret's brother in Carona, and one is in the possession of Thomas Levy in Hamburg.

Does the fountain also function?

Yes, in our case it does. The water trickles very lightly from the two heads of the snakes into the basin above the pedestal.

In my view Meret Oppenheim never really made a distinction between applied and fine arts. The various fields flow into one another. Her objects designed for certain purposes also contain her specific poetry.

Pullover with Breast Pouches – Pullover mit Brusttaschen, ca. 1942/2003

Yes, you're absolutely right. In addition to her art, totally regardless of the costumes for the Picasso play, she also did sketches for fashion and furniture. For example, already in the early 1940's she had designed a pullover with bag-like bulges, into which the wearer could place her breasts. I distinctly remember this idea of hers – I thought it was pretty funny.

Many of Meret Oppenheim's works reveal that she had a vivid sense of humor.

She certainly had a sense of humor, particularly in a subtle, surreal sense, not in a loud or coarse manner. This wasn't like her at all.

Meret Oppenheim also displayed this keen capacity for sophisticated wittiness in the case of your 'Topography of Chance', which was first published in 1962 in a small catalogue version. Here you commented on and recorded in a plan all of the objects situated on the kitchen table in your Paris hotel room on a particular October day of the year 1961. And Meret Oppenheim symbolically enshrouded the table scenario in a blanket of snow...

What happened, was this: In the winter of 1962 I sent to Meret the original version of my 'Topographie Anecdotée du Hasard', a little gray booklet. She asked me

for a further copy and a list of the heights of all the objects located on the table. So I mailed her both, whereupon she sent the second copy of the book back to me with a layer of cotton, where only a few objects had been cut out that were higher than fifteen centimeters. And this was accompanied by the words: 'Daniel's table under a blanket of fifteen centimeters of snow'. The notion of snow falling in a Paris hotel room is, of course, a wonderful idea. But Meret simply had such ingenious ideas.

1 The interview took place on June 6, 2003.
2 Fondazione Il Giardino di Daniel Spoerri, I-58038, Seggiano (Gr), www.danielspoerri.org; appointment by phone at: 0039/0564/950457.

„Sie war wahnsinnig offen für alles"

Erinnerungen des Fallenbild-Erfinders Daniel Spoerri
an die Schweizer Freundin Meret Oppenheim

Daniel Spoerri, 1930 in Rumänien geboren und in der Schweiz aufgewachsen, war 1960 Mitbegründer der Künstlergruppe Nouveaux Réalistes in Paris, zu der unter anderem auch Yves Klein und Jean Tinguely gehörten. Im gleichen Jahr entstanden die ersten Assemblagen gefundener Gegenstände, gefolgt von den „Fallenbildern", die dem Künstler internationalen Ruhm bescherten: Tischplatten mit Geschirr und Essensresten, als Wandobjekte im eingefrorenen Moment fixiert. Spoerri brachte „Eat Art" ins Museum, war Dichter, Tänzer, Regisseur und Restaurantbetreiber. Er lebt heute, nach langen Aufenthalten in Paris und Italien, im Tessin. Daniel Spoerri begegnete Meret Oppenheim in Bern, als er noch Tanz und Theater betrieb. Es war der Beginn einer intensiven Freundschaft, über die der Künstler im Gespräch mit Belinda Grace Gardner Auskunft gibt.[1]

Belinda Grace Gardner: Sie waren lange mit Meret Oppenheim befreundet. Wann sind Sie sich begegnet?

Daniel Spoerri: Das war 1954 in Bern. Ich war kurz zuvor aus Paris gekommen und hatte ein Engagement als Solo-Tänzer am Berner Stadttheater. Bern war damals recht überschaubar. In der Altstadt lebten alle Intellektuellen und Künstler – das war ein ganzes Milieu. Man traf sich immer an denselben Orten, zum Beispiel im Café Commerce, das sich übrigens bis heute kaum verändert hat. In dem Zusammenhang lernten Meret und ich uns kennen.

Meret Oppenheim hat dann auch an einer Ihrer Inszenierungen mitgewirkt.

Allerdings. Noch als Tänzer hatte ich begonnen, in einem Berner Kleintheater Inszenierungen zu machen – darunter die deutsche Erstaufführung von Ionescos „Die kahle Sängerin" und Picassos Stück „Wie man Wünsche am Schwanz packt", zu dem Meret gleich mehrfach beitrug.

Kleintheater Kramgasse 6, Bern
Zum 75. Geburtstag Picassos
deutschsprachige Erstaufführung

Pablo Picasso
Wie man Wünsche am Schwanz packt
Drama in 6 Akten
Inszenierung: Isaac Tarot
Bühnenbilder: Otto Tschumi
Kostüme und Übersetzung:
Meret Oppenheim
Besetzung:
Der Dickfuß: Michel Och-Salgo
Daniel Spoerri (alternierend)
Die Torte: Nusch Bremer
Die Kusine: Anita Kaspar
Der Stumpf: Karl Wirsch
Die magere Angst: Beatrice Tschumi
Die fette Angst: Esther Wirz
Die Gardinen:
Meret Oppenheim, Lilly Keller
Première: Samstag, 1. Dez. 1956
20.30 und 22 Uhr, anschließend jeden
Dienstag, Donnerstag, Freitag
und Samstag 20.30 Uhr
Dauer der Vorstellung: 48 Min. 40 Sek.
Eintritt: Fr. 3.- plus Steuer
Vorverkauf bei Müller & Schade
Theaterplatz 6
Textbuch beim Arche-Verlag, Zürich

XMAS-Schau
ebenfalls im Keller. Es stellen ein und aus:
Hildi Brunschwyler, Ruth Fausch
F. Fedier, A. Flückiger, M. Gierisch
W. Grab, R. Iseli, Lilly Keller
Margrit Linck, B. Luginbühl
E. Moeshnang, Meret Oppenheim
M. Richterich, A. Tomkins, O. Tschumi
W. Voegeli, R. Wasmer, K. Wirth
Vernissage:
Freitag, 30. Nov. 1956, 20.30 Uhr
Die Ausstellung ist geöffnet:
täglich ab 19.00 Uhr
Samstag von 17 Uhr an Katalog Fr. 1.50

Poster for the theater play by Pablo Picasso,
Le Désir Attrapé par le Queue, Bern, 1956
Plakat für das Theaterstück von Pablo Picasso,
Wie man Wünsche am Schwanz packt, Bern, 1956

53

Das war die Aufführung im Jahr 1956. Picassos Stück war eine Art surreal-absurdes Drama, nicht wahr?

Ja, kann man sagen. Aber wenn man es interpretiert, erschließt sich schon die Bedeutung. Und die lautet einfach, man soll Wünsche nicht an die Stelle des Lebens selbst setzen. Es ist ein existenzialistisches Stück. Wünsche sind in die Zukunft projiziertes Wollen und nicht im Hier und Jetzt, worauf der Existenzialismus ja beruht, verankert. Und das hat Picasso auf seine phantasievolle Art ausgedrückt. Ich glaube, er hat das ganze Stück in nur vier Tagen geschrieben. Es enthält viele Szenen, die ziemlich verrückt sind. Die Figuren des Mädchens und ihres Liebhabers hat er beispielsweise „Torte" und „Dickfuß" genannt. Übersetzt wurde das Stück von Paul Celan, was ja im Prinzip großartig ist. Doch waren wir nicht so begeistert – wir fanden, es hatte nur wenig mit Picasso zu tun. Insbesondere Meret war der Ansicht, man müsste das Stück neu übersetzen – so wie Picasso es geschrieben hatte – und kein Celan-Gedicht daraus machen.

Vermutlich hatte das Original viel mehr Brüche...

Sehr viel mehr Brüche als in Celans Übertragung. Celan hat Picassos Sprache stark poetisiert. Der „Dickfuß" etwa, den ich auch selber spielte, hat eine lange Szene, wo er, ähnlich wie Samuel Becketts Figuren, ohne Punkt und Komma vor sich hin plappert. Diesen Wortschwall hat Celan in Sätze verwandelt, worauf Meret dann eben sagte, komm, wir übersetzen das neu. Das Stück hat damals der Arche-Verlag herausgegeben. Und der Verleger hatte nicht das Recht, uns eine neue Übersetzungsbewilligung zu geben, da Picasso den Celan-Text autorisiert hatte. Doch war er bereit über das, was auf der Bühne geschah, hinwegzusehen. Also haben wir die Version von Meret Oppenheim gespielt, ohne kund zu tun, dass sie von ihr stammt. Meret hat für die Aufführung auch die Kostüme und Masken gemacht und zudem noch die Rolle einer der „Gardinen" übernommen. Das Theater war wirklich winzig, die Bühne umfasste wohl kaum mehr als sechs Quadratmeter. So spielten wir also das Picasso-Stück im ganz intimen Kreis inklusive eines kleinen Skandals.

Was war das für ein Skandal?

1956, als wir unsere Premiere hatten, waren gerade die sowjetischen Streitkräfte in Ungarn einmarschiert. Studenten haben vor dem Theater protestiert, weil sie dagegen waren, dass wir ein Stück von einem Kommunisten spielten, nämlich von Picasso. Doch war unser Publikum natürlich nicht wegen eines Kommunisten im Theater, sondern wegen des Künstlers Picasso. Die Aktion der Studenten ging dann auch in die Hose. Man kann sich heute kaum noch vorstellen, dass so etwas denkbar wäre. Jedenfalls wurde Meret, die siebzehn Jahre älter war, in der Berner Zeit eine sehr gute Freundin von mir. Ich hatte noch ziemlich viele Flausen im Kopf, mit allem, was ich vorhatte und machen wollte. Aber gerade das hat sie wohl fasziniert. Sie war wahnsinnig offen für alles. Auch als ich dann 1960

in Paris meine künstlerische Laufbahn einschlug und zu den Nouveaux Réalistes gehörte, stand sie dem sehr positiv gegenüber. Schließlich war sie zu dem Zeitpunkt bereits seit Jahrzehnten als Künstlerin tätig und hatte mich als Ballett-Tänzer und Regisseur kennen gelernt. Sie hätte ja auch der Ansicht sein können, dass ich mich mal eben schnell in die Kunstszene hineinschummele. Denn solche Tendenzen gab es. Gerade die Leute, die mich noch als Tänzer kannten, hatten es leicht zu sagen, schade, dass er jetzt so einen Blödsinn macht. Als Tänzer war er ganz gut, aber dass er nun einfach Objekte aufklebt, ist schon bedauerlich. Das hat sie nie getan, sondern meiner künstlerischen Arbeit immer Wertschätzung entgegengebracht.

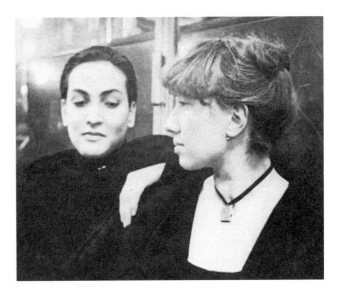

Wie haben Sie Meret Oppenheim erlebt?

Meret war eine genialische Person, geistig sehr interessiert und unendlich frei. Überdies sah sie unheimlich interessant aus, ihr ganzes Leben lang. Als sie noch ganz jung war, wirkte sie fast knabenhaft.

Sie hatte etwas Androgynes...

Sie war eine Garçonne, das hat sie wirklich repräsentiert. Mit ihrer burschikosen Art, dem kurzen Haar und ihrer besonderen Attraktivität entsprach sie genau dem Schönheitsideal der Avantgarde damals. Meret kam ja mit der Malerin Irène Zurkinden in den frühen 1930er Jahren nach Paris. Dort tauchten sie sofort ins Geschehen ein, besuchten die berühmten Cafés und die Ateliers, lernten Alberto Giacometti, André Breton und viele andere Künstler aus der Gruppe der Surrealisten kennen. So begegnete Meret auch Max Ernst, mit dem sie eine Weile zusammen war. Sie

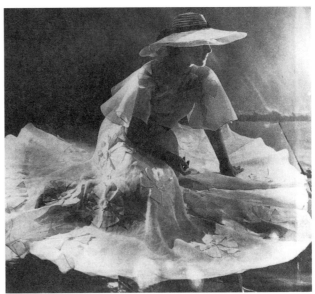

M.O. and Irène Zurkinden, Café du Dôme Paris, 1932

M.O., Paris,1936; Photo: Dora Maar

hatte auch einen erotischen Zugang zu Frauen und etliche sehr enge Freundinnen. Eine gute Freundin von ihr war beispielsweise Dora Maar, die damalige Geliebte von Picasso...

...der ja den Anstoß zu Meret Oppenheims berühmter „Pelztasse" von 1936 gab.

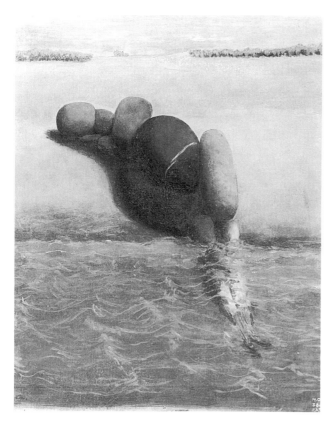

Stone Woman – Steinfrau, 1938

Richtig. Meret hat mir natürlich berichtet, wie die Idee dazu entstanden ist. Sie hatte ein selbst entworfenes Armband aus Metall mit Pelz beklebt. Im Café de Flore, wo sie mit Dora Maar und Picasso verabredet war, führte sie den Armreif stolz vor. Daraufhin soll Picasso gesagt haben, dass man mit Pelz alles überziehen kann.

Worauf Meret Oppenheim wohl geantwortet hat, auch diesen Teller und die Tasse dort. Kurz darauf umhüllte sie für Bretons Surrealisten-Ausstellung in der Galerie Charles Ratton eine gewöhnliche Tasse aus dem Kaufhaus samt Untertasse und Löffel mit Pelz und schuf somit das surrealistische Objekt schlechthin. Allerdings war die „Pelztasse" streckenweise bekannter als die Künstlerin, die sie erfunden hatte. Zugleich wurde Meret Oppenheim lange viel zu stark darauf reduziert.

Ich glaube, dass diese Tasse, die so berühmt wurde, ihr furchtbar geschadet hat. Alle sprachen sie lange Zeit nur auf die Tasse an oder wussten respektive gar nicht ihren Namen. Viele kannten die Tasse, ohne zu wissen, dass sie von Meret Oppenheim war. Das war einfach nur die „Pelztasse", punkt. Sie hatte keinen…

…Autor.

…Autor, ja. In dieser Hinsicht hatte ich ein prägnantes Erlebnis. Das muss um 1971 herum gewesen sein, ich lebte damals schon zwei Jahre im Tessin. Ein Fotograf aus Stuttgart kam dort vorbei, um ein Interview mit mir zu führen. Meret war gerade auf Besuch, was ich dem Fotografen mitteilte. Der aber sagte, Herr Spoerri, ich bin Ihretwegen hier, nicht wegen irgendjemandem. Worauf ich ihn fragte, ob er die „Pelztasse" kenne. Da sagte er, ja, sie ist phantastisch, das tollste Objekt, das es gibt. Als er begriff, dass eben jene Meret Oppenheim vor ihm stand, die dieses Objekt geschaffen hatte, war ich natürlich weg vom Fenster. Er ist nur noch um die Meret herumscharwenzelt. Sie selbst aber wollte diese Tasse loswerden und hat dann die Geschichte von Picasso erzählt. Wer weiß, ob sich Picasso überhaupt in dieser Form geäußert hat? Irgendwann hat sie die „Pelztasse" regelrecht gehasst.

Es war ja auch eine enorme Einengung und gerade die schätzte Meret Oppenheim nun offenbar gar nicht…

Nein, sie war ja das Gegenteil – offen für alles.

**Betrachtet man Meret Oppenheims Gesamt-
werk, entdeckt man bei ihr Exkursionen in
unterschiedlichste Richtungen.**

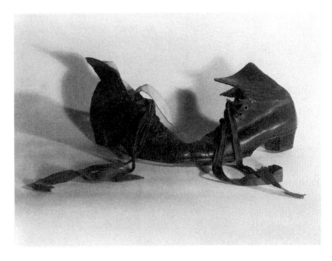

Sie hatte durchaus einen eigenen Stil, doch hat sie
einige Zeit herumexperimentiert, bis sie ihren Stil
fand. Es gibt von ihr ein ganz berühmtes Bild, die
„Steinfrau", die halb auf festem Grund liegt, halb
im Wasser verschwindet. Max Ernst hat Meret
sicher zeitweilig beeinflusst, vielleicht auch gewis-
se Giacometti-Figuren – man entdeckt alles Mög-
liche bei ihr.

Le couple – Das Paar, 1956

**Ihr Werk ist sehr hybrid. Dennoch ziehen sich
verschiedene Stränge hindurch. Man findet
Gegensätze, die in prekärer Balance gehalten
werden. Divergierende Elemente, die zu surrealen Synthesen verschmolzen
werden, was sowohl formal als auch inhaltlich geschieht. Verwandlungen, das
Leichte, das ins Schwere umkippt – und umgekehrt. Organisches, das den
rationalen Raum einnimmt, überwuchert, sprengt. Wolken, Falter, Vogel-
wesen, die sich frei schwebend davon machen. Auch die Bilder selbst entziehen
sich dem eindeutigen Zugriff. Sie enthalten eine rätselhafte Poesie, die Meret
Oppenheim in ihren Gedichten wiederum sprachlich in Bilder umsetzt...**

Ich glaube, es ist eine Mischung verschiedener, auch widersprüchlicher Elemente.
Mich persönlich haben besonders ihre Objekte beeindruckt, wie etwa ihr wun-
derbares „Le couple". Es ist anlässlich einer Ausstellung zu unserer Picasso-
Inszenierung entstanden. Wir hatten damals die Idee, Künstler einzuladen, zur
Premiere Werke zu schaffen, die – wie im Fall von Picasso und seinem Stück –
aus dem Gesamtwerk vielleicht etwas herausfallen. Das war das Thema. Da
haben einige Berner Künstler mitgemacht. Und Meret kam mit diesem Objekt:
einem Paar zusammengewachsener, hoher Schnürstiefelchen. Es ist ganz phanta-
stisch. Ich finde es im Grunde fast noch genialer als die „Pelztasse". Mit ihren
Objekten wie „Le couple", „Ma gouvernante" oder dem „Eichhörnchen" – ein
Bierglas mit buschigem Schwanz – hat sie ja längstens bewiesen, dass die „Pelz-
tasse" keineswegs nur so ein spontaner Einfall war.

**In Bern hat Meret Oppenheim 1959 eine Aktion gemacht, die sie „Frühlings-
fest" nannte, eine Art frühes Happening vor sehr kleinem Publikum. Es gibt
davon eine recht unscharfe Aufnahme, worauf etwas schemenhaft eine liegen-
de Frau zu erkennen ist, die von Blüten umrankt ist. Die Anwesenden dinier-
ten von ihrem nackten Körper. Haben Sie das „Frühlingsfest" miterlebt?**

Nein, da war ich nicht dabei. Allerdings habe ich kurz darauf in Paris die

57

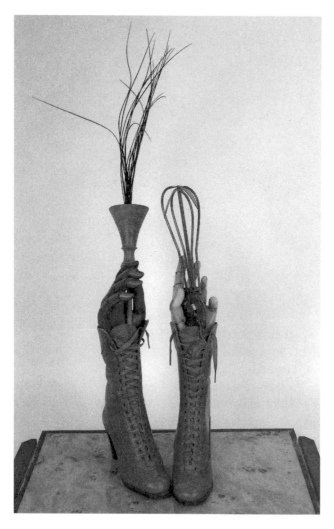

Daniel Spoerri, Les bottines, 1990

Nachfolge-Aktion bei Daniel Cordier gesehen, im Rahmen der berühmten Surrealisten-Ausstellung 1959. Ich besuchte mit Tinguely die Vernissage, und da gab es einen Raum, wo ein Mädchen lag. Sie hatte Hummern in den Achseln und so weiter. Und die Leute aßen von dieser Frau. Was damals vom Gesetz her noch nötig war, mir aber unangenehm auffiel, war, dass diese Frau so ein rosafarbenes Trikot trug. Sie war gar nicht nackt. Wir beide, Tinguely und ich, waren enttäuscht und fanden es blöd, von einem Trikot zu essen. Aber bei Merets „Frühlingsfest" in Bern war das sicher anders. Die Künstlerin Lilly Keller, eine Freundin von Meret und auch von mir in der Zeit, als ich noch Tänzer war, hat es mir beschrieben. Es nahmen daran tatsächlich nur eine Handvoll Leute teil.

Nach ihrer großen Retrospektive im Moderna Museet Stockholm 1967 wurde Meret Oppenheim als Künstlerin wiederentdeckt. Man könnte auch sagen: überhaupt erst richtig zur Kenntnis genommen. Zwischen ihrem frühen und späten Ruhm lag eine lange Schaffenskrise, die um 1936 begann und bis 1954 andauerte. Der Ausbruch der Krise fiel zusammen mit ihrer Rückkehr in die Schweiz. Der Zweite Weltkrieg bahnte sich an, auch wirtschaftlich war die Situation für Meret Oppenheim schwierig. Beides trug zur Entscheidung bei, Paris zu verlassen. Kein isoliertes Phänomen, wenn man bedenkt, dass um die Zeit viele aus der Gruppe der Surrealisten ins Exil gingen.

Künstlern wie Meret oder auch Serge Brignoni und Otto Tschumi, ebenfalls Schweizer Maler und im weiteren Sinne Surrealisten, die damals vor dem Krieg in Paris lebten – also zwischen 1932 und 1938 – wurde sozusagen die Karriere durch den Krieg abgeschnitten. Viele sind dann nicht mehr zum Zuge gekommen, die in Paris ihren Weg gegangen wären. Nach ihrer Rückkehr in die Schweiz hatte Meret es einige Zeit recht schwer. Sie machte ja dann diese Ausbildung als Restauratorin, um Geld zu verdienen. Und es dauerte eine Weile, bis sie als Künstlerin wieder Anerkennung fand. In der Schweiz wusste man zunächst nicht viel über sie, kannte nur die Tasse. Doch was sie jetzt machte oder ob sie überhaupt noch etwas machte, konnte keiner so recht sagen.

Heute weiß man, dass sie durchaus noch während ihrer Krise künstlerisch gearbeitet hat, wenn auch mit gedrosseltem Elan. Vieles hat sie während dieser

Phase auch verworfen oder zerstört. Mitte der vierziger Jahre begegnete dann Meret Oppenheim Wolfgang La Roche, den sie 1949 heiratete. Kannten Sie ihn?

Durchaus. Wolfgang La Roche gehörte zur berühmten Basler La Roche-Familie. Er arbeitete ursprünglich als Produktionsleiter oder etwas Ähnliches beim Film. La Roche und Meret haben sich, glaube ich, eine Zeit lang sehr geliebt. Er hatte eine Harley-Davidson, ein Riesenmotorrad. Damit fuhren die beiden in der Schweiz herum. Einen Helm, fand er, braucht man nicht, wenn man keinen Unfall macht. So saßen sie also immer mit fliegenden Haaren auf dieser Harley. Man muss natürlich wissen: Damals war kaum etwas los auf den Straßen. Später führten dann beide ihr eigenes Leben, aber bis zum Tod von La Roche 1967 blieben sie zusammen. Irgendwann stürzte sich Meret wieder mit Energie in ihre Kunst. Meret nahm sich eine kleine Wohnung mit Atelier in Bern. Man begann sie zu schätzen und zu bewundern. Sie war sehr beliebt, aber auch eine heikle Person – sie war halt auch verletzlich.

Das spiegelt sich in ihren Arbeiten, finde ich. Selbst wenn sie manchmal burlesk wirken, haben sie eigentlich immer eine Zartheit, etwas Suchendes – fast als wenn eine Spinne einen Faden auswirft, um irgendwo in der Luft Halt zu finden. Aber vielleicht ist gar kein Halt da. Als Sie beide sich kennen lernten, hatte Meret Oppenheim ihre schwere Zeit allerdings schon hinter sich gebracht. Es gibt diverse Fotos, wo sie in selbst entworfenen Kostümen und Schmuckstücken zu sehen ist. Haben Sie erlebt, dass sie bei Ausstellungen oder anderen Ereignissen in phantastischen Gewändern oder Verkleidungen auftrat?

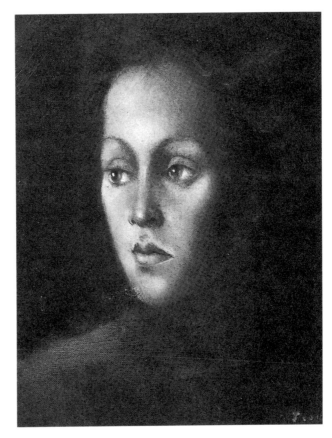

Nein, nicht so extrem, höchstens zur Fasnacht. Sie war immer ausgesprochen apart und fiel halt als Person sehr auf. In dem Milieu, in dem sie verkehrte, war sie wirklich sehr bekannt – eben auch durch ihre Offenheit, ihr Interesse und ihre Weltläufigkeit. Französisch sprach sie fließend, Deutsch natürlich und Italienisch. Sie bekam auch ständig Besuch. Als ich noch Tänzer war, ist sie mit Elisa Breton einmal bei mir aufgetaucht. Und ich habe für die beiden gekocht – Ich glaube, Pellkartoffeln mit Käse oder sowas. Leonor Fini war bis zum Schluss eine sehr gute Freundin von ihr. Sie kannte Giacometti, Duchamp, all diese Leute. Und sie war einfach so bereit zu allem. Zum Beispiel hatte ich irgendwann die Idee, dass es toll sein würde, einmal im Transiberien-Express zu fahren. Da hat sie gleich gesagt, wenn du das

Leonor Fini, Portrait of M.O., painting, 1938

machst, komm ich mit. Zehn Tage Zug, über die Mongolei bis an die japanische Grenze, und dann wieder zurück.

Und, haben Sie die Reise gemacht?

Nein. Meret war mutiger als ich. Ich habe das einfach nur so vor mich hin gesagt, das wäre schön, das sollte man mal machen. Sie wäre sofort aufgebrochen. Sie hat sogar einmal mit Drogen experimentiert.

Ja, unter ärztlicher Kontrolle, und ihre Erfahrung anschließend in einer Gouache mit dem Titel „Psilocybin" fest gehalten.

Das hatte natürlich nichts mit Sucht zu tun. Sondern geschah schlicht aus Neugier. Sie war gegenüber dem Leben, den Menschen, dem Körper, der Sexualität, einfach unglaublich neugierig. Sie wollte über alles Bescheid wissen, aber nie auf oberflächliche oder sensationsheischende Art. Auf eine sehr vornehme und geistige Art.

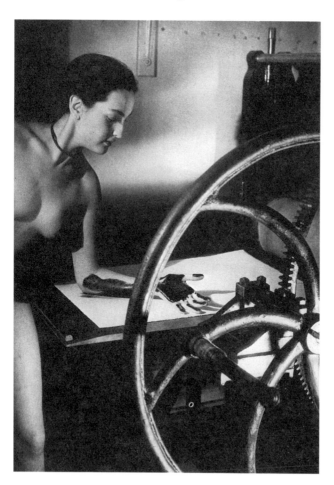

M.O., Paris, 1933; Photo: Man Ray

Zu Meret Oppenheims Wahl-Verwandten gehörten Dichterinnen der Romantik wie Bettina Bretano und Karoline von Günderode, denen sie in ihrem Spätwerk Bilder gewidmet hat. Andererseits war sie sehr eine Frau des 20. Jahrhunderts und ihrer Zeit eigentlich stets voraus. Ein wenig erinnert sie mich aber auch an die Schriftstellerin und Psychoanalytikerin Lou Andreas-Salomé, die mit Rilke und Nietzsche befreundet war. Die Surrealisten feierten Meret Oppenheim im Zuge von Man Rays berühmter Aktaufnahme mit Druckerpresse als inspirierende „Érotique-voilée". Auch Lou Andreas-Salomé wurde zur „Muse" bedeutender Männer stilisiert und somit als autonome Künstlerpersönlichkeit ausgeblendet. Sie trat ebenfalls sehr frühzeitig für eine „Gleichwertigkeit" der Frau ein.

Ja, da gibt es sicherlich Verbindungen. Aber Meret entsprang letztlich eben auch der Aufbruchszeit der zwanziger und dreißiger Jahre, in der gerade in Paris allerhand in Bewegung kam…

…und Frauen begannen, ihre eigenen Ziele zu verfolgen und sich von Konventionen zu befreien.

Ja, sich zu emanzipieren, aber ohne darauf zu beharren wie die Feministinnen in späteren Jahren,

M.O., Casa Costanza Carona, 1980; Photo: Thomas Kaiser

die dann den Männern gegenüber bösartig wurden. Das war bei den emanzipierten Frauen damals nicht der Fall. Sie waren einfach souverän, wenn sie die Kraft hatten, es zu sein. Und setzten sich und ihre Rechte durch, nach der Maxime: Ich habe das Recht, weil ich es so will. Ich denke dabei auch an Eva Aeppli, die zwar an Jahren jünger ist, aber auch auf eine ganz frauliche Art zu ihrer Kunst steht.

Meret Oppenheim hat die Kraft gefunden, noch einmal richtig loszulegen. Die letzten beiden Jahrzehnte ihres Lebens waren eine hochproduktive Zeit. Wo andere Künstler vielleicht in Bewährtem erstarren, hat sie immer noch Neues ausprobiert, sich ständig gewandelt, ganz sicher keine Ruhe gegeben – ein fast antizyklisches Verhalten.

Weil sie so lange unter Druck stand – ein Druck, den sie schon als junges Genie aushalten musste und der sich möglicherweise in ihrer Schaffenskrise niederschlug. Als sie merkte, dass sie davon befreit war, setzte das ungeheure Energien bei ihr frei. Ja, sie wurde eigentlich immer aktiver. Anfang der siebziger Jahre hat sie sich auch wieder in Paris eine Wohnung genommen – eine lustige Wohnung. Es war wahrscheinlich einmal ein Palais gewesen, aber davon war nur noch ein

Rest übrig. Das Apartment wurde durch Mäuerchen und Trennungen geradezu in Stückchen zergliedert. Eine Treppe führte hinunter in den Keller, und dort hatte sie noch einen weiteren seltsamen Raum. Meret hat immer seltsame Orte gehabt.

Das Haus ihrer Familie in Carona hat ja auch einen ganz besonderen Zauber. Überall hat Meret Oppenheim darin ihre gestalterischen Spuren hinterlassen. Man findet dort alle möglichen angesammelten Kuriositäten, dazwischen ihre künstlerischen Sachen. Es wirkt verwunschen und märchenhaft.

Ja, es ist bis heute ein wunderschönes Haus. Gebaut wurde es von Tessiner Handwerkern, die ihre ganzen Stuckateur-Künste darin zur Geltung brachten. Merets Großvater hatte es gekauft und es gehörte dann der ganzen Familie. Aber eingerichtet hat es hauptsächlich Meret. Sie war wahnsinnig pingelig. In der Beziehung war sie eine echte Restauratorin, unheimlich exakt. Sie hat ja unter anderem auch Schwitters restauriert. Im ganzen Haus verteilte sie Zettelchen, worauf stand, was zu tun sei, weil die Familienmitglieder abwechselnd da waren. Das Haus in Carona war wunderbar, ebenso wie ihr Atelier in der Berner Altstadt.

Der Brunnen, den Meret Oppenheim 1983, zwei Jahre vor ihrem Tod, in Bern verwirklichte, löste zunächst viel Wirbel aus.

Das war am Anfang, als der Brunnen noch sehr karg wirkte. Einige beschwerten sich darüber, aber das hat sich bald gelegt. Mittlerweile ist er so verschwiemelt und überwachsen, wie Meret ihn intendiert hatte. Er steht direkt auf dem zentralen Platz in Bern, dem Waisenhausplatz, vor dem Polizei-Hauptquartier, welches signalisiert: Wir wahren die Ordnung und halten uns auch daran. Bern ist architektonisch recht naiv. Quer gegenüber steht das Bundeshaus, links und rechts davon sind Banken. Auf dem Platz selbst findet ein ganz liebenswürdiger Markt statt, wo die Bauern aus der Berner Umgebung ein paar Eier und Zwiebeln verkaufen. Dort also hat Meret ihren Brunnen hingestellt. Pflanzen sollten sich auf dem Brunnen ausbreiten. Doch wurde er aus Beton gefertigt, und darauf wächst eben so schnell nichts. Seit Einweihung des Brunnens sind bald zwanzig Jahre vergangen. Jetzt ist er von Pflanzen und hängendem Moos überwuchert und sieht sehr schön aus. Ein anderer Brunnen von Meret steht übrigens in meinem Künstlerpark in der Toskana[2].

In Ihrem Skulpturengarten, wo Sie seit 1990 auch Werke von Künstlerfreunden aufstellen?

Genau. Als der Brunnen in meinen Park gelangte, war Meret bereits gestorben. Er basiert auf einem frühen Gips-Entwurf von 1967 und heißt „Hermesbrunnen". Das Hauptelement bilden zwei Schlangen, die sich um einen Stab mit Ästen herumwinden. Oben wird der Brunnen von einer kleinen goldenen Kugel und ausgebreiteten Flügeln gekrönt. Man kann durchaus etwas Erotisches darin sehen. Gestalterisch lässt der Brunnen an einen Hermaphroditen, ein Zwitterwesen,

denken, was – wie ich Meret kannte – nicht so weit hergeholt ist. Meret hat den Brunnen nie gießen lassen. Eines Tages besuchte mich einer ihrer Neffen, Martin Bühler, der auch einmal Assistent von Tinguely war. Er fragte mich, ob ich diese Plastik nicht für meinen Park haben wolle. Ich war sofort begeistert, denn man nennt den Park auch mein Poesiealbum. Alle meine Freunde sind darin vereint, und selbstverständlich wollte ich auch etwas von Meret dort haben. Es gab noch ein paar Komplikationen, weil Meret ihre Brunnen-Plastik nachträglich für eine Ausstellung bemalt und kleine Perlchen an die Zungen der Schlangen angebracht hatte, die wie Wasserperlen herunter rieselten. Damit war es ein eigenständiges Kunstwerk, das die Erbengemeinschaft mir in dieser Form nicht geben konnte. Ein Steinmetz hat dann eine exakte Kopie davon angefertigt, von der bis jetzt drei Güsse gemacht wurden. Einen bekam ich, ein weiterer ist bei Merets Bruder in Carona und einer ist in Hamburg bei Thomas Levy.

Und funktioniert der Brunnen auch?

Ja, bei uns funktioniert er. Wasser tröpfelt ganz leicht aus den zwei Schlangen-Köpfen in die Schale über dem Sockel.

Meret Oppenheim hat meiner Ansicht nach eigentlich keine Trennung gemacht zwischen angewandter und bildender Kunst, beides geht ineinander über. Auch die Gebrauchsgegenstände bergen die ihr spezifische Poesie.

Hermes Fountain – Merkursbrunnen 1966/2000
in "Il Giardino di Daniel Spoerri", Photo: Roman März

Ja, da haben Sie völlig Recht. Neben ihrer Kunst hat sie, ganz unabhängig von den Kostümen für das Picasso-Stück, ja auch zahlreiche Möbel- und Mode-Entwürfe gemacht. Zum Beispiel hatte sie bereits Anfang der vierziger Jahre einen Pullover entworfen, bei dem Ausbuchtungen hinein gestrickt waren, in welche die Trägerin ihre Brüste wie in zwei Beutel hineinlegen konnte. An diese Idee kann ich mich noch genau erinnern, das fand ich wirklich sehr komisch.

Viele von Meret Oppenheims Arbeiten offenbaren, dass sie viel Humor hatte.

Ja, Humor hatte sie, vor allem diesen feinen, surrealen Humor, also keinen brutalen, groben Humor. Den hatte sie nicht.

Jenen geistreichen Witz hat Meret Oppenheim auch bei Ihrer „Topographie

des Zufalls" bewiesen, die in der Erstausgabe 1962 als kleines Katalogbuch erschien. Darin hatten Sie sämtliche Gegenstände, die sich an einem bestimmten Oktobertag im Jahr 1961 auf dem Küchentisch Ihres Pariser Hotelzimmers befanden, in einer Planzeichnung festgehalten und kommentiert. Und Meret Oppenheim hat die Tisch-Szene symbolisch in eine Schneedecke gehüllt...

Das war so: Ich schickte ihr im Winter 1962 die Urfassung meiner „Topographie anecdotée du hasard", ein kleines graues Büchlein. Sie bat mich um ein weiteres Exemplar sowie um die Höhen sämtlicher Objekte, die auf dem Tisch standen. Die listete ich ihr dann auf, worauf sie mir das zweite Exemplar zurückschickte mit einer Watteschicht, wo nur einige Objekte ausgeschnitten waren, die höher als fünfzehn Zentimeter waren. Und dazu stand dann: Daniels Tisch unter einer Decke von fünfzehn Zentimetern Schnee. Die Vorstellung von Schneefall in einem Pariser Hotel-Zimmer – das ist natürlich wunderbar als Einfall. Solche genialischen Ideen hatte Meret eben.

1 Interview vom 6. Juni 2003.
2 Fondazione Il Giardino di Daniel Spoerri, I-58038, Seggiano (Gr)
www.danielspoerri.org, telefonische Voranmeldung unter: 0039/0564/950457.

M.O., Duisburg, 1975; Photo: Brigitte Hellgoth

Jewelry
Schmuck

Sketch for fabric pattern – Entwurf für Stoffmuster

Juli 35

Ringe innen Holz (Buchs), mit Schlangen u.
Eidechshaut überzogen. grün, blau
rot, schwarz-weiss (Python), beige. Wasserfarbe
Bourgois.
16 - 19 mm durchmesser. Querschnitt: ⌓

Holz-Leder: Kleister. Leder = Vernis (Mazon?)
Bourgois.
10 - 20 Privat.
50 Stk à 20 frs. [S]
2 " à Saks & Comp. (Eidechs u. Python)

M.O. 2-3 frs.

Sept. 35.
Dieses Armband gab mir die Idee für Pelztasse, Teller u. Löffel!
Armreifen. Messingrohr. Durch-
messer 65 mm u. weniger. 6 cm breit
Ränder 1½ mm breit, 1 mm (gut) hoch.

mit Fell beklebt ("Clicot" sécotine) Seehund, Leopard.
Habe mein Armband 1959 Aube. Elléoët-Breton
geschenkt
Stück à 120 frs. [S] 2 Stk.
vergoldet
M.O. 20 frs. (ohne Fell).
Tilly Visser 1 Stk à 70 frs.

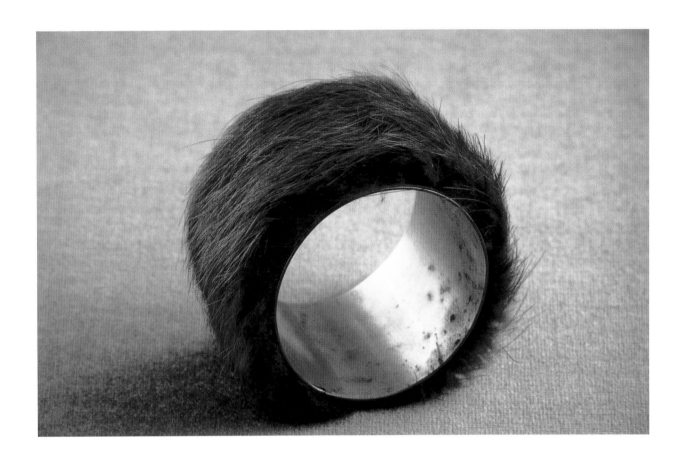

above – oben
Bracelet – Armband, 1935

left – links
Sketches and notes for rings and bracelets – Skizzen und Notizen für Ringe und Armreifen, 1935

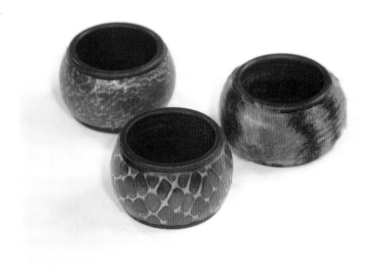

Covered wooden rings –
Bezogene Holzringe 1935/2003

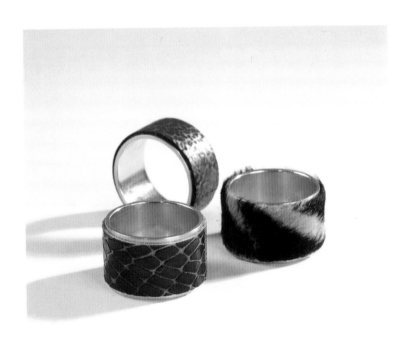

Covered metal rings –
Bezogene Metallringe 1935/2003

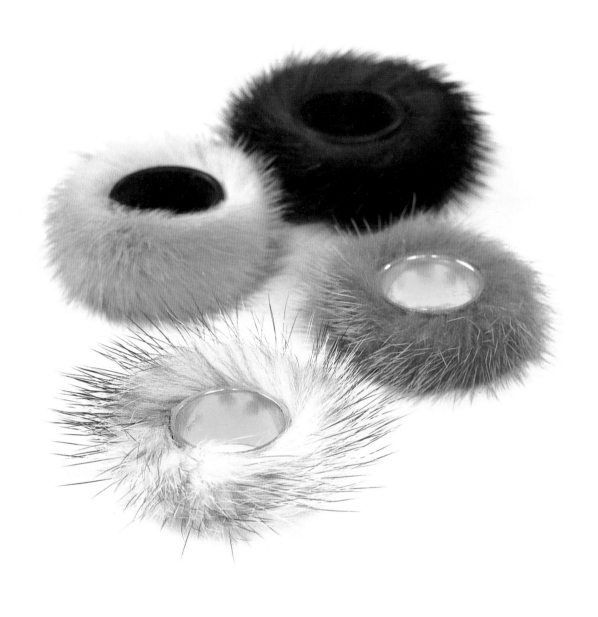

Metal and wooden rings covered with fur – Metall- und Holz-Ringe mit Fell bezogen 1935/2003

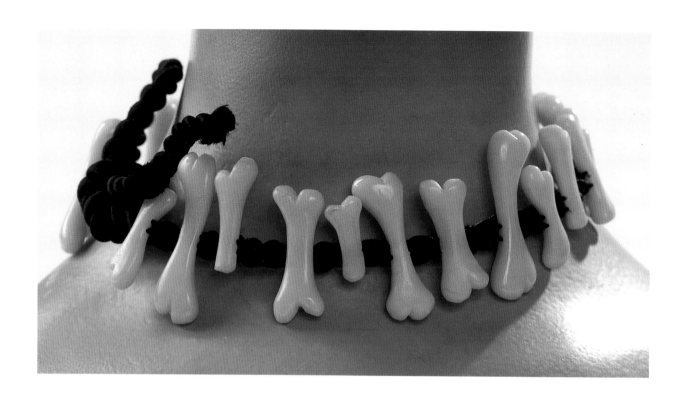

Choker – Halsband, 1934-36/2003

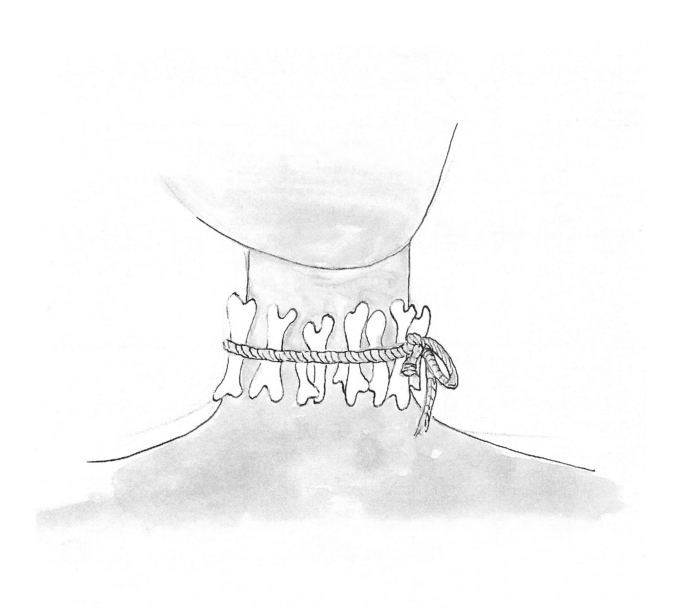

Sketch for choker – Entwurf für ein Halsband, 1934-36

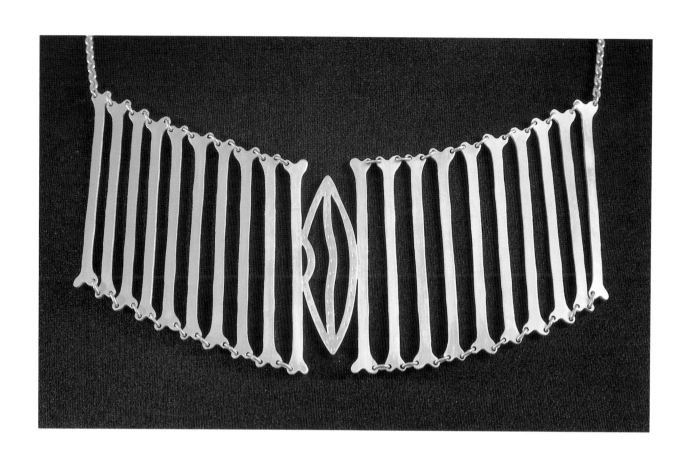

Bone Necklace with Mouth – Knochenkette mit Mund, 1935-36/2003

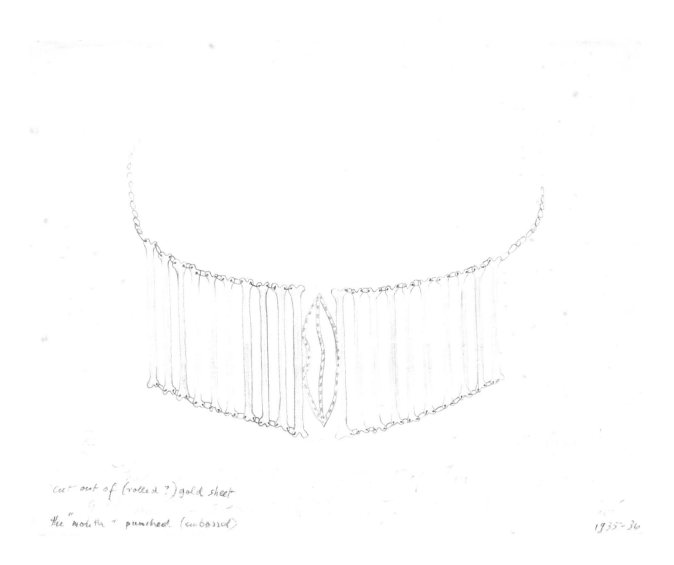

cut out of (rolled ?) gold sheet

the "mouth" punched (embossed)

1935-36

Sketch for Bone Necklace with Mouth – Entwurf für Knochenkette mit Mund, 1935-36

Es war für einen
Kettbewerb. Weil ich
fürchtete meine Zeichnungen
seien nicht "schön" genug, liess
ich sie von einem Grafiker
zeichnen!

Idee ist
von mir,

nicht von mir
gezeichnet, sondern von Grafiker in Paris!

Sketches for earrings –
Ideen für Ohrschmuck, 1936

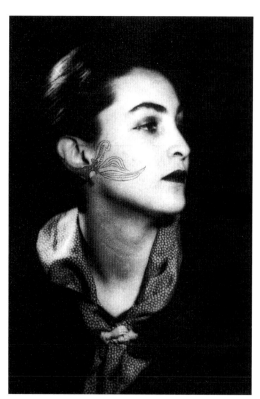

"Man Ray Photo on which I drew this" M.O.
"Photo von Man Ray, wo ich dieses drauf gezeichnet habe" M.O.,
1936

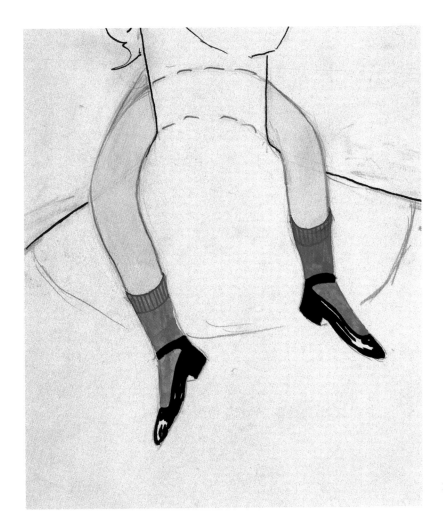

Sketch for choker –
Entwurf für Halsband, 1936

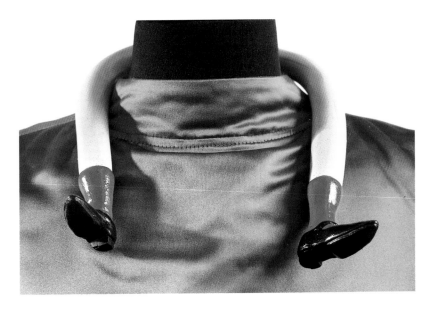

Choker – Halsband, 1936/2003

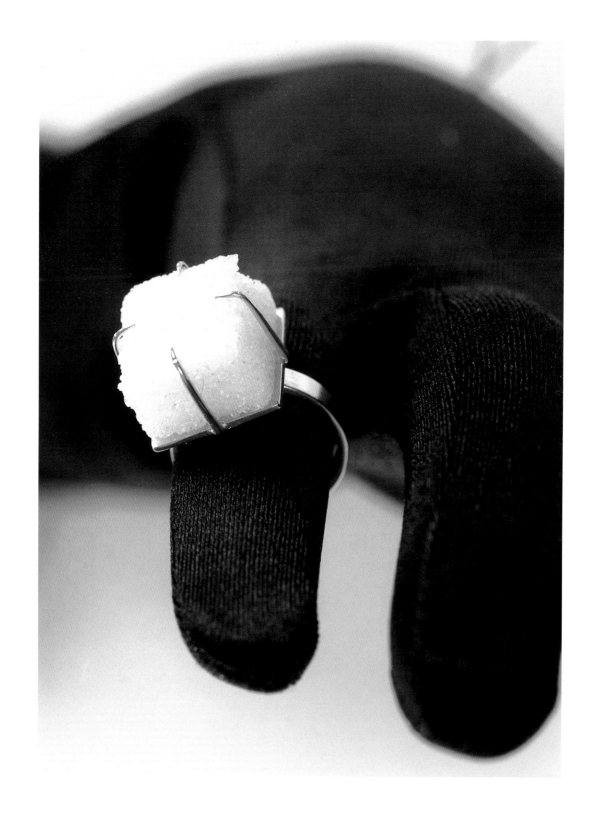

Ring with Sugar Cube – Ring mit Zuckerwürfel, 1936-37/2003

Sketches for accessories – Entwürfe für Accessoires, 1936-37

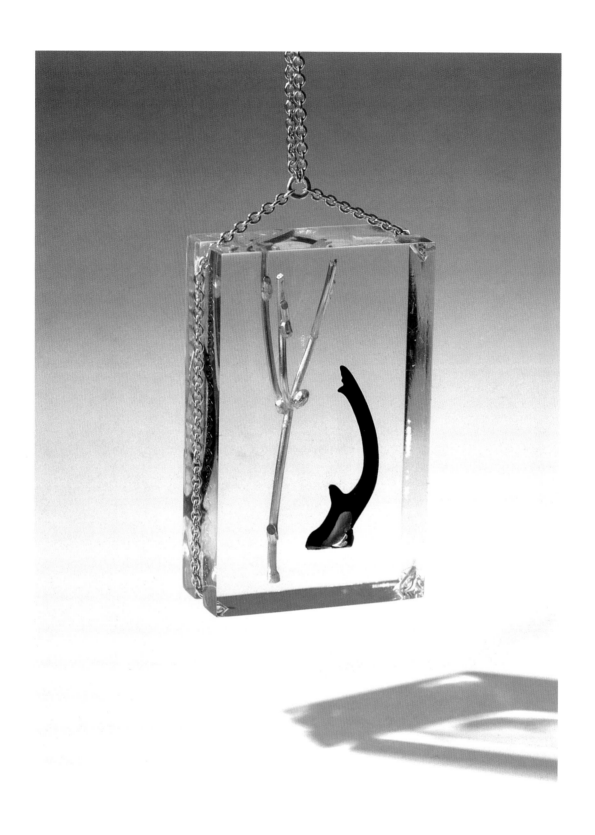

Pendant – Anhänger, 1937/1985

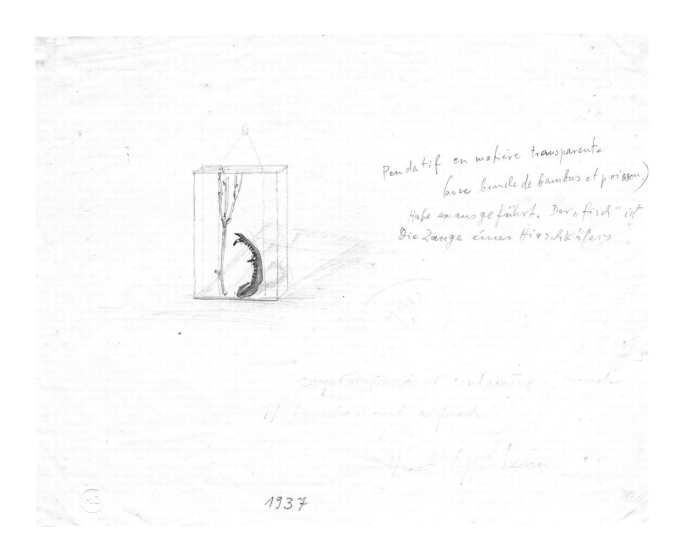

Pendatif en matière transparente
(avec branche de bambus et poisson)
Habe es ausgeführt. Der „fisch" ist
Die Zange eines Hirschkäfers

1937

Sketch for pendant – Skizze für einen Anhänger, 1937

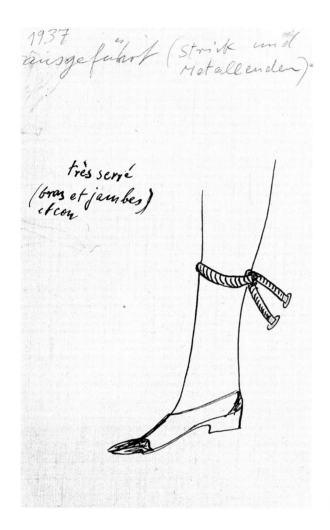

1937
ausgeführt (Strik und Metallenden)*

très serré
(bras et jambes)
et cou

Sketch for a leg choker – Skizze für ein Beinband, 1937

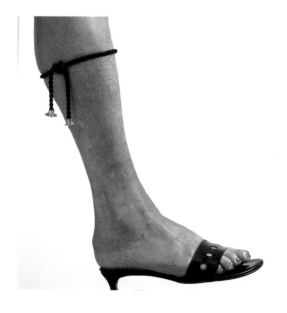

Leg choker – Beinband, 1937/2003

(roues d'horloges dorées)

A brooch,

Real little thoothed
wheels. gilded, red,
white, green gold.
the wheals must turn

(I had it executed –
but lost it)

clock work

above – oben
Sketch for Clip Tournant –
Skizze für Clip Tournant, 1937

left – links
Clip Tournant, 1937/2003

81

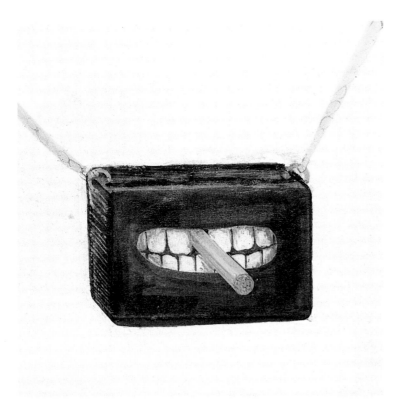

Sketch for a pendant –
Entwurf für einen Anhänger, 1937

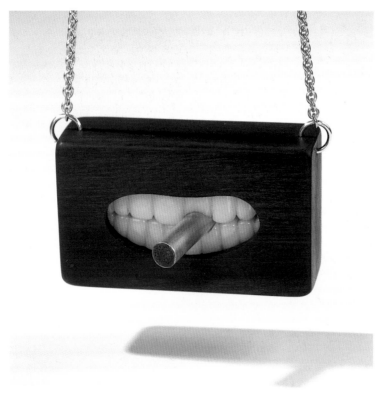

Pendant – Anhänger, 1937/2003

82

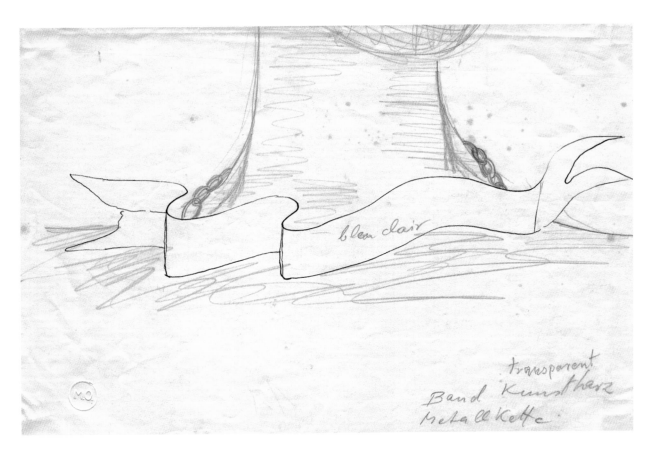

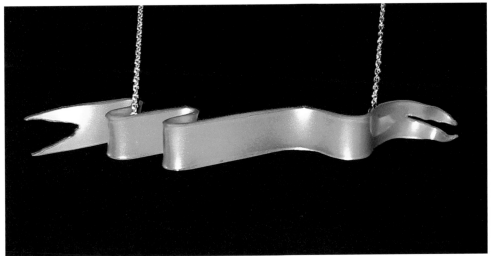

above – oben
Sketch for a necklace – Entwurf für eine Halskette

below – unten
Necklace – Halskette, 2003

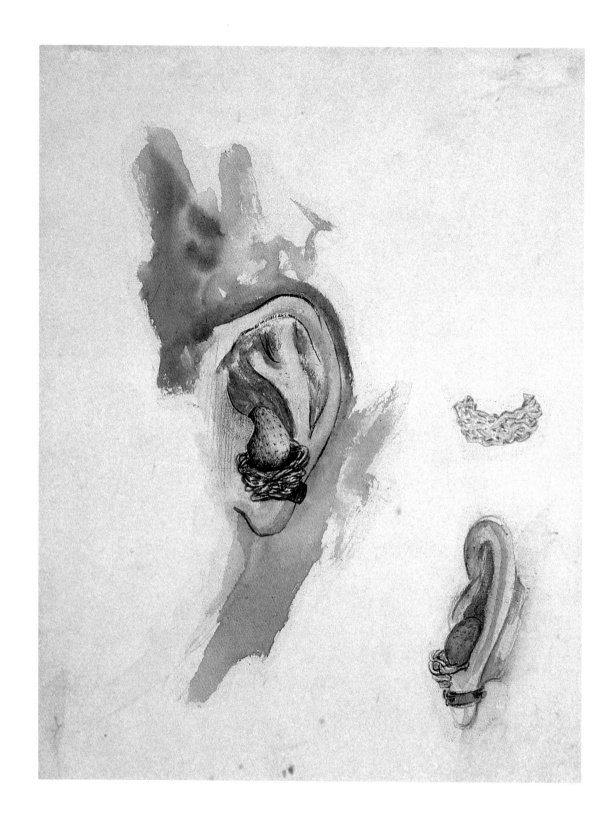

Sketch for earring – Entwurf für Ohrring, 1942

Brosche

(Vergrösserer
Ausführung
noch schöner)

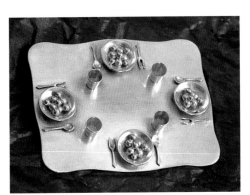

above – oben
Sketch for a brooch –
Skizze für eine Brosche, ca. 1936-40

left – links
'Laid Table', brooch –
"Gedeckter Tisch", Brosche, ca. 1936-40

85

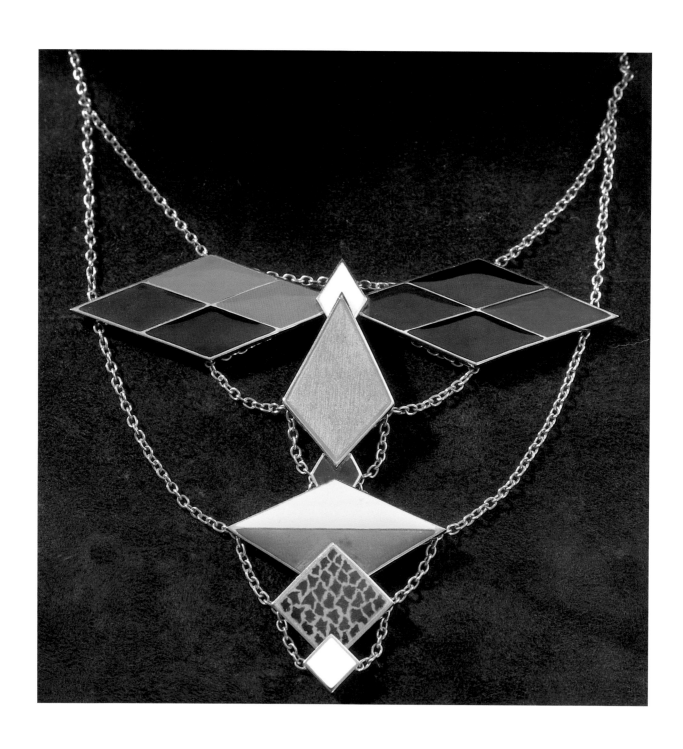

The Poet – Der Dichter, 1966

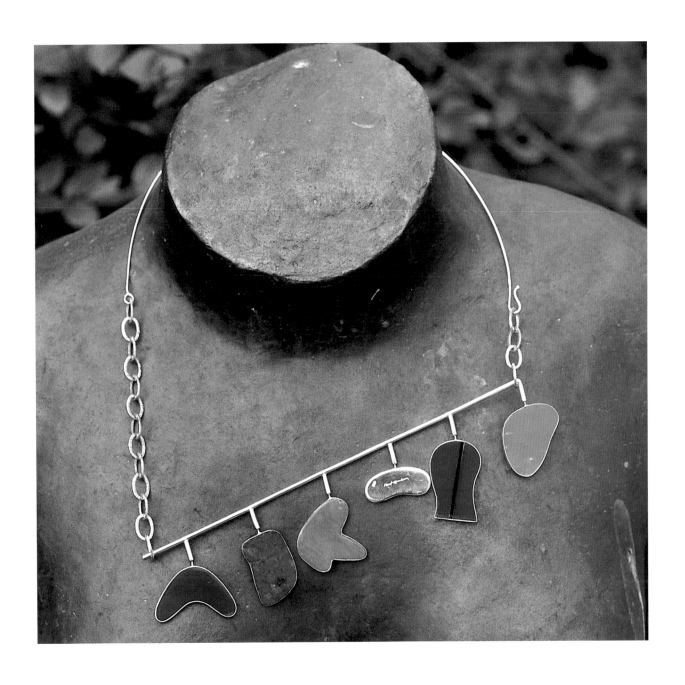

Necklace 'Husch-Husch' – Halskette "Husch-Husch" 1985

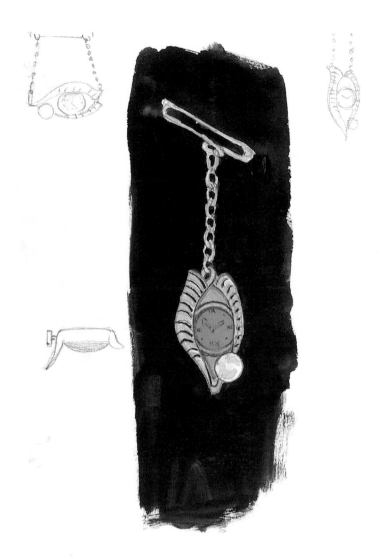

10. Sketch for pendant watch –
Entwurf für Anhängeruhr, 1940-45

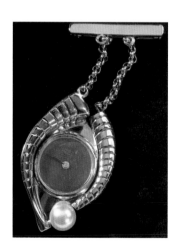

Pendant watch – Anhängeruhr, 1985

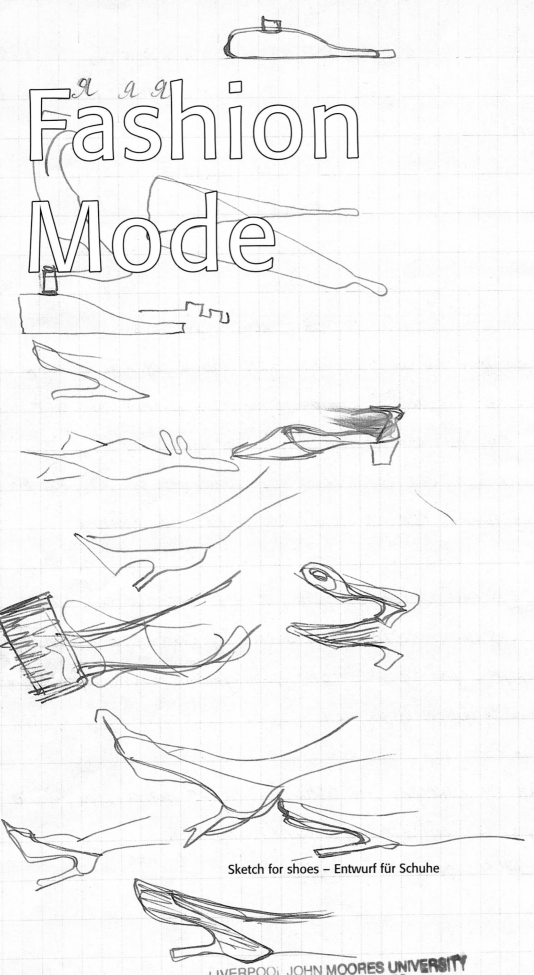

Fashion
Mode

Sketch for shoes – Entwurf für Schuhe

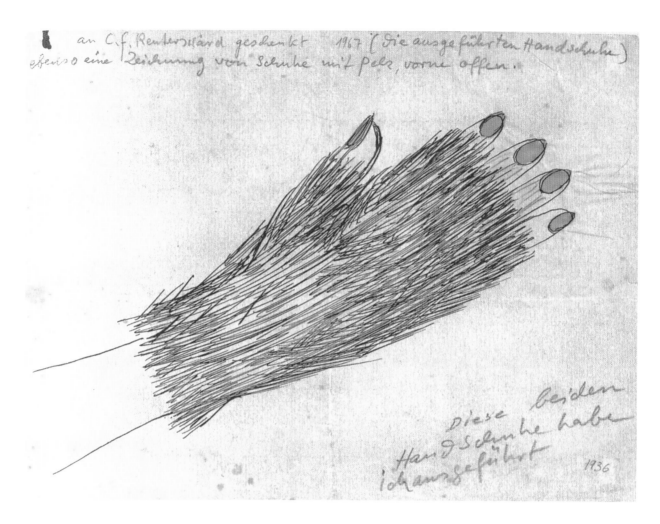

an C.f. Reuterswärd geschenkt 1967 (die ausgeführten Handschuhe)
ebenso eine Zeichnung von Schuhe mit Pelz, vorne offen.

diese beiden
Handschuhe habe
ich ausgeführt 1936

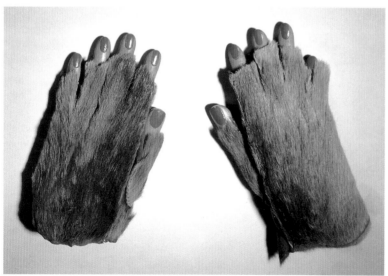

above – oben
**Sketch for glove –
Entwurf für Handschuh 1936**

left – links
**Fur Gloves with Wooden Fingers –
Pelzhandschuhe mit Holzfingern, 1936**

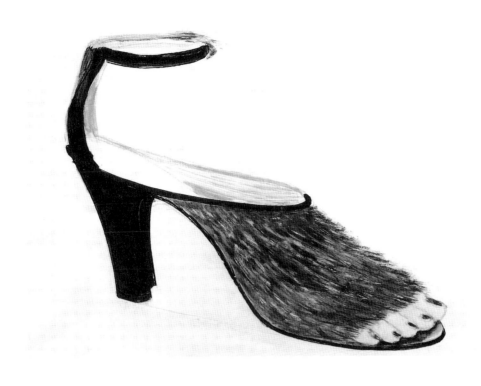

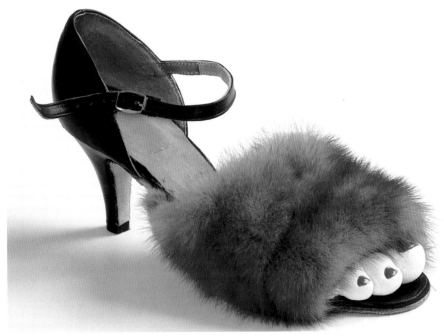

above – oben
Sketch for Shoe with Fur – Skizze für Schuh mit Pelz, 1936

below – unten
Shoe with Fur – Schuh mit Pelz, 1936/2003

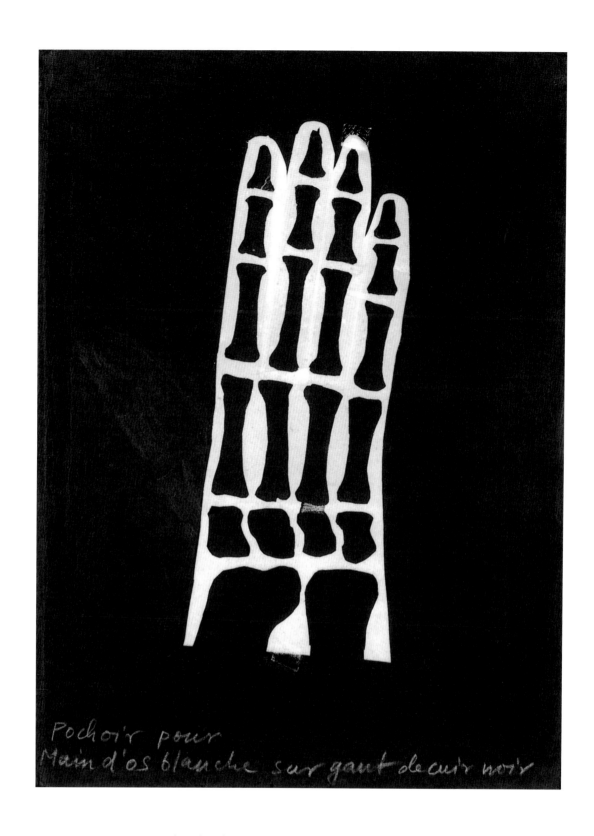

Template for gloves – Schablone für Handschuhe, 1936

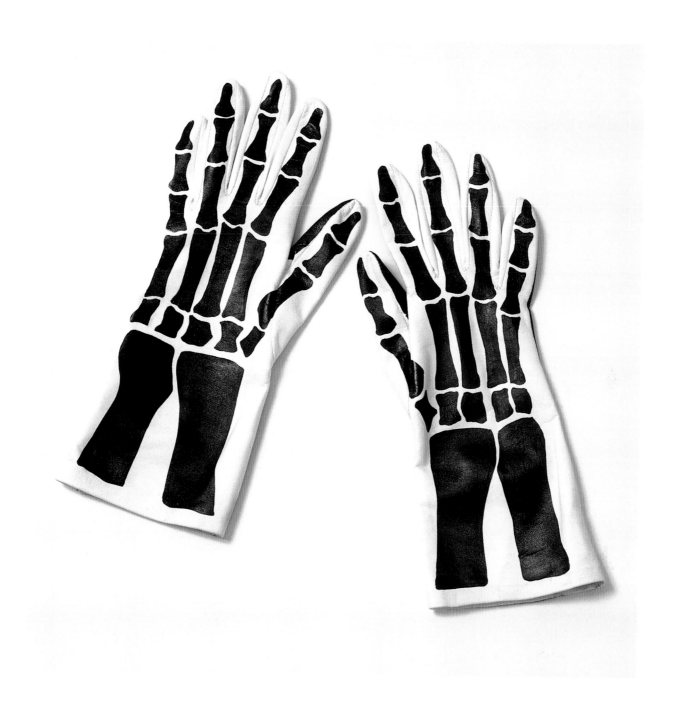

Skeleton-Hand Gloves – Knochenhandschuhe, 1936/2003

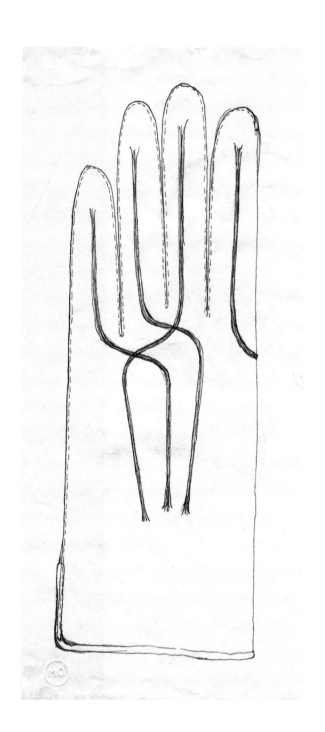

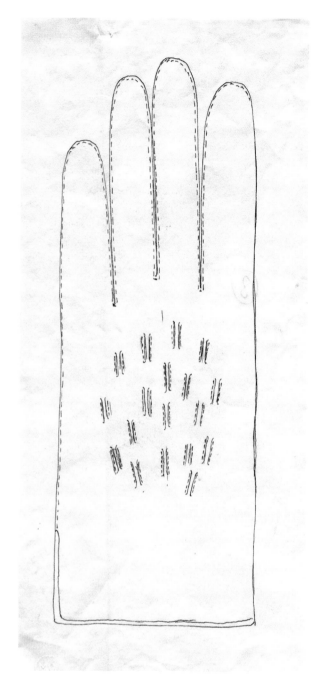

left – links
Sketch for glove – Skizze für Handschuh, 1942-45

right – rechts
Sketch for glove – Skizze für Handschuh, 1942-45

Sketches for gloves and other accessories –
Skizzen für Handschuhe und andere
Accessoires, 1940-45, Detail

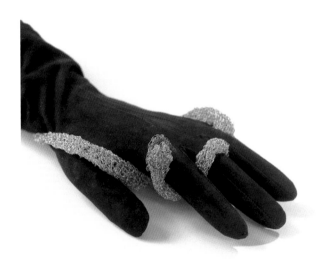

Glove with Snake – Handschuh mit Schlange,
1940-45/2003

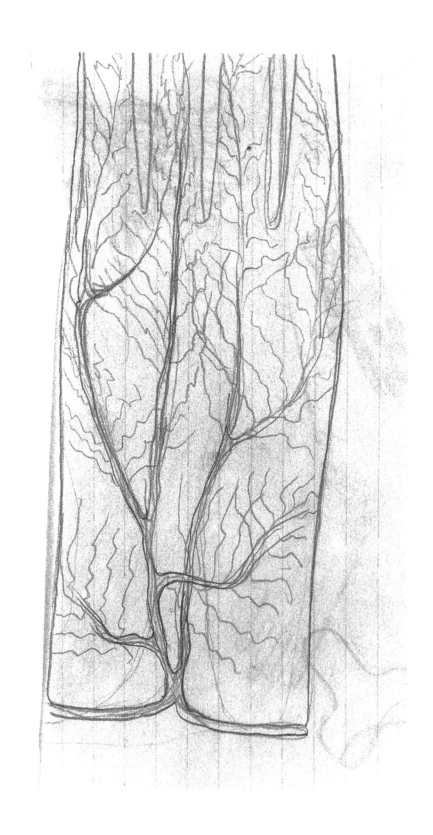

Sketch for Gloves with Veins – Entwurf für Handschuhe mit Adern, 1942-45

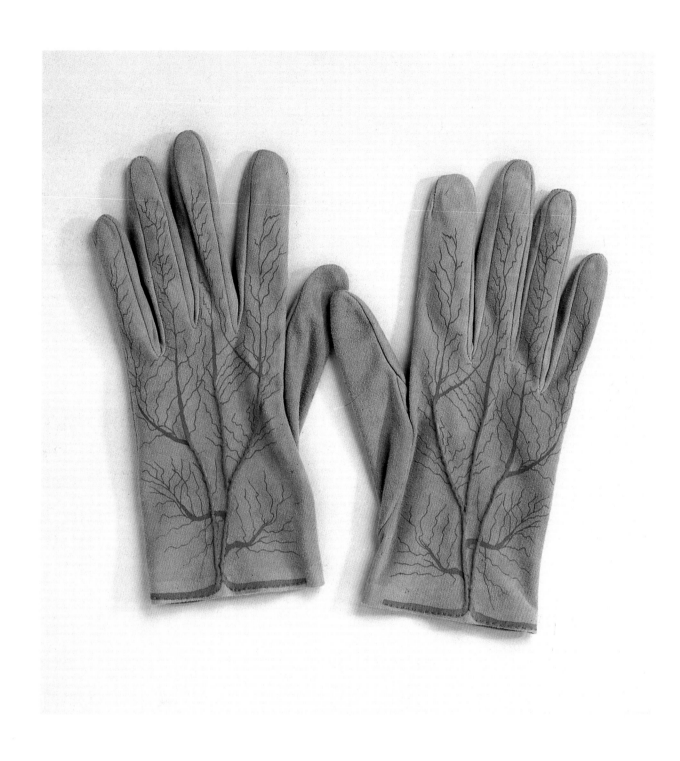

Pair of Gloves with Veins – Handschuhe mit Adern (Paar), 1985

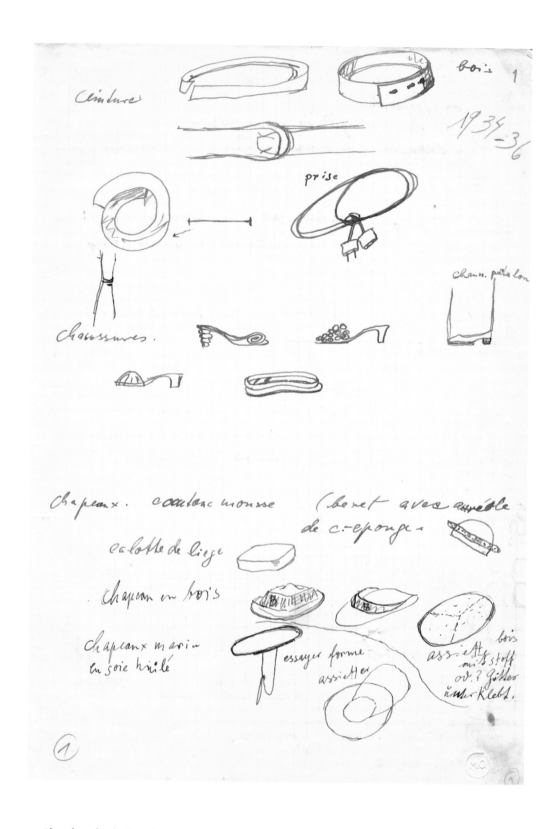

Sketches for belts, shoes, and hats – Entwürfe für Gürtel, Schuhe und Hüte, 1934-36

Hat with Halo – Hut mit Heiligenschein, 1934-36/2003

above – oben
Sketch for Hat for Three Persons – Chapeau pour trois personnes –
Skizze für Hut für drei Personen, 1936-42

below – unten
Hat for Three Persons – Hut für drei Personen, 1936-42/2003

above – oben
Girl, Carrying on her Head a Cloud with Rabbit –
Mädchen, auf dem Kopf eine Wolke mit Hasen Tragend, 1941

below – unten
Rabbit Hat – Hasenhut, 1941/2003

101

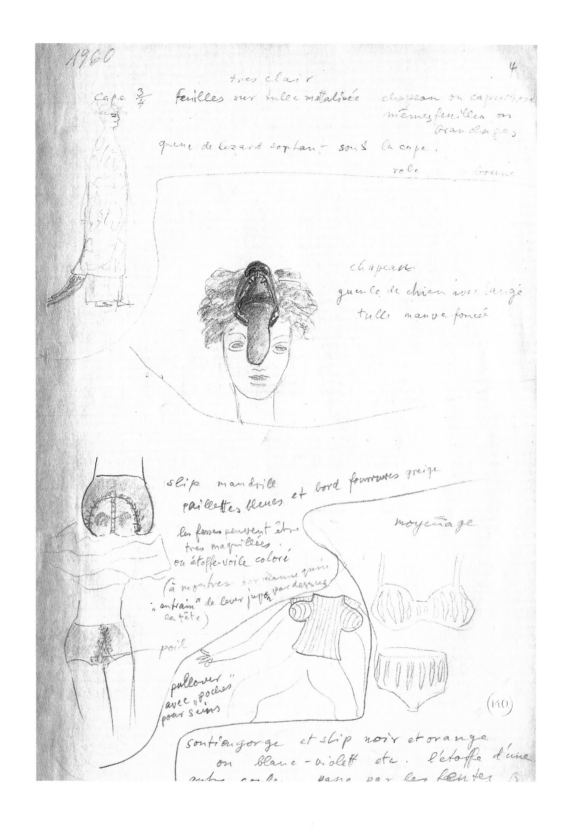

Sketches for cape, hat and varieté undergarments – Entwürfe für Cape, Hut und Varieté-Unterwäsche, ca. 1942

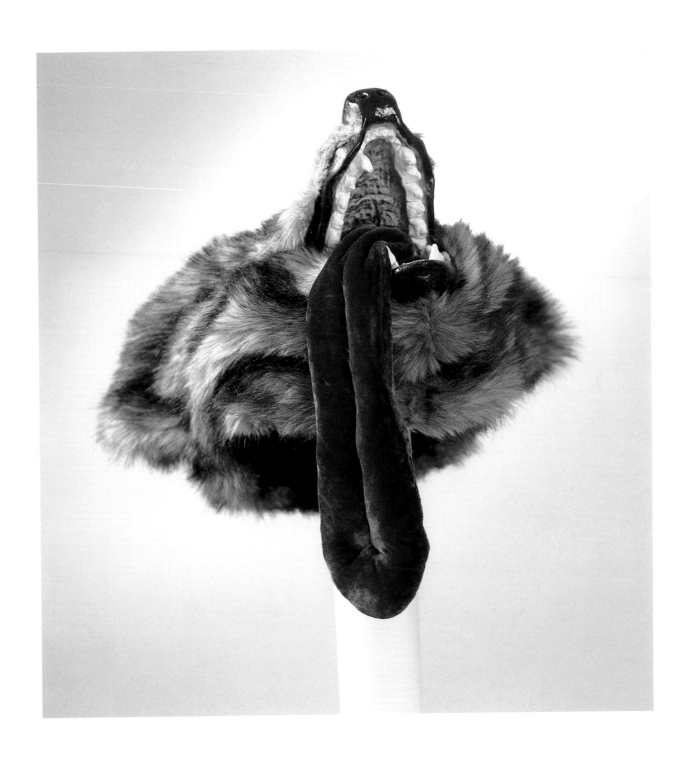

Dog's Snout Hat – Hundeschnauzenhut, 1942/2003

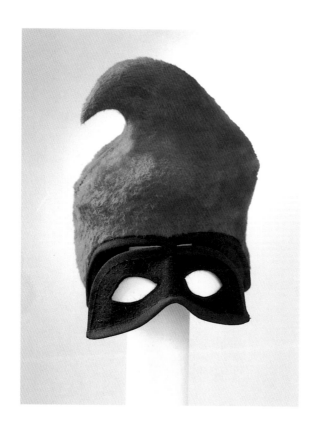

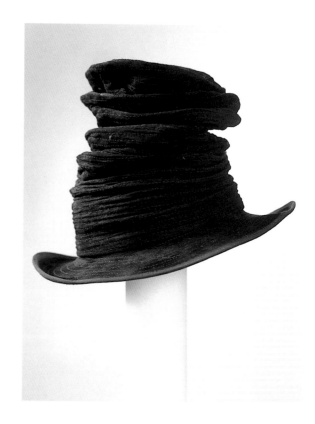

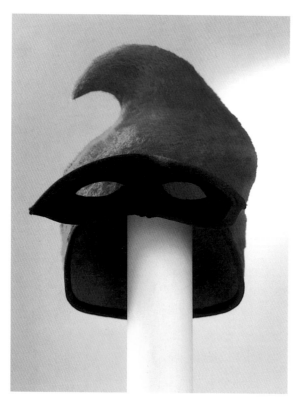

above left and left – oben links und links
Red Hat – Roter Hut, ca 1942/2003

above right – oben rechts
Cylinder – Zylinder, 2003

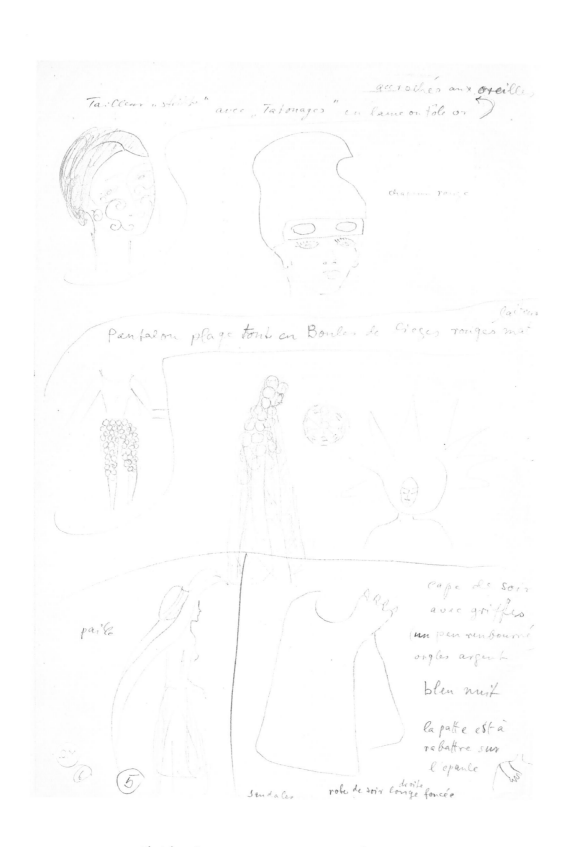

Sketches for costumes – Kostümentwürfe, ca. 1942

 seide u. Perlen.

 gedrechseltes Holz

 Kieselsteine (poliert)

 x – beliebig
Rand Seide (rot od. weiss, schwarzgrau)
Stern aus Stroh.

Knöpfe

Sketches for buttons – Skizze für Knöpfe, 1944

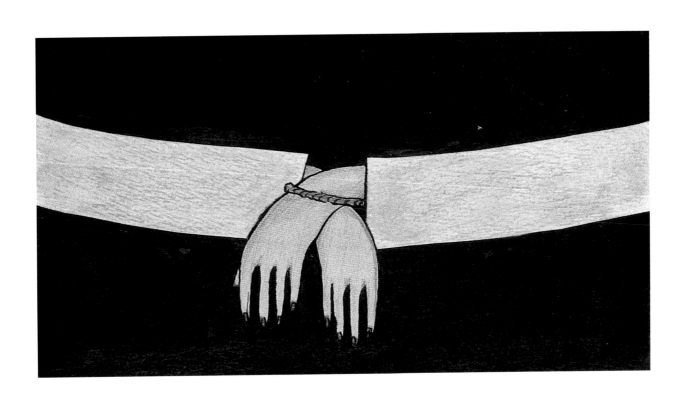

Sketch for a belt – Skizze für einen Gürtel

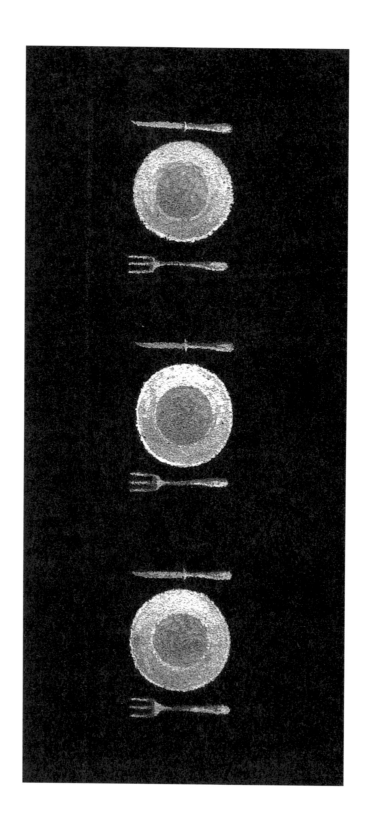

Buttons for an evening jacket – Knöpfe für eine Abendjacke, 1942-45

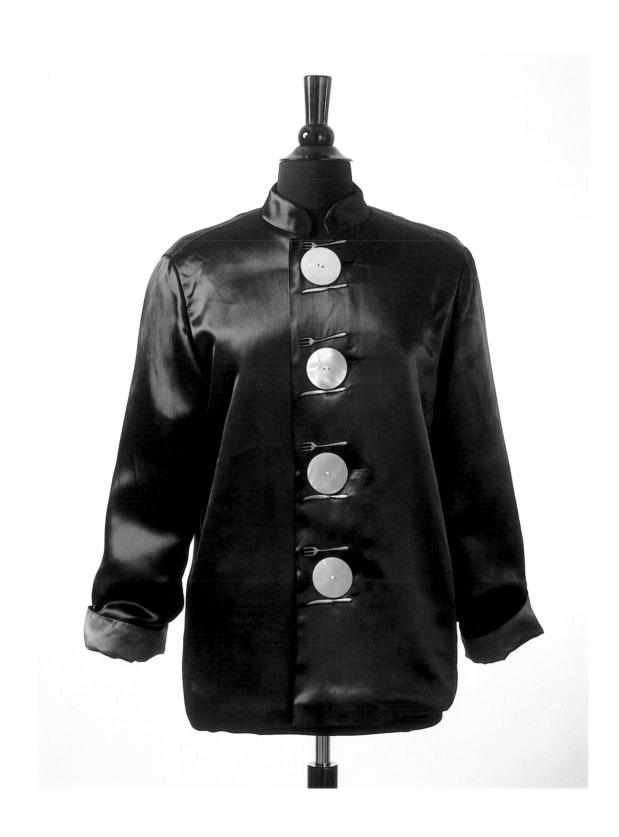

Evening Jacket – Abendjacke, 1942-45/2003

109

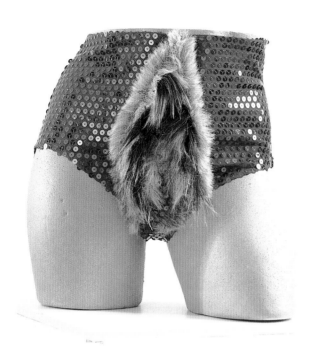

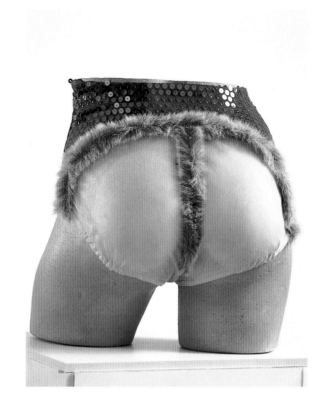

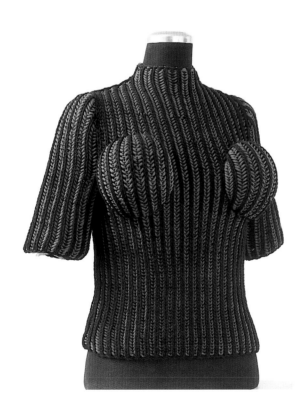

above left and above right – oben links und oben rechts
'Slip Mandrill', varieté undergarments –
„Slip Mandrill", Varieté-Unterwäsche, ca. 1940/2003

left – links
Pullover with 'Breast Pouches' –
Pullover mit "Brusttaschen", ca. 1942/2003

Papierkleider II/1967

1. Ahlen von den „richtigen" Kleidern den Vorteil, billig zu sein. Man muss sie „oft wechseln tragen" resp. „Besichtigen" Kleidern scheint mir daran, dass man sie oft anziehen kann, z.b. ein aller extravagantes, extrem auffälliges Kleid kann man eigentlich nur ein mal tragen. ~~Aus diesen~~ Darum sollte man aus Papier die extremsten Modelle machen. Ausserdem, und daneben sollte man aber ein Norm-Kleid, eine „Robe-fourreau" machen, die nur in uni-farben-, schwarz ~~oder~~ weiss ~~oder~~ und in allen farben die Mode ~~sind~~ will (oder 3-4) hergestellt wird. Wie Papiertaschentücher, 10.- ~~Ausserdem aber eine~~ Der Schnitt dieser Robe-fourreau wechselt höchstens jährlich, für diesen fourreau werden aber eine Unmenge Phantasie-accessoires hergestellt: Ärmel an Ketten (Plastik) aneinander gehängt (u.. über den Kopf gestülpt).
Hänger, mit Schleifchen auf der Seite gebunden (diese flachen ☐ Teile mit ganz „dummen" Mustern bedruckt). Oder Material wie Gras ▐ hellgrün. Diese Hänger wären schöner über von oben bis unten durchgehen dem Hosen-dress. (solchen aus papier?) ~~Oder~~ kurze oder lange Übor-Jacken-Kasaks, Kimonos, mit und ohne Ärmel; z.B. riesig

⑥ Orange-schwarze Formen-Blumen die nur untereinander durch Stiele oder Striche et

Notes and sketches for paper dresses – Notizen und Skizzen für Papierkleider, 1967

111

Auch symetr. od. assymetr. Ornament über das ganze, zu ⅔ durch-
sichtige Oberteil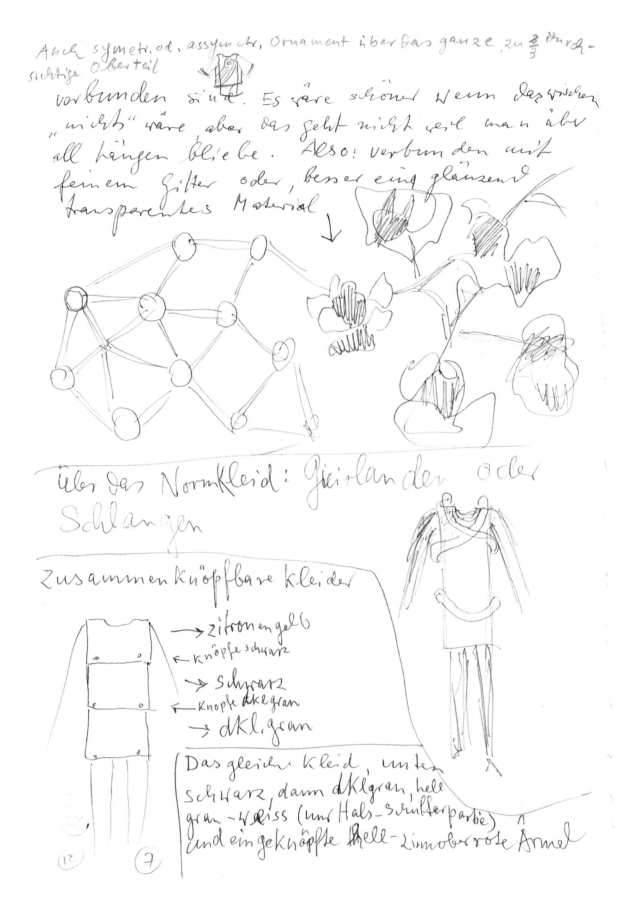

verbunden sind. Es wäre schöner wenn dazwischen
„nichts" wäre aber das geht nicht weil man über-
all hängen bliebe. Also: verbunden mit
feinem Gitter oder, besser eine glänzend
transparentes Material

Über das Normkleid: Girlanden oder
Schlangen

Zusammenknöpfbare kleider

→ Zitronengelb
← Knöpfe schwarz
→ Schwarz
← Knöpfe dkl.gran
→ dKl.gran

Das gleiche kleid, unten
schwarz, dann dKl.gran, hell-
gran - weiss (um Hals-schulterpartie)
und eingeknöpfte hell-Zinnoberrote Ärmel

⑦

Die einzelnen Teile dieser Knopf Kleider
können auch schmäler sein, so dass aus
dem braven Minikleid "fürs Büro" ein Mini-Mini
wird

Weiter für "über Normkleid: phantastische
Kragen, Capes, spitzen- Ärmel

Rücken

geprägte Muster farb. od. Ton in Ton
stark "lackiert" Karussellpferd

Auf der Rückseite des Norm Kleider stoffes ein
Centimeter netz, damit immer ange-
geben werden kann an welche Stelle Knöpfe
Haken oder "Klebband" angebracht werden
soll, für die Bestimmung der Accessoires

d'après
svanberg

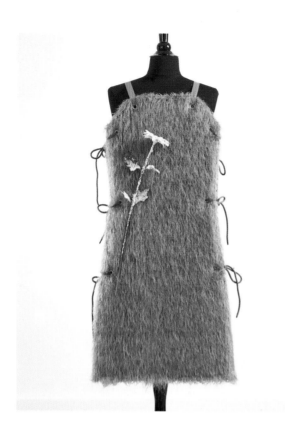

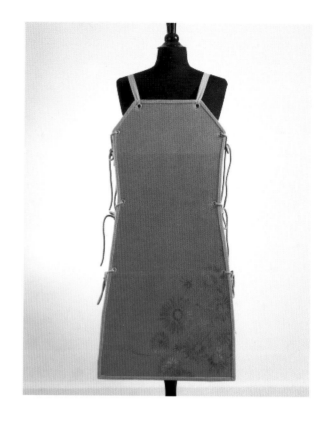

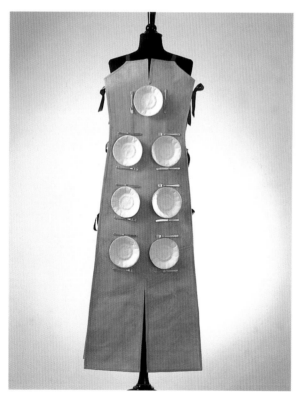

above left and above right – oben links und oben rechts
Robe Simple, 1942-45/2003

left – links
Robe de Diner, 1942-45/2003

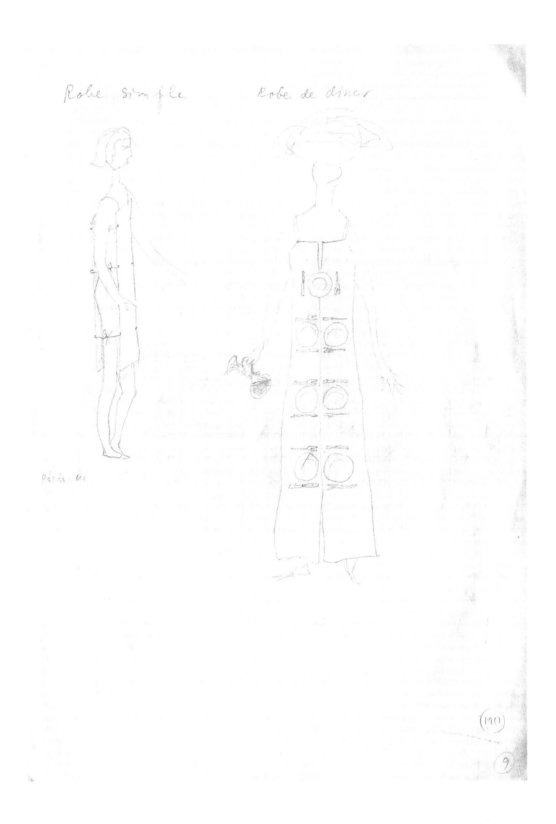

Sketch for Robe Simple, Robe de Diner, 1942-45

Design for the cover of the Swiss magazine 'Annabelle' –
Entwurf für die Schweizer Frauenzeitschrift "Annabelle" 1940-45

Furniture
and other objects
Möbel
und andere Objekte

MERET OPPENHEIM

Edition eines Glastisches für zehn Gedecke. Numeriert und signiert. Zwanzig Exemplare.

M.O. at her Crystal Table for Ten Place Settings – M.O. an ihrem Glastisch für zehn Gedecke, 1985

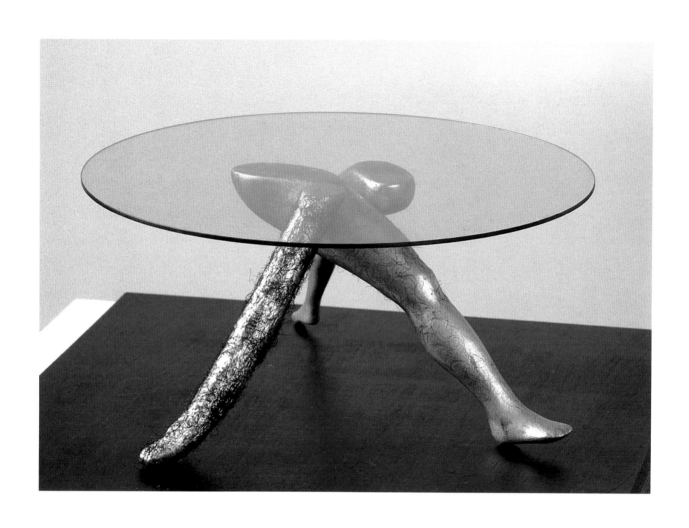

Table with Three Legs, model, 1938/2003

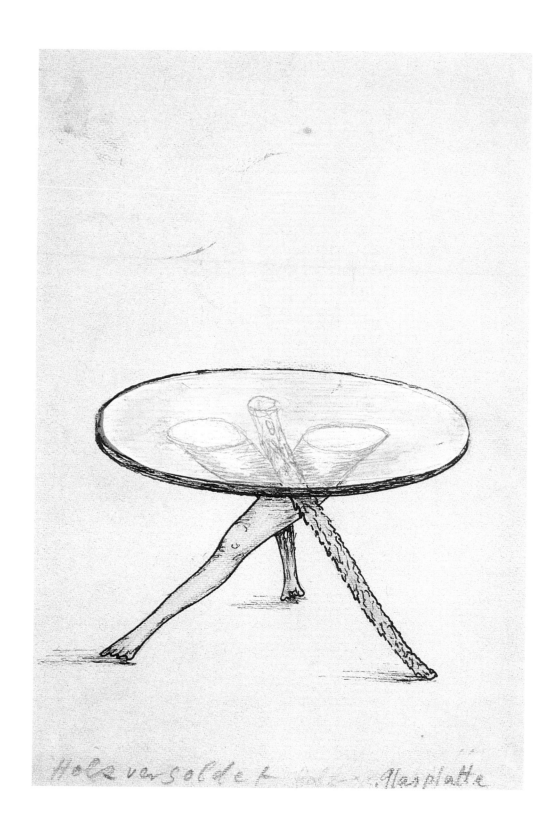

Sketch for Table with Three Legs – Entwurf für einen Tisch mit drei Beinen, 1938

119

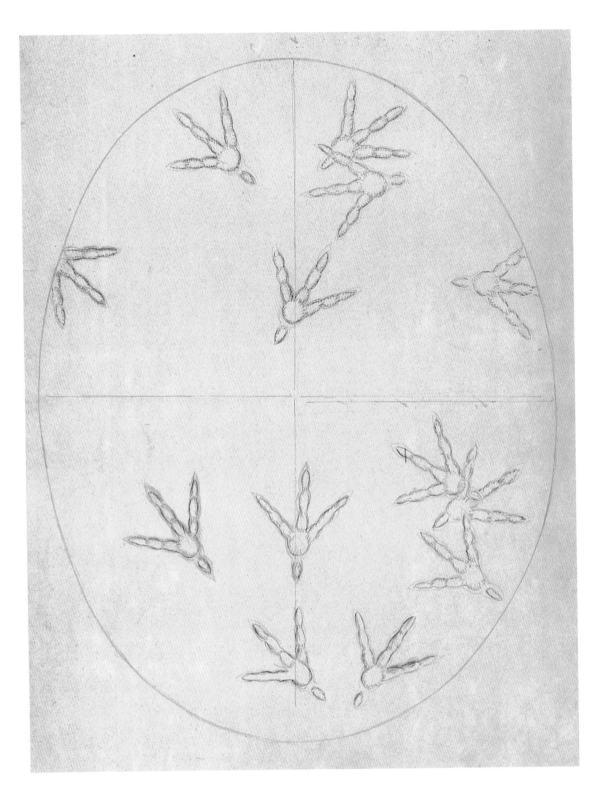

Sketch for tabletop of Table with Bird's Legs –
Skizze für die Platte des Tisches mit Vogelfüssen, 1983

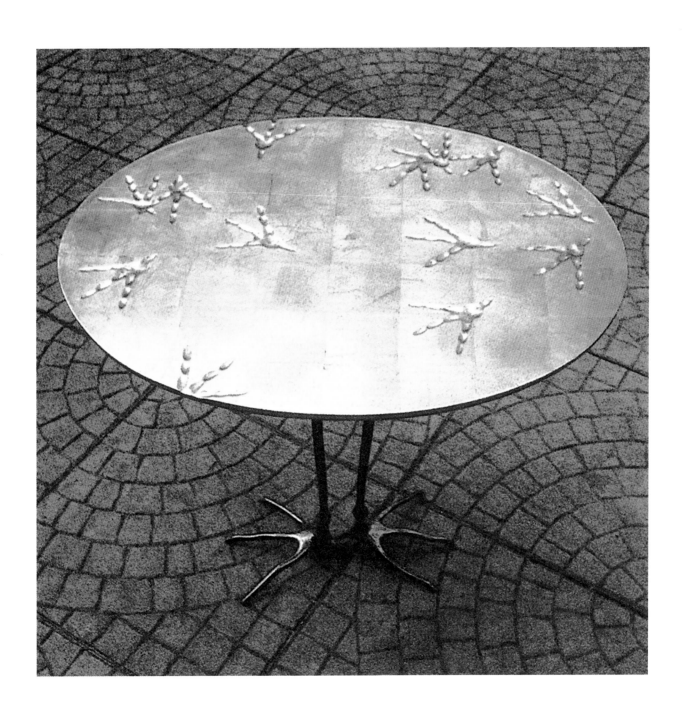

Table with Bird's Legs – Tisch mit Vogelfüssen, 1939/1983

Sketch for an illuminated garden table –
Entwurf für einen Gartentisch mit Licht

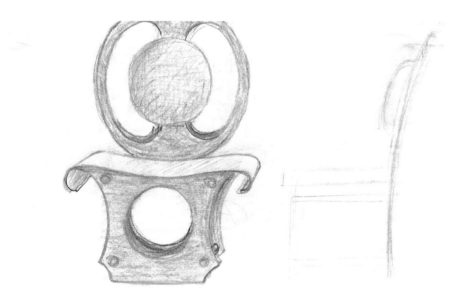

Sketch for a garden chair
of wrought iron –
Entwurf für einen Gartenstuhl
aus Schmiedeeisen

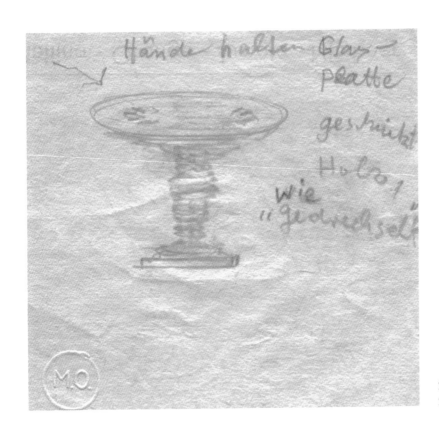

Sketch for a table –
Skizze für einen Tisch, 1940-45

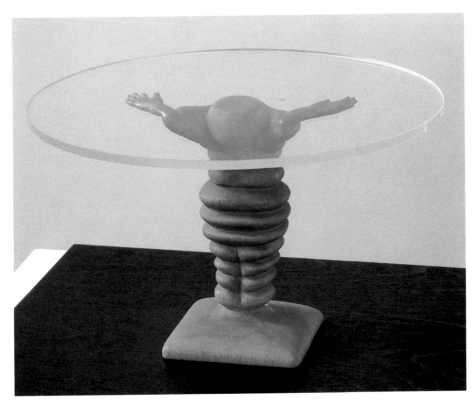

Table, model –
Tisch, Modell,
1940-45/2003

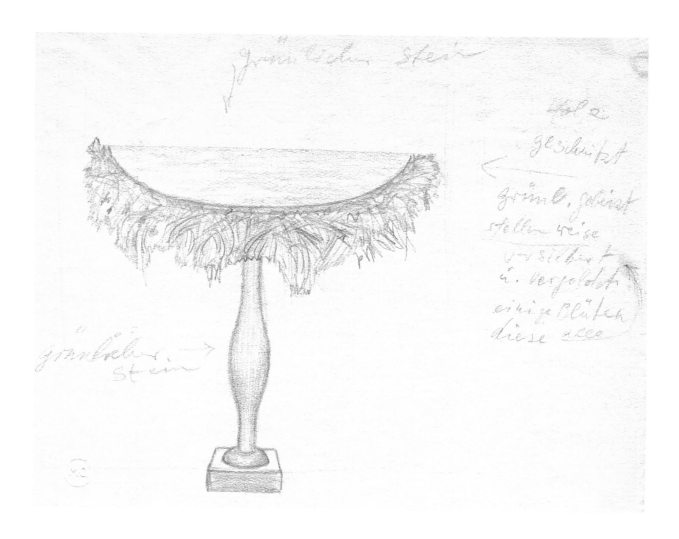

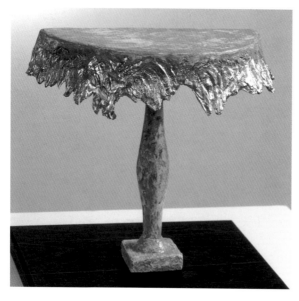

above – oben
Sketch for a console – Skizze für eine Konsole, 1940-45

left – links
Console, model – Konsole, Modell, 1940-45/2003

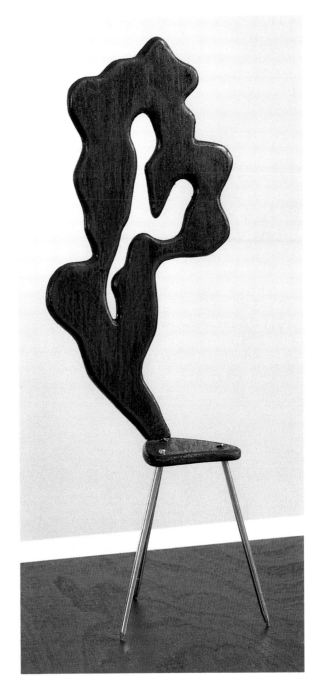

left – links
Sketch for a chair – Entwurf für einen Stuhl, 1940-45

right – rechts
Chair, model – Stuhl, Modell, 1940-45/2003

Weiss
Holz od polyester
cheminée-Stuhl

1967

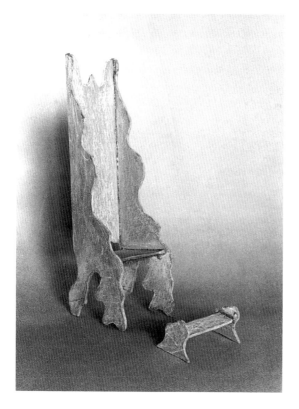

above – oben
Sketch for a hearth chair –
Skizze für einen Kaminstuhl, 1967

left – links
Armchair and footstool, model –
Sessel und Fußbank, Modell, 1972

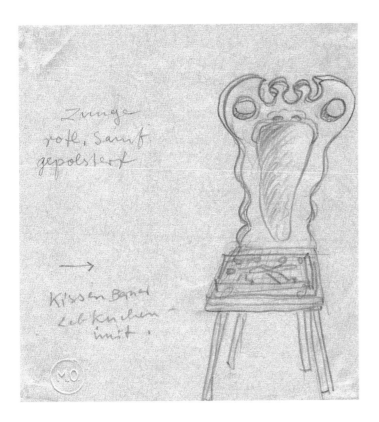

Sketch for Läbchuechegluschti –
Skizze für Läbchuechegluschti, 1967

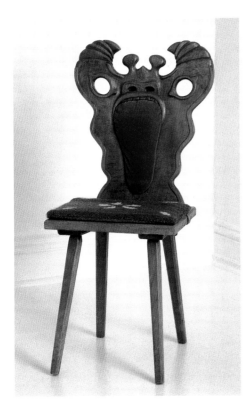

Läbchuechegluschti, 1967

127

above left – oben links
Cadavres Exquis – Chair in a Waterfall – Stuhl in einem Wasserfall, 1975

above right – oben rechts
Cadavres Exquis – Chair for Singers – Stuhl für Sänger, 1975

below left – unten links
Cadavres Exquis – Flitting Chair – Flitzender Stuhl, 1975

below right – unten rechts
Cadavres Exquis – The Fairy Queen's Throne – Der Thron der Feenkönigin, 1975

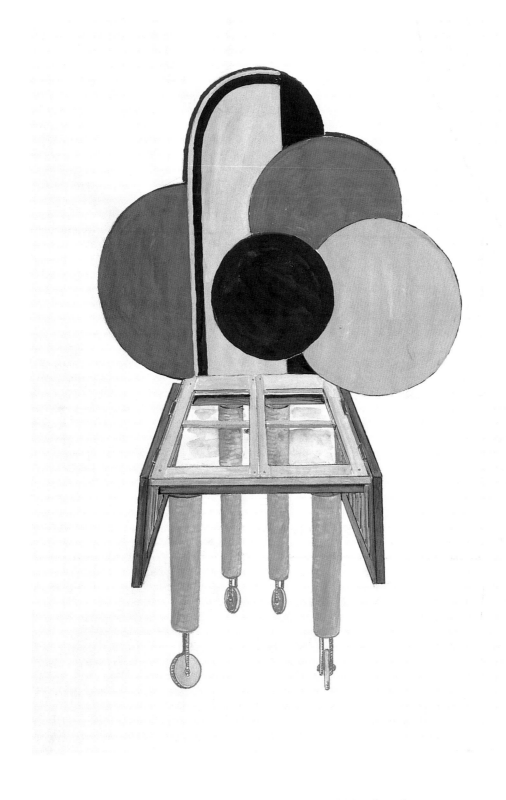

Cadavres Exquis – Chair for the Year 2000 – Stuhl für das Jahr 2000, 1975

Sketches for perfume flasks – Entwürfe für Parfümflakons, 1936

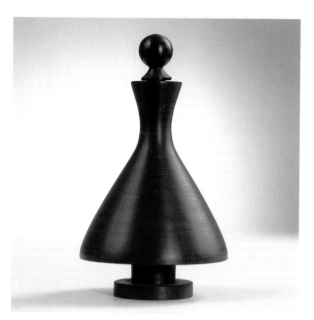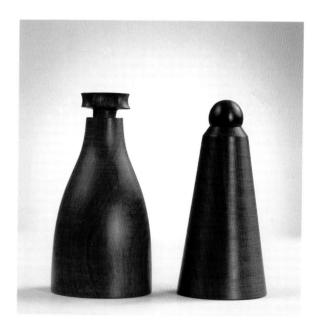

above – oben
Sketch for a perfume flask – Entwurf für ein Parfümflakon, 1936

below – unten
Wooden models for perfume flasks – Holzmodelle für Parfümflakons, 1936/84-85

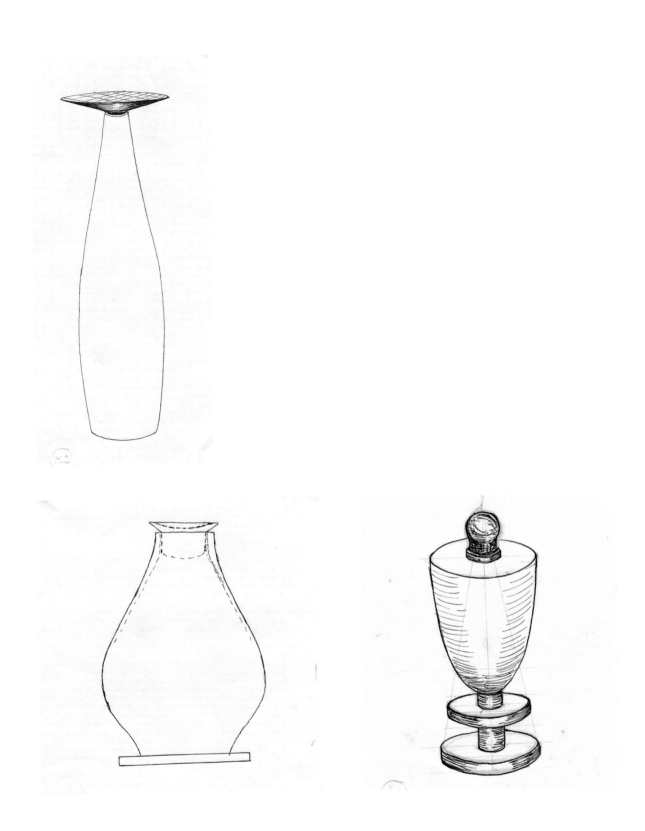

Three sketches for perfume flasks – Drei Entwürfe für Parfümflakons, 1936

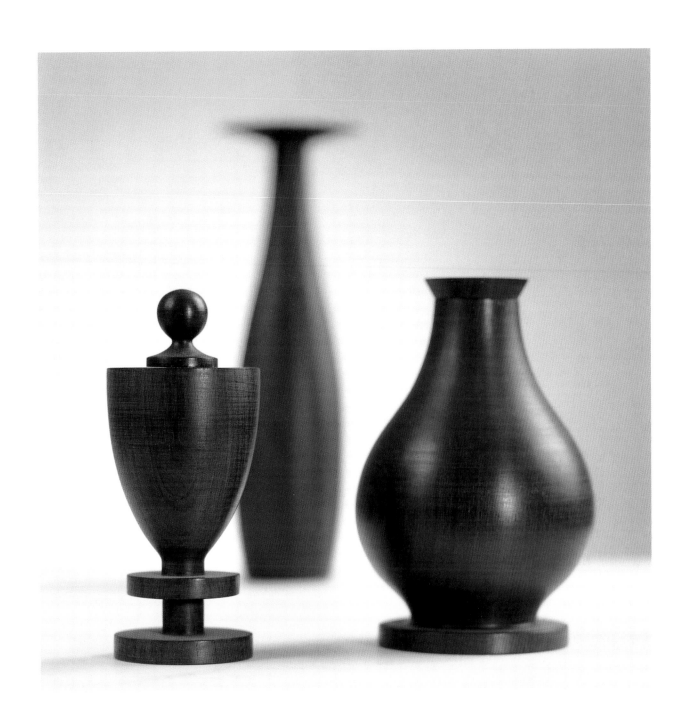

Wooden models for perfume flasks – Holzmodelle für Parfümflakons, 1936/1984-85

Sketches for perfume flasks – Entwürfe für Parfümflakons, 1936

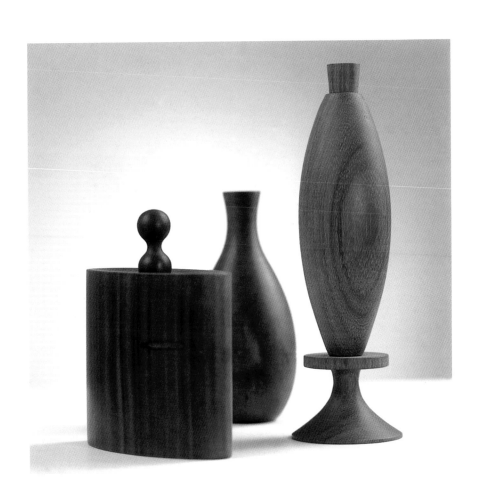

above – oben
Wooden models for perfume flasks – Holzmodelle für Parfümflakons, 1936/1984-85

below – unten
Four sketches for glass perfume flasks – Vier Entwürfe für Parfümflakons aus Glas, 1936

135

Fell-Teppich

Sketch for a carpet – Entwurf für einen Teppich

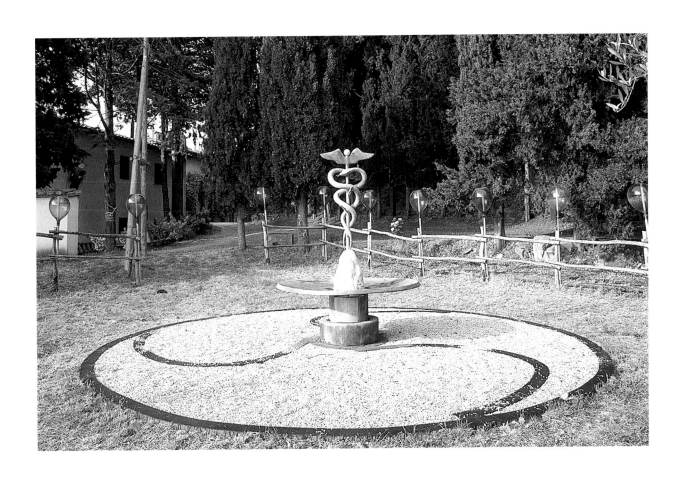

Hermes Fountain – Merkursbrunnen, 1966/2000

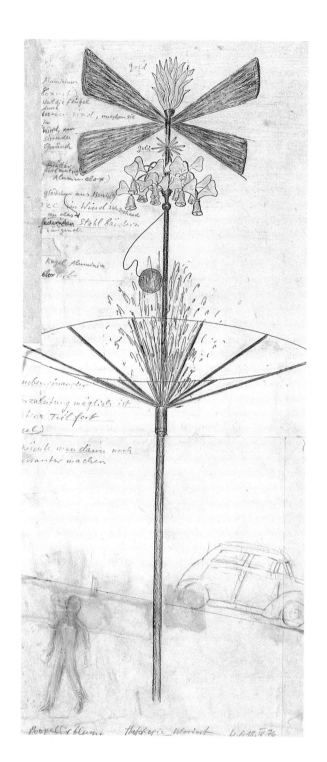 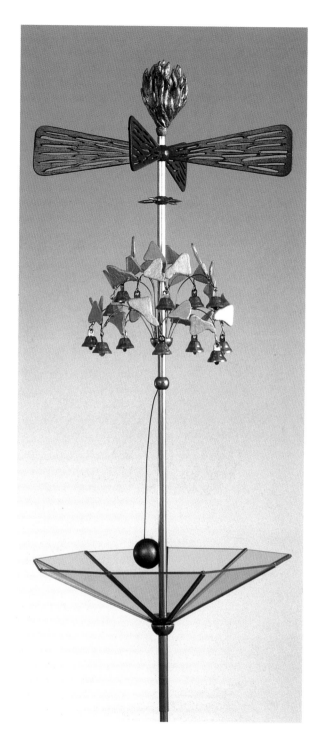

left – links
Sketch for Wind Trees – Skizze für Windbäume, 1976

right – rechts
Model for Wind Trees – Modell für Windbäume, 1976/2003

'Crystal', model
for fountain –
"Kristall", Modell
für Brunnen, 1979

'Blossom', model for fountain –
"Blüte", Modell für Brunnen, 1979

139

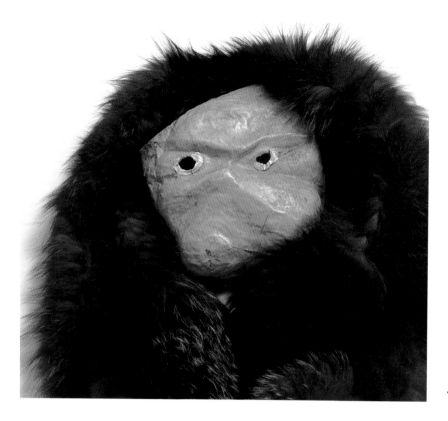

Yellow Mask – Gelbe Maske, 1936

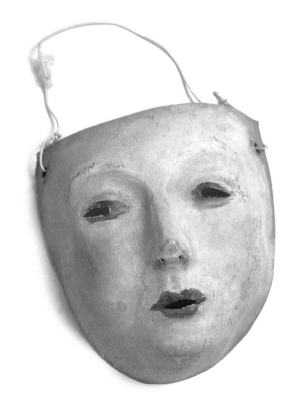

Child's Face – Kindergesicht

Pink Wire Eyes –
Rosarote Drahtaugen

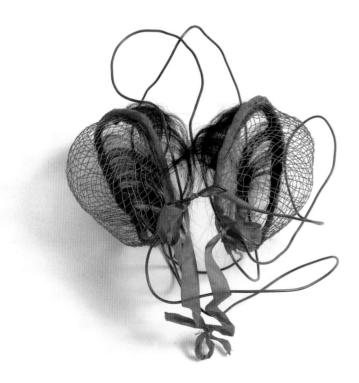

Red and Black Wire Eyes –
Rote und schwarze Drahtaugen

Plates
Abbildungen

MERET OPPENHEIM

Autumn – Herbst, 1930

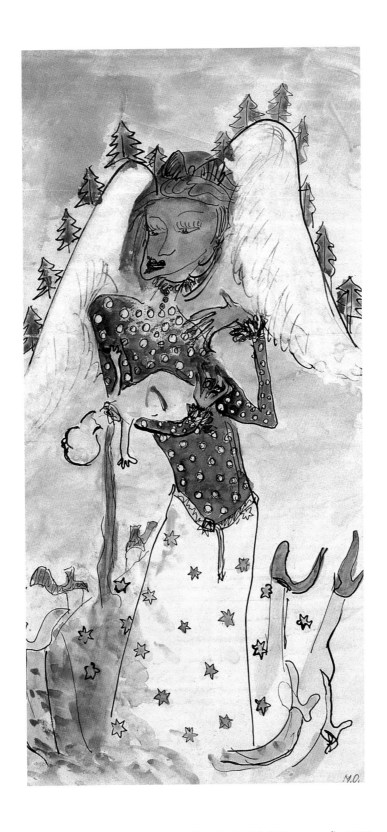

Votive Picture (Destroying Angel) – Votivbild (Würgeengel), 1931

Trunked Animal at the Beach – Rüsseltier am Strand, 1932

Half-length Portrait of a Woman – Brustbild einer Frau, 1932

La chimère de Notre Dame et Jeanne d'Arc, 1932

Portrait of Irène Zurkinden, 1933

White Porcelain, Little Red
Bricks –
Weisses Porzellan, rote
Ziegelchen, 1933

Architectural Fragment with
Rays of Light –
Architektonisches Gebilde
mit Lichtstrahlen, 1933

Detail from the End of the World – Detail aus Weltuntergang, 1933

Dream – Traum, 1937

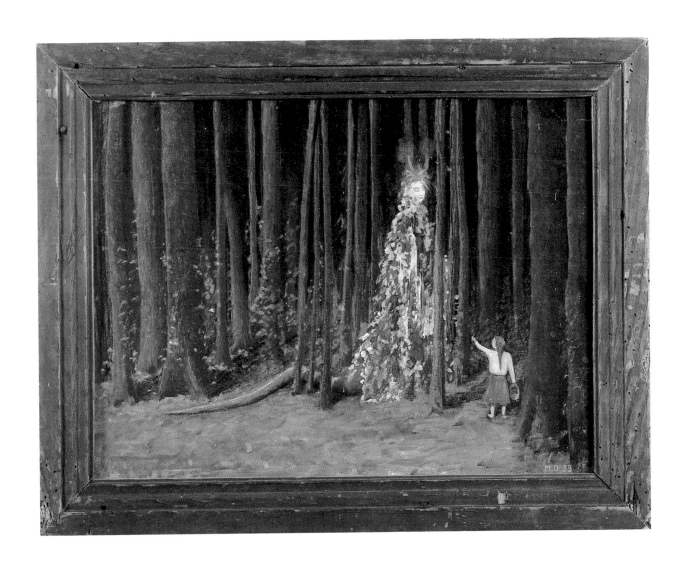

The Woman of the Woods – Die Waldfrau, 1939

Sophistry – Sophisterei, 1942

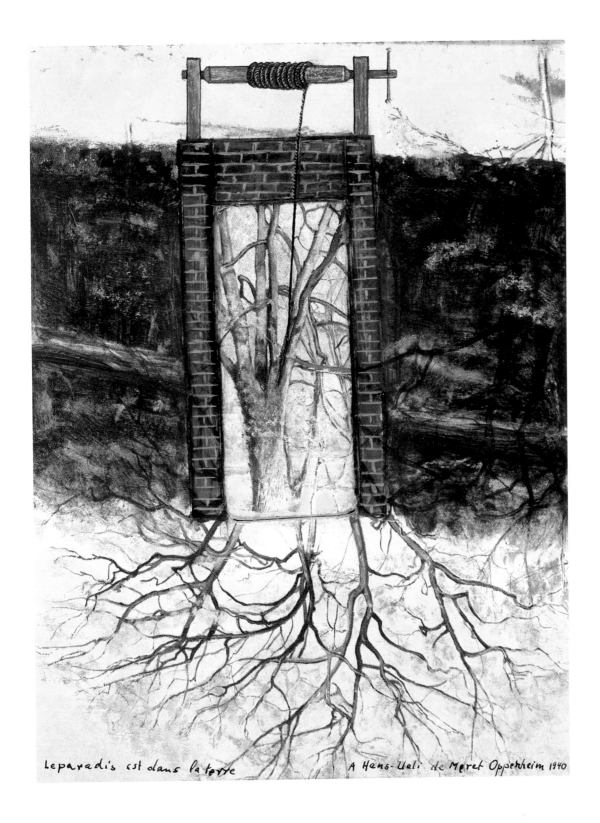

Le paradis est dans la terre A Hans-Ueli de Moret Oppenheim 1940

The Paradise is Under the Earth – Das Paradies ist unter der Erde, 1940

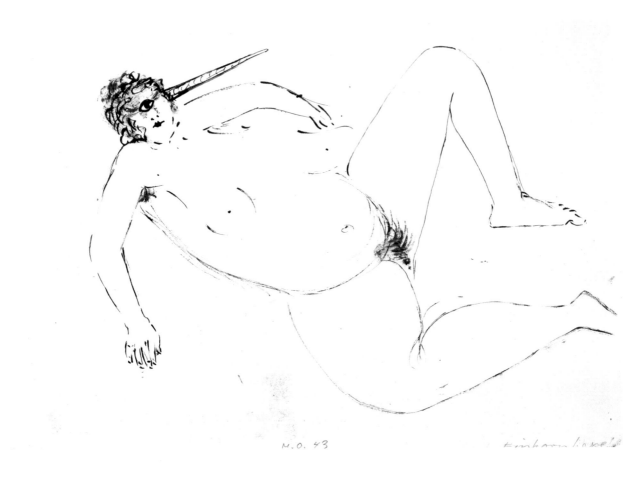

above – oben
Unicorn Witch – Einhornhexe, 1943

left – links
**Note for Mask –
Notiz für die Maske, 1943**

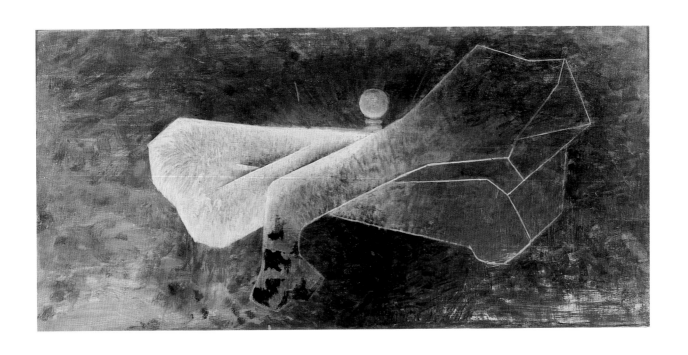

The Tragicomical – Das Tragischkomische, 1944

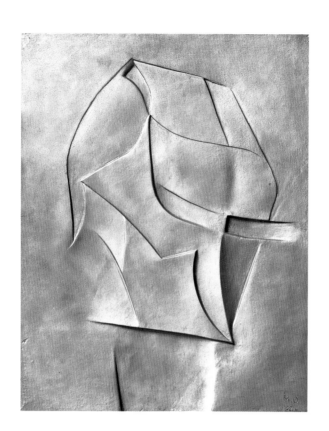

Garibaldina, 1952

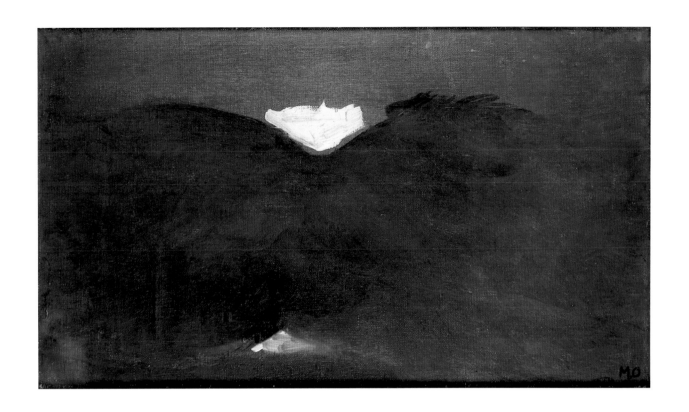

Phalène–Moth – Nachtfalter, 1954

LIVERPOOL JOHN MOORES UNIVERSITY
LEARNING SERVICES

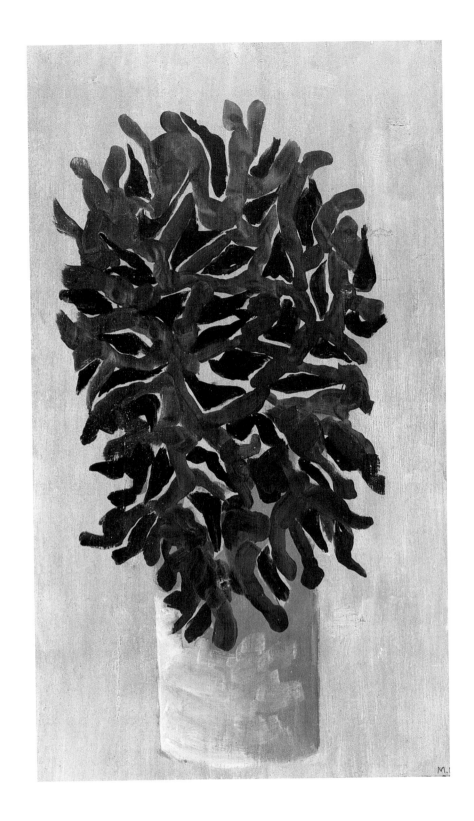

Gu-gugg (How He Stares, the Old Fellow!) – Gu-gugg (Wie er schaut, der Alte!), 1954

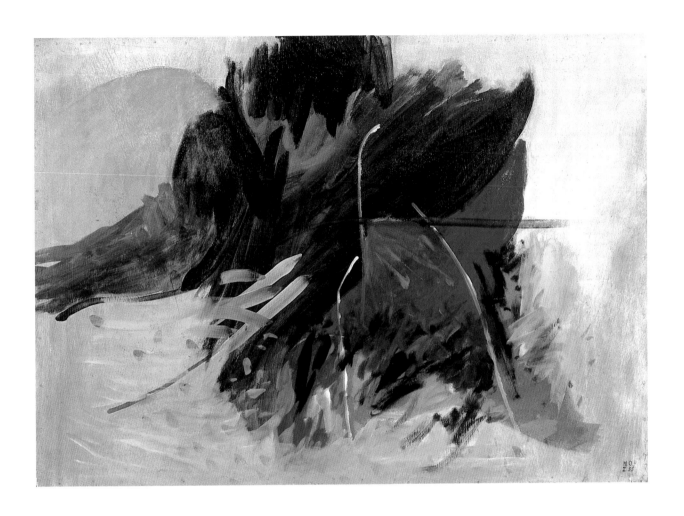

Summer Brushwood (Pan is Hiding) – Sommergestrüpp (Pan verbirgt sich), 1955

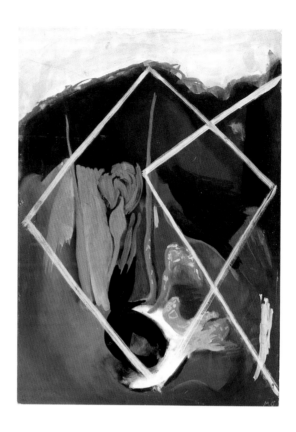

One Will See – On va voir –
Man wird Sehen, 1955

left – links
**Cat with Candle on It's Head –
Katze mit Kerze auf dem Kopf,
1957**

right site – rechte Seite
**Cat with Candle on It's Head,
Illustration for a Poem –
Katze mit Kerze auf dem Kopf,
Illustration zu einem Gedicht,
1957**

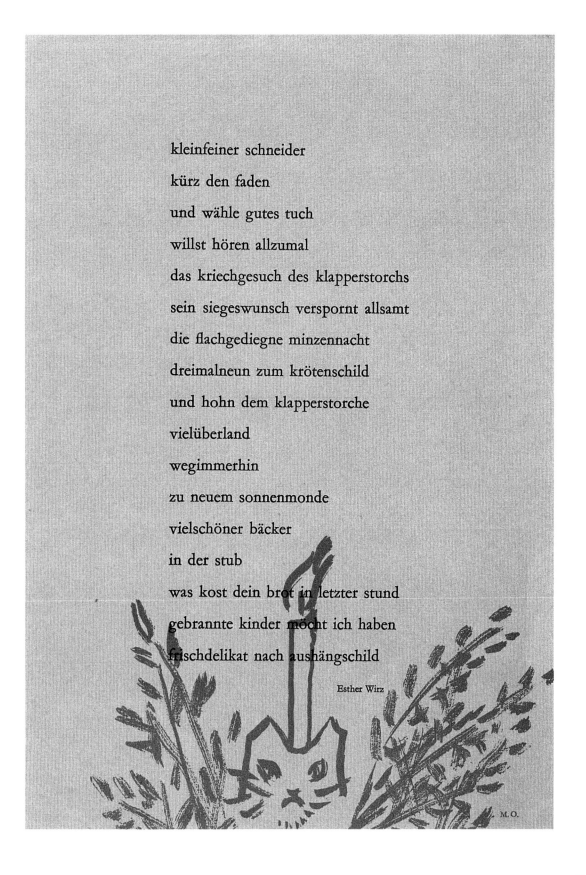

kleinfeiner schneider

kürz den faden

und wähle gutes tuch

willst hören allzumal

das kriechgesuch des klapperstorchs

sein siegeswunsch verspornt allsamt

die flachgediegne minzennacht

dreimalneun zum krötenschild

und hohn dem klapperstorche

vielüberland

wegimmerhin

zu neuem sonnenmonde

vielschöner bäcker

in der stub

was kost dein brot in letzter stund

gebrannte kinder möcht ich haben

frischdelikat nach aushängschild

Esther Wirz

M. O.

Tour avec entrée voutée 1958

Tower with Arched Entrance – Turm mit Gewölbtem Eingang, 1958

Bushes – Gebüsch, 1958

Wallowing Horse – Sich wälzendes Pferd, 1958

Spring Sky – Frühlingshimmel, 1958

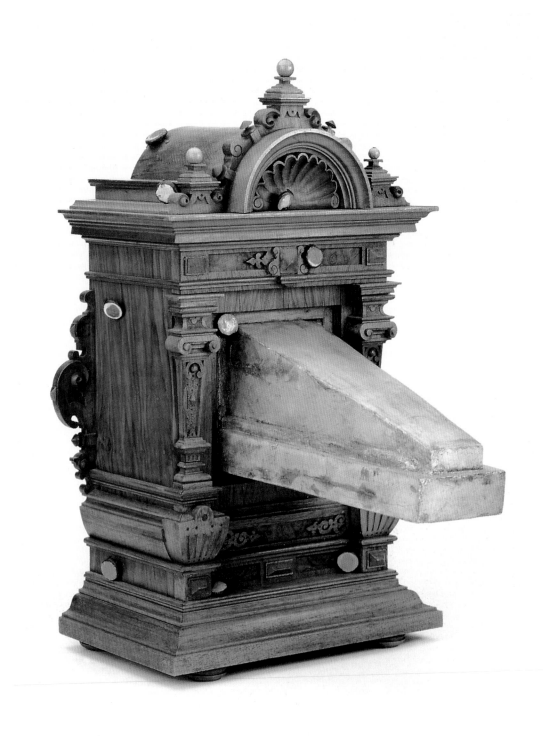

Demon with Animal Head – Tierköpfiger Dämon, 1961

Source – Quelle, 1958

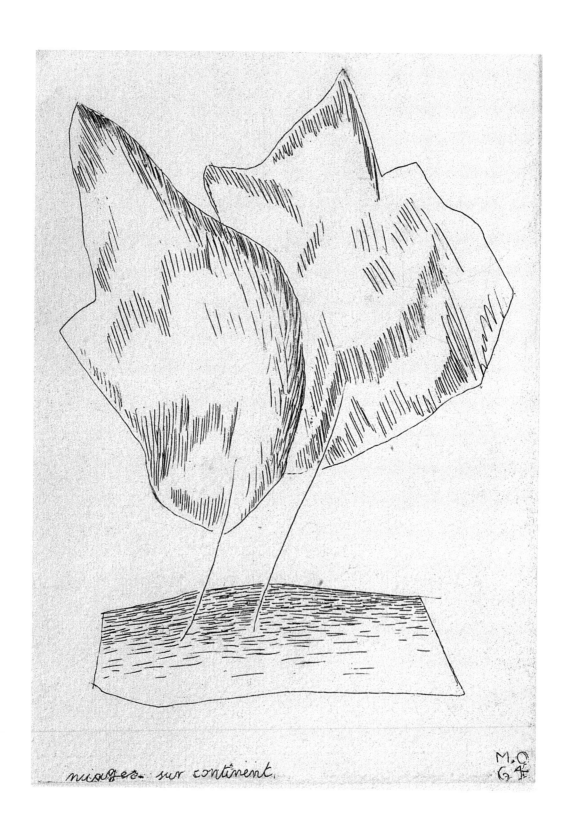

nuages sur continent.

M.O
64

Clouds over Continent – Wolken über Kontinent, 1964

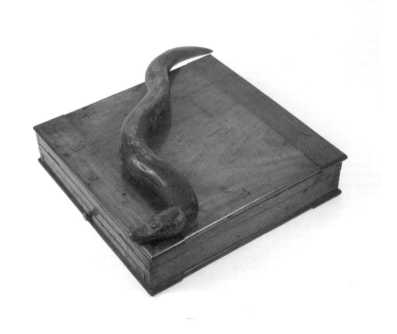

The Black Snake Knows the Path of the Islands – Le Serpent Noir Connait le Chemin de Îls –
Die schwarze Schlange kennt den Weg der Inseln, 1963

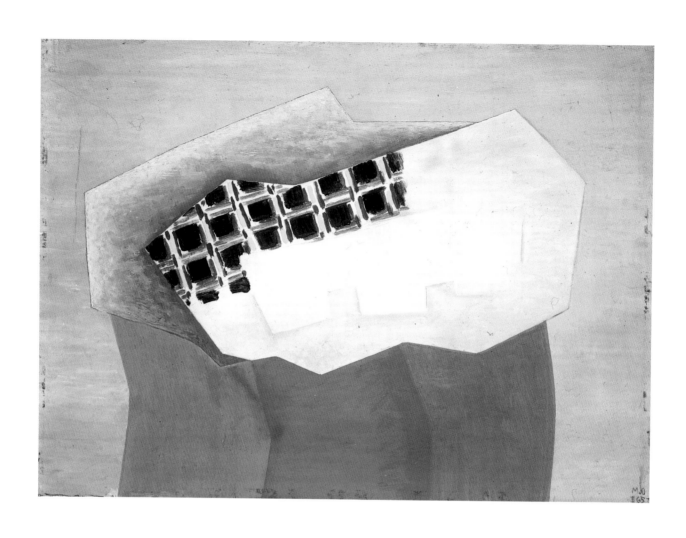

Gray Cloud Dressed – Graue Wolke bekleidet, 1965

Black Chimney – Schwarzer Kamin, 1966

Bon Appétit, Marcel, 1966

November, 1967

Collage from the 'Gallery of Voyage' – Collage aus "Reisegalerie", 1969

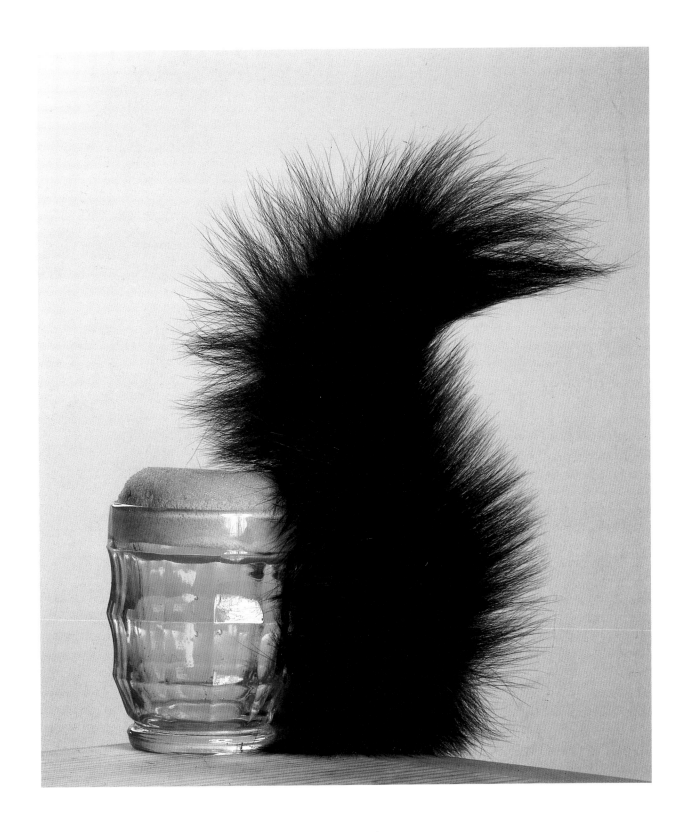

Squirrel – Eichhörnchen, 1969

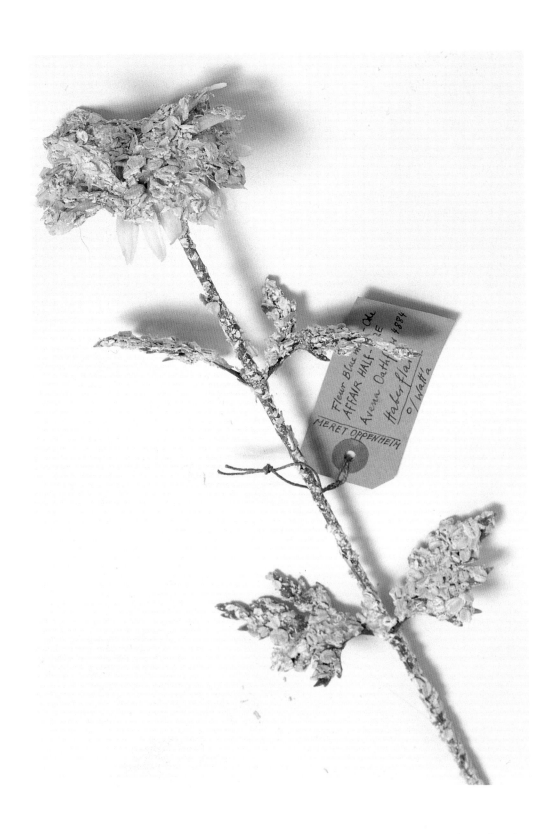

Avena Oathflow 4884 – Fleur Bluemay-Ode – AFFAIRE HALF-ERE – Haberflair, o/Watt'a, Hafer-Blume, 1969

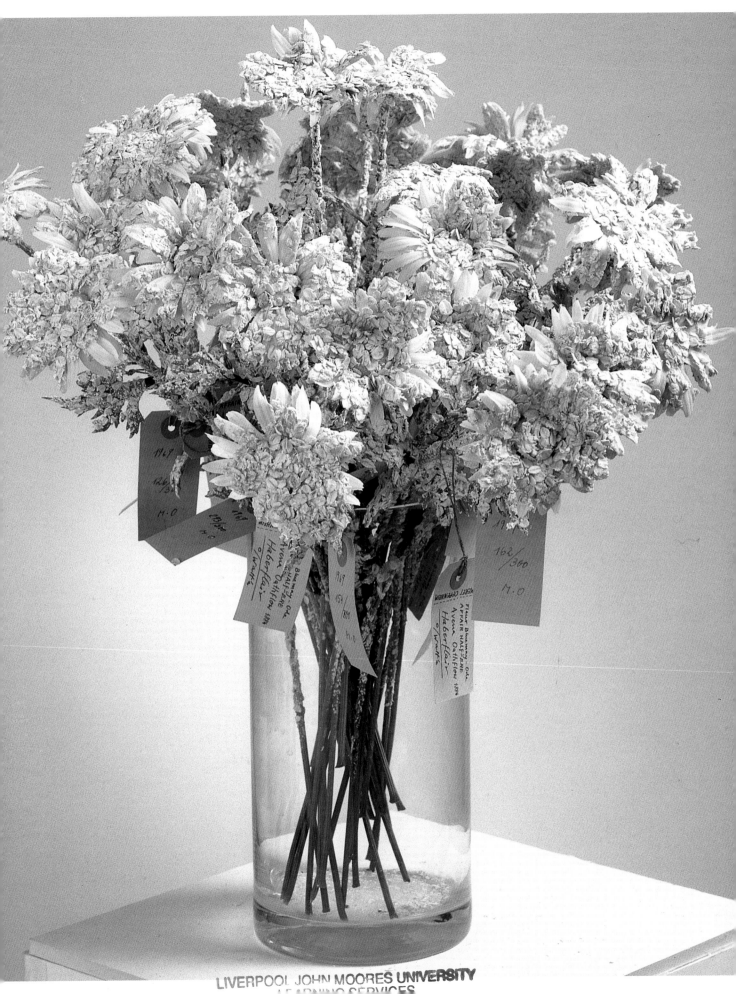

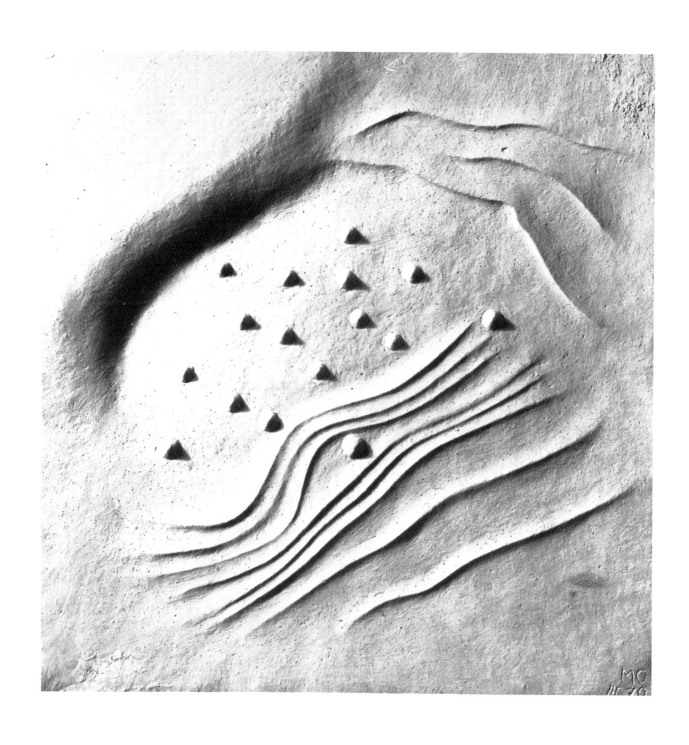

Small Jura Landscape – Kleine Juralandschaft, 1970

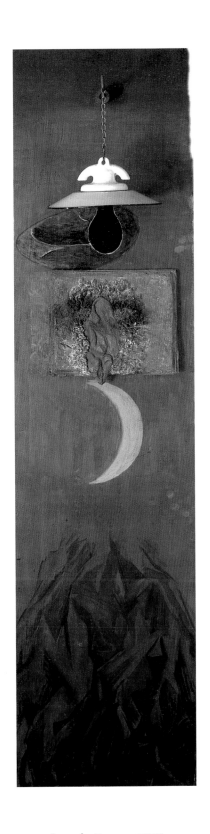

Irma la Douce, 1970

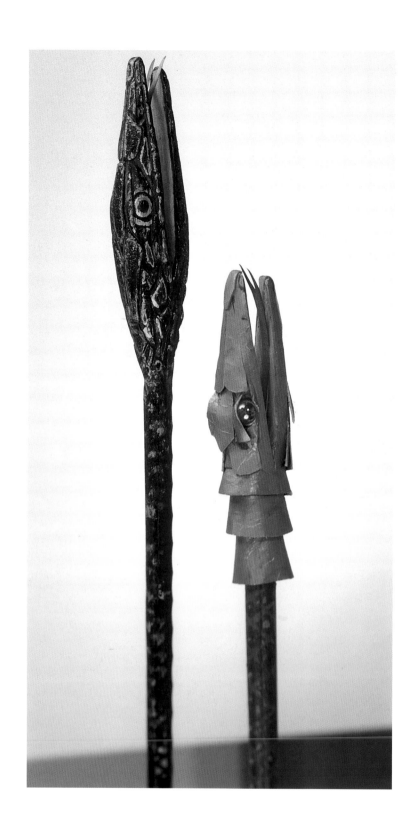

Whip Snakes – Peitschenschlangen, 1970

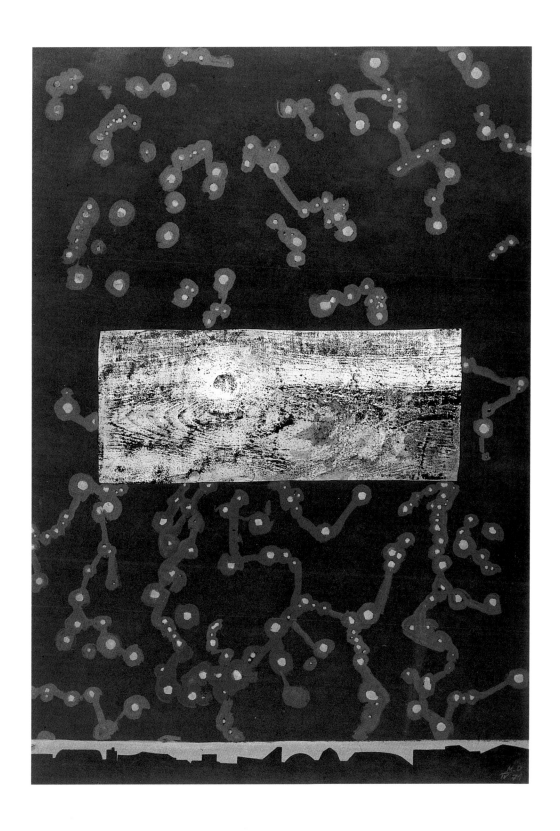

Star-Studded Sky and Sunset – Gestirnter Himmel und Sonnenuntergang, 1971

left – links
**The Delicate Assassin – L'Assassin Delicat –
Der empfindliche Meuchelmörder, 1971**

below left – unten links
**God is Tolerant – Dieu est ouvert –
Gott ist tolerant, 1971**

below right – unten rechts
**He Looks Around – Il se Retourne –
Er sieht sich um, 1971**

The Embarrassing End – La Fin Embarrassée – Ende und Verwirrung, 1971

Night-Sky with Agates – Nachthimmel mit Achaten, 1971

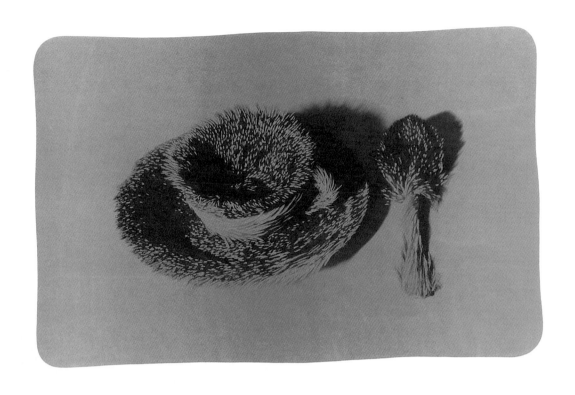

Poster Fur Cup – Poster Pelztasse, 1971

Laden Table, Dog Underneath – Beladener Tisch, darunter Hund, 1972

Writing Paper for a Black Swan – Briefpapier für einen schwarzen Schwan, 1972

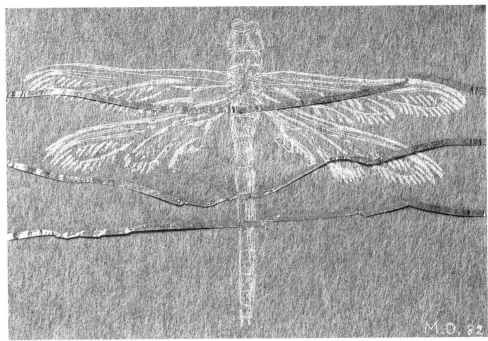

above – oben
Dragonfly Campoformio – Libelle Campoformio, 1972

below – unten
New Year's Card for Atelier 5, Bern – Neujahrskarte für Atelier 5, Bern, 1982

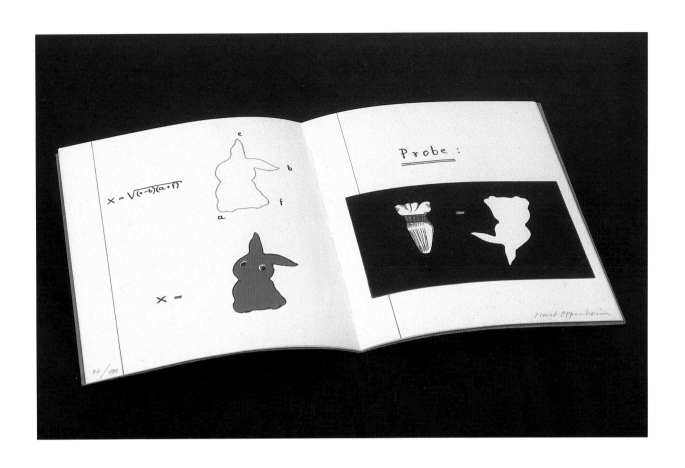

The Exercise Book – Das Schulheft, 1973

They are Dancing – Sie tanzen, 1973

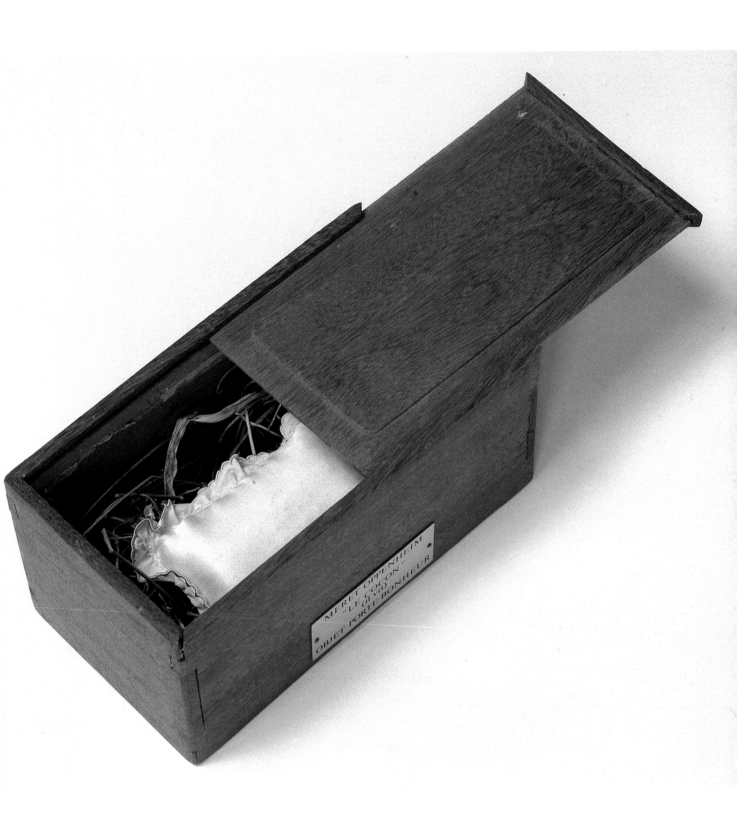

The Cocoon (It's Alive) – Le cocon (il vit) – Der Kokon (er lebt), 1974

My Flag – Meine Fahne, 1974

Stones - Black Drops, Disappearing
towards the White Center –
Steine - schwarze Tropfen, die zur
weißen Mitte hin verschwinden, 1974

Lagoons – Lagunes – Lagunen, 1974

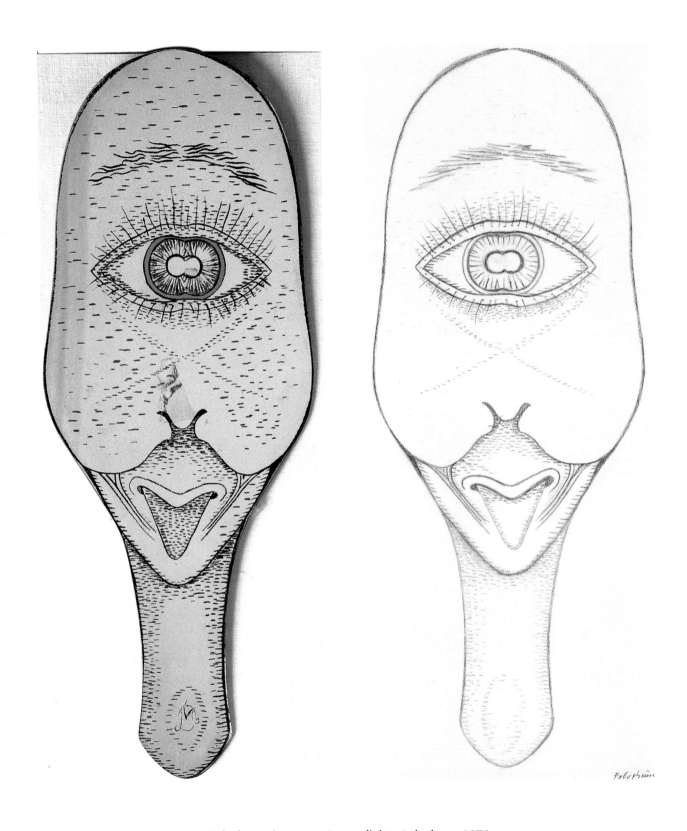

Polypheme in Love – Der verliebte Polyphem, 1974

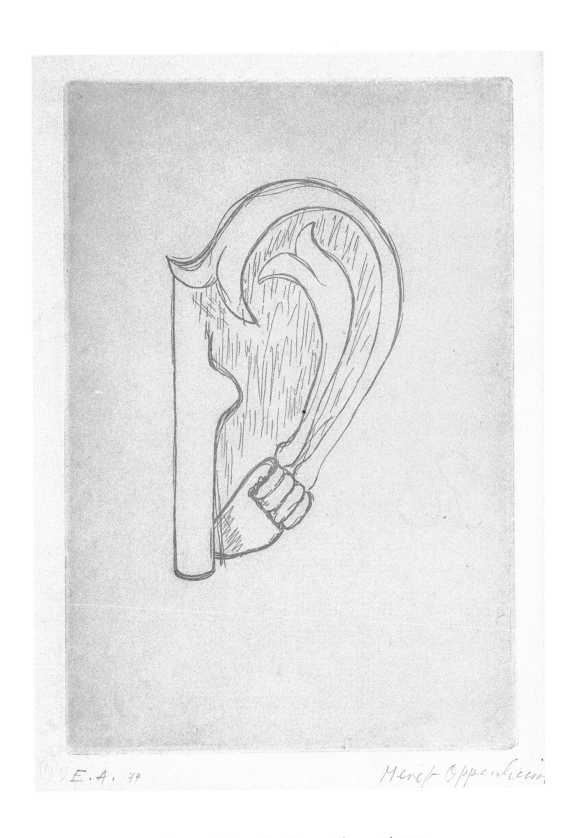

E.A. 74 Meret Oppenheim

Giacomettis' Ear – Das Ohr von Giacometti, 1974

Porter in the Fog – Der Träger im Nebel, 1975

Reddish Moon and Cypresses against Black Sky –
Rötlicher Mond und Zypressen vor schwarzem Himmel, 1975

Parapapillonneries –The Cypress Sphinx Moth –
Der Zypressenschwärmer, 1975

Parapapillonneries – The Silk Moth and Proud
Rosamunde – Seidenmotte und die
stolze Rosamunde, 1975

Parapapillonneries – The Silverbottom –
Der Silberschwanz, 1975

Queen of Termites – Termitenkönigin, 1975

Little Red Man in a Mussel Shellm –
Kleines rotes Männchen in einer Muschel, 1975

Agate – Achat, 1976

Japanese Garden – Japanischer Garten, 1976

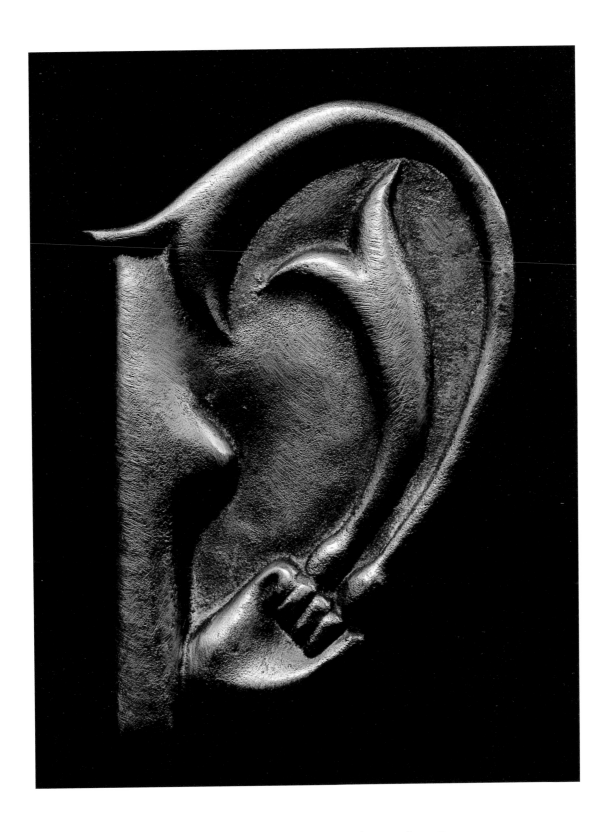

Giacometti's Ear – Das Ohr von Giacometti, 1977

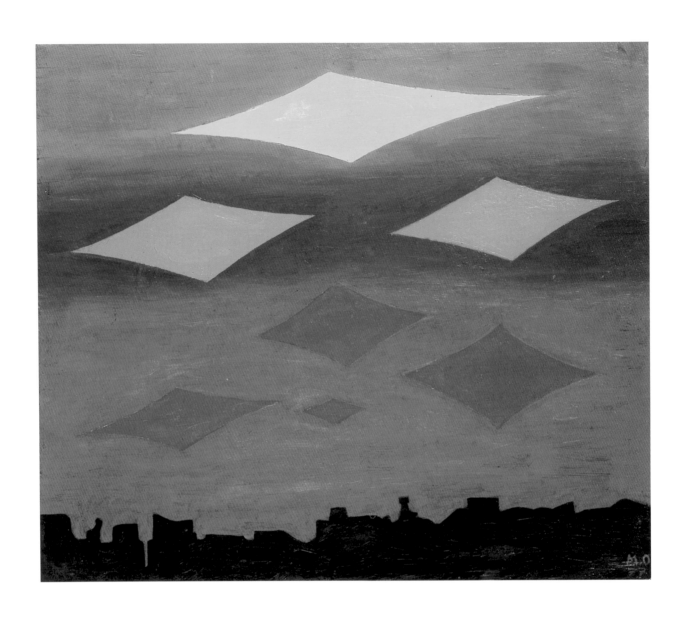

New Stars – Neue Sterne, 1977

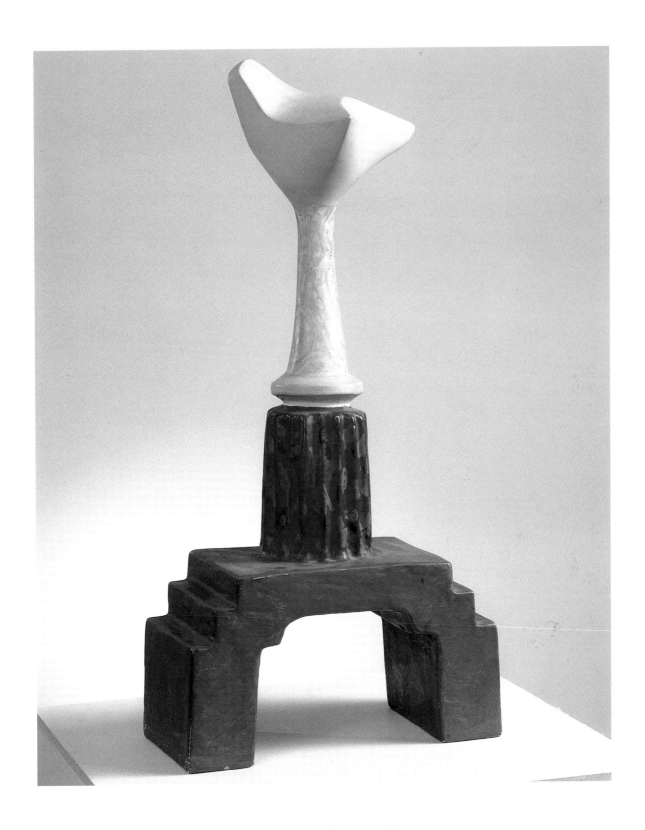

Cloud on Bridge – Wolke auf Brücke, 1977

Lying Profile with Butterfly –
Liegendes Profil mit Schmetterling, 1977

Young Man in Profile (Call Me as You Like) –
Jüngling im Profil (nenne mich wie Du willst), 1977

206

Snail – Schnecke, 1977

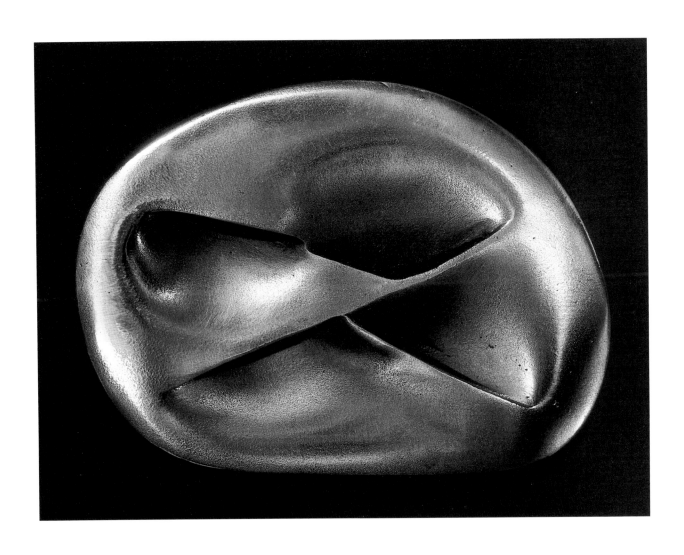

Subterranean Loop –Unterirdische Schleife, 1977

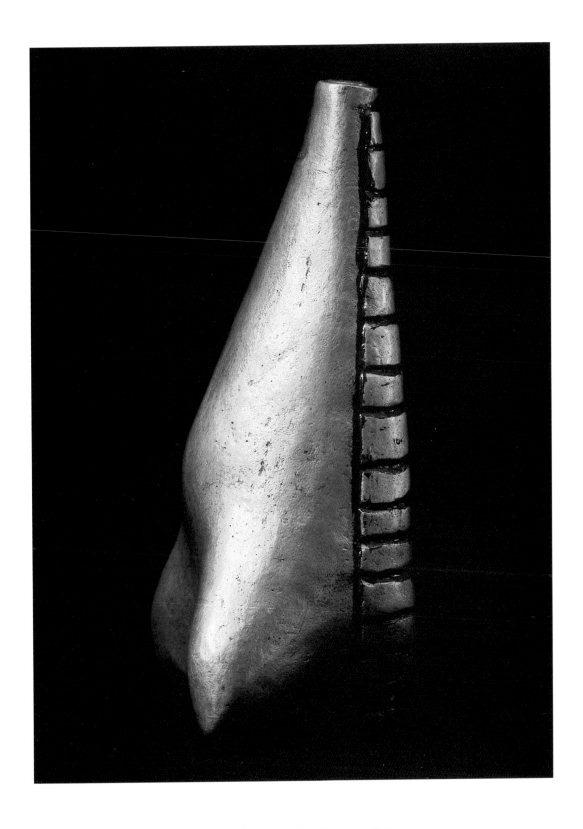

Primeval Venus – Urzeitvenus, 1977

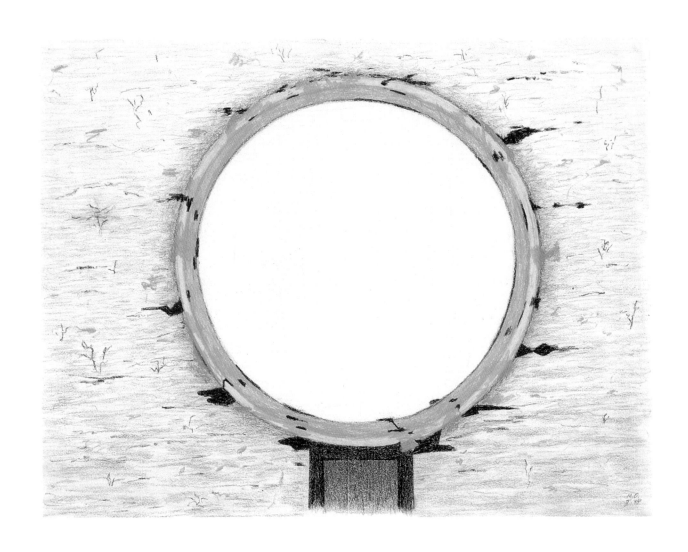

Green Mirror before Desert – Grüner Spiegel vor Wüste, 1978

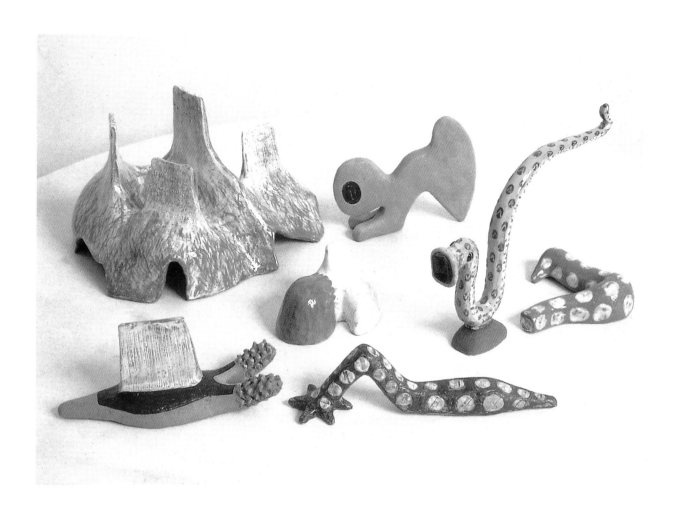

Six Little Primeval Animals and a Sea Snail's Shell – Sechs Urtierchen und ein Meerschneckenhaus, 1978

Stones –
Steine, 1978

212

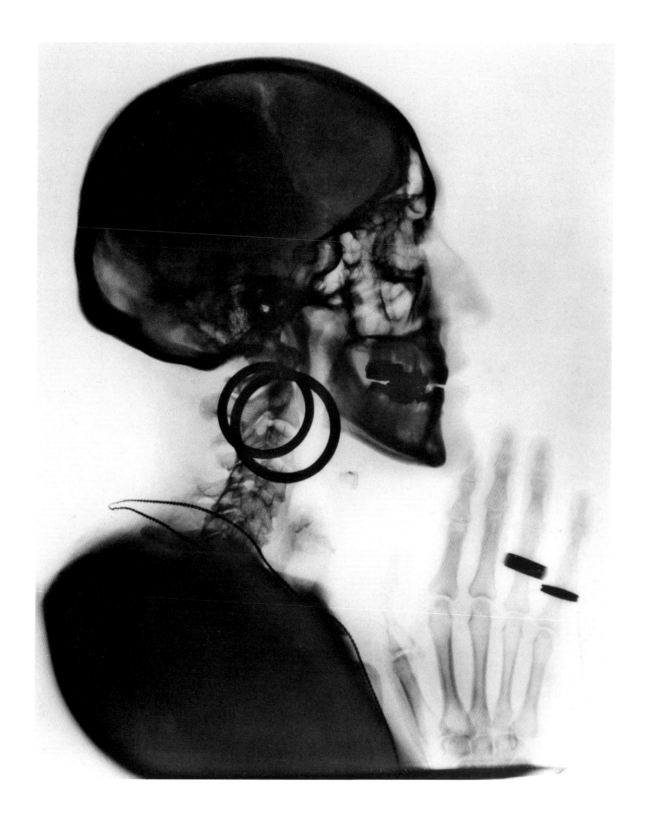

X–Ray, 1978

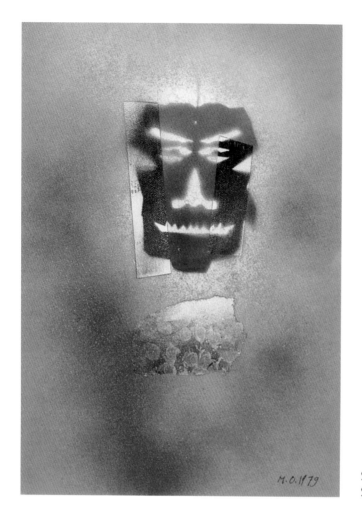

Shadow Multiplication –
Schatteneinmaleins, 1979

White Bird over Water – Weisser Vogel über Wasser, 1980

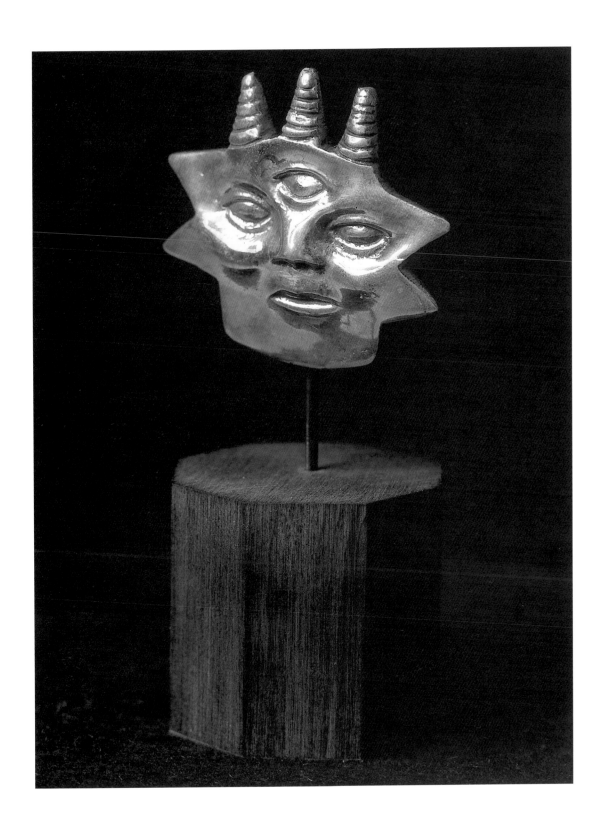

Little Sun Head – Sonnenköpfchen, 1978

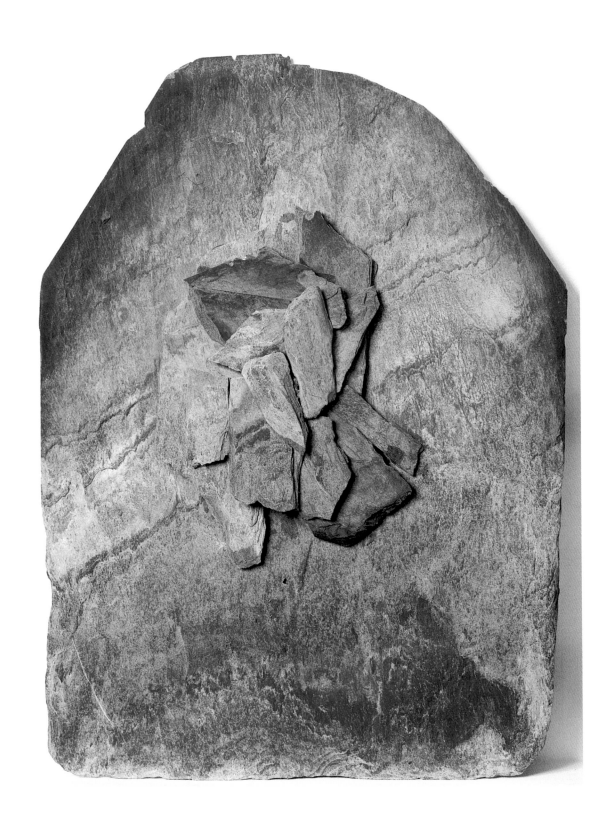

The Old man from the Mountain – Der Alte vom Berg, 1979

Eternal Calender 'Even Days, Uneven Days' – Ewiger Kalender "Gerade Tage, ungerade Tage", 1980

217

Mit dem Radaugott um die Welt
Fische an den Sohlen
Flossen am Absatz
Die goldne Sonne in der Mitte
Sein Herz bekränzt mit Epheu
Sein Gesicht gefüllt mit roten Beeren
Seine nächsten Hände liegen auf den Felsen
Wenn er die Spur verliert
Flüchtet er zum Abgrund
Und lässt alle Löffel fallen.

Sansibar, 1981

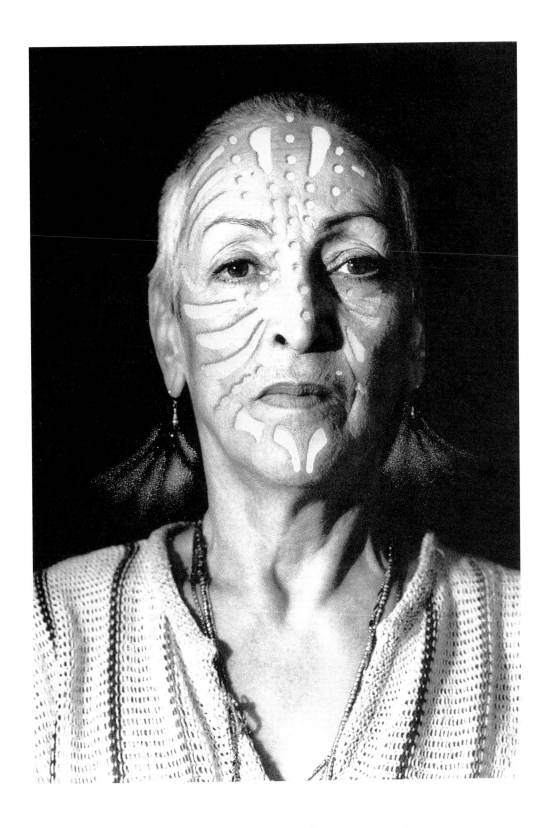

Portrait with Tattoo – Portrait mit Tätowierung, 1980

left – links
**For Traute Fischer for her Birthday –
Für Traute Fischer zum Geburtstag, 1983**

below – unten
Megalithikum, 1983

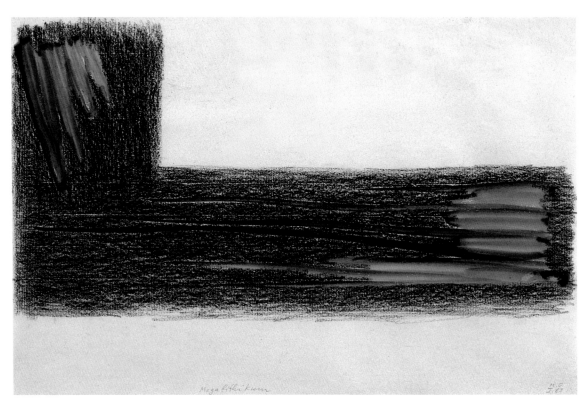

Am Anfang ist das Ende
der Vulkan überhäuft uns mit Geschenken
wie traurig waren wir
der Himmel tropft auf die Teller
das Gras sinkt herab mit Tau bedeckt
Halleluja Schabernack und kein Ende
die Schelmen blasen die Schelmei
zaghaft liegen die Wasserrosen und schlagen
die Augen auf und zu
die Reusen sind leer
der schwarze Sack ist voll
was dem Apfel die Kerne sind der Erde die Ameisen
kein Geräusch ist hörbar
nur die Mondsichel steht am Himmel
das Feuerwerk knallt und die Nacht ist paillettenübersät.

Caroline, 1984

I'm a Child in Swaddling Clothes Swaddled with an
Iron Hand – Ich bin ein Wickelkind, gewickelt mit
eisernem Griff, 1985

Creakingly Steps the Violet –
Knarrend tritt das Veilchen, 1985

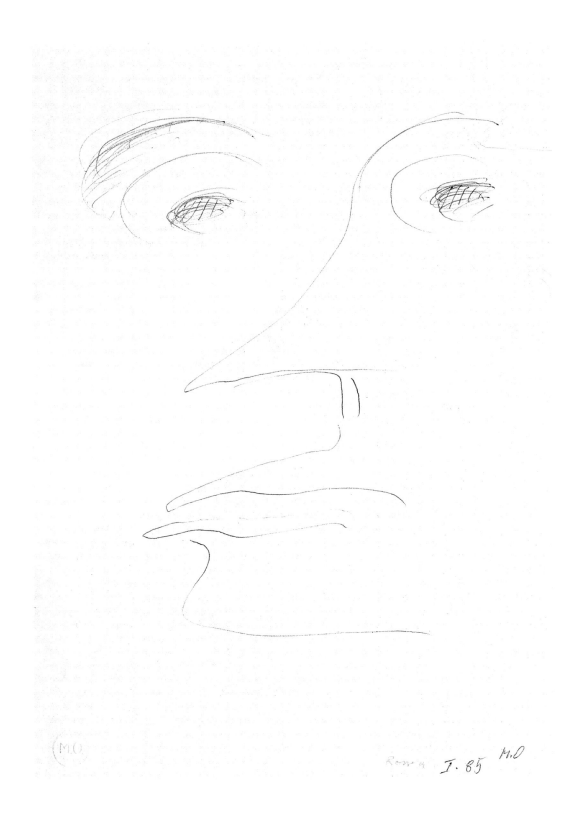

Roma, 1985

223

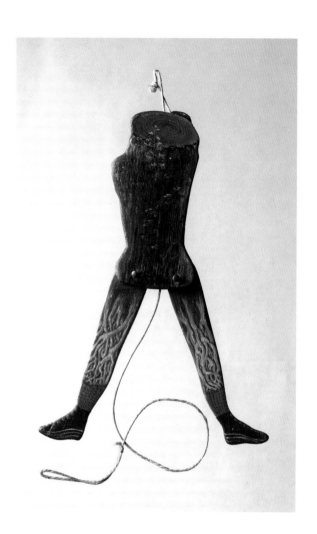 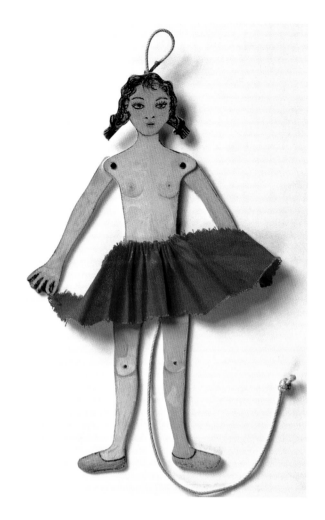

left –links
Wooden Log Jumping Jack – Baumstamm-Hampelmann, 2001

right – rechts
Project for Mine Ha Ha – Projekt für Mine Ha Ha, 1973/1984/2004

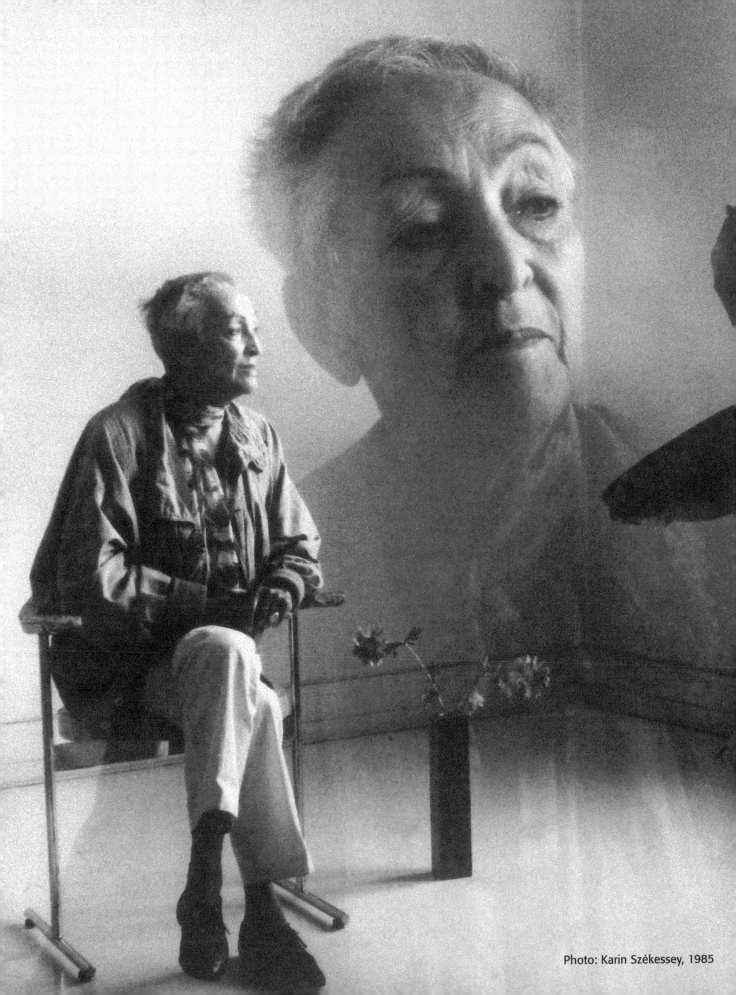

Photo: Karin Székessey, 1985

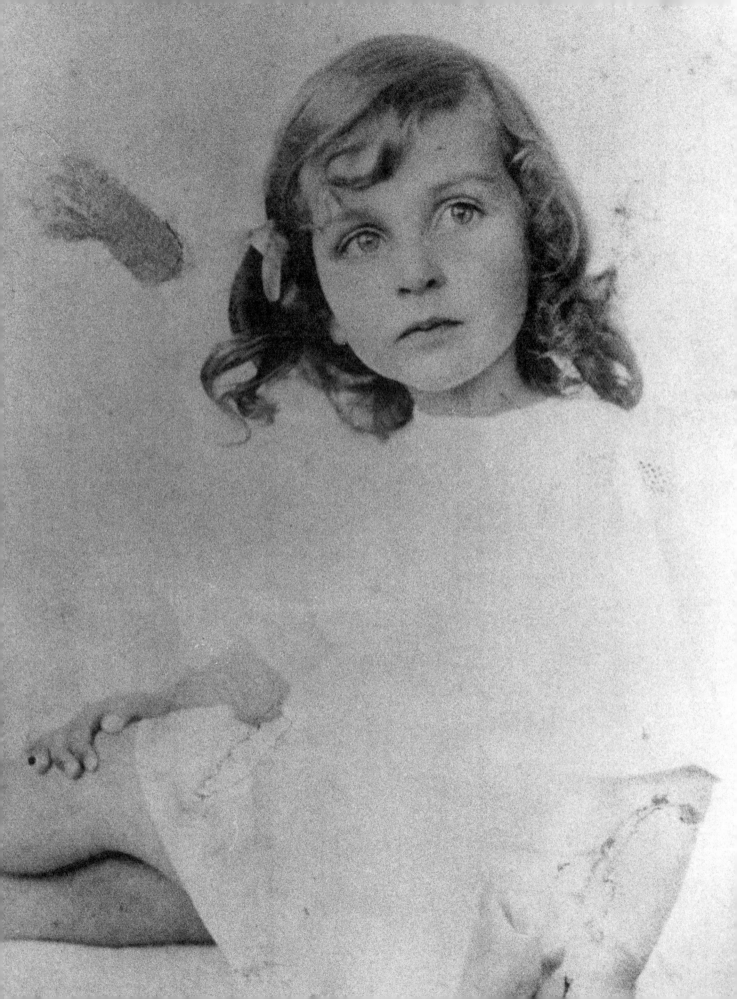

Biography

Meret Oppenheim was born on October 6, 1913, as the first child of the doctor Erich Alphons Oppenheim and his wife Eva Oppenheim-Wenger in the district of Charlottenburg in Berlin. When her father was conscripted in 1914, M.O. moved with her Swiss mother to her grandparents' home in Delémont in Switzerland. She spent her early childhood there in the Jura region of the canton Bern with her sister Kristin and her brother Burkhard and often spent her holidays with her grandparents. At the end of the First World War, her father opened a practice in Steinen in Southern Germany. M.O. went to schools in several places, including Steinen, Basle, and Lorrach.

Her grandmother Lisa Wenger-Ruutz, who had been one of the few female students at the Dusseldorf Academy of Art and was a well-known writer, had a great influence on Meret Oppenheim. Lisa Wenger-Ruutz illustrated one of the most popular Swiss children's books, *Joggeli söll go Birli schüttle*. Meret Oppenheim's grandparents owned a house in Carona that was visited by many artists and writers, including Hermann Hesse, who was briefly married to her aunt, Ruth Wenger. At the age of 16, M.O. created the collage *Das Schulheft* ('The Exercise Book'), which contained the equation $x = Hase$ (x = rabbit). In 1957, the collage was published in the magazine *Le Surrèalisme même*, No. 2, under the title *Le cahier d'une écolière* ('A Schoolgirl's Exercise Book').

Having decided to become a painter, M.O. in 1931 left school with her parent's permission. In Basle, she had made the acquaintance of the painters Walter Kurt Wiemken and Irène Zurkinden. In 1932, at the age of 18, she went to Paris with Irène Zurkinden to study art. She attended classes at the Académie de la Grande Chaumière only occasionally, as she preferred to work on her own in her room at Hotel Odessa, Montparnasse. She wrote poems and produced watercolors and drawings, among those also the sketch *Einer der zuschaut, wie ein anderer stirbt* ('One Who Watches while Another One Dies'). This later served as the basis for the sculpture *Le spectateur vert* ('The Green Spectator'), which was first realized in painted wood and copper in 1959 (Kunstmuseum Bern), followed in 1976 by a version in serpentine and gold (Wilhelm-Lehmbruck-Museum, Duisburg).

Alberto Giacometti and Hans Arp visited Meret Oppenheim in 1933 in her studio at 44 avenue de Châtillon and invited her to exhibit with the Surrealists in the Salon des Surindépendants. M.O. often spent time in Alberto Giacometti's atelier, observing him at his work. Here in 1933 she did the drawing *L'Oreille de Giacometti* ('Giacometti's

left page – linke Seite
M.O., 1916; Photo: M.O. Archives

above – oben
Meret Oppenheim's grandparents, parents, Hermann Hesse, and Ruth Wenger – Großeltern Wenger, Eltern, Hermann Hesse, Ruth Wenger, Photo: M.O. Archives

227

above – oben
Giacometti's Ear – Das Ohr von Giacometti, 1974
right page – right Seite
Erotique-voilée 1933, Photo: Man Ray

Ear'), which she modelled in wax and cast in bronze in 1959. In 1977 the object was reproduced as a multiple for her exhibition in 1978 at the Thomas Levy gallery in Hamburg. The drawing *Plan für die Urzeitvenus* ('Plan for Primeval Venus') and the model for *Urzeitvenus* were both also produced by her in 1933. The model was cast in bronze in 1962, followed by an edition in 1977. Meret Oppenheim became part of the circle around André Breton and regularly participated in Surrealist group exhibitions until 1937. In the winter of 1933/34 she met Man Ray, who asked her to pose for him for a series of photographs. The world-famous portrait of Meret Oppenheim with a printing press was taken in the studio of Louis Marcoussis and reproduced with her permission in the magazine *Minotaure*, No. 5, in 1934. Man Ray also documented M.O. in a number of other photographic works, including representations of her wearing a bathing cap. In 1934 Meret Oppenheim met the painter Max Ernst at a party in the studio of Kurt Seligmann. A passionate affair with Max Ernst began, which M. O. ended within a year as she felt her artistic freedom was being restricted by the older and more famous artist.

In 1936 Meret Oppenheim's father had to give up his practice in Steinen because the National Socialists imposed sanctions on him due to his Jewish-sounding name. This meant that M. O. no longer received any financial support from him. In the same year, she created her famous work *Le Déjeuner en fourrure* ('Breakfast in Fur'), which was purchased by Alfred H. Barr from the Charles Ratton gallery for the Museum of Modern Art in New York.

In the very same year, Meret Oppenheim had her first solo exhibition at the Schulthess gallery in Basle. Max Ernst wrote the text for the invitation. The object *Ma gouvernante – my nurse – Mein Kindermädchen,* which was exhibited there, today belongs to the collection of the Moderna Museet in Stockholm. Being in a financially difficult situation, Meret Oppenheim tried to earn money with design concepts for clothes and jewelry. Bice Curiger comments that "[…] even the most extravagant couturiers often find her ideas just a touch too crazy. True to her disposition she develops her concepts without adhering to the current fashion codex, instead creating her own set of cultural references."[1]

In 1937, M.O. went back to Basle and attended the school of applied arts there for two years. Around this time her creative crisis began that was to last for 18 years. During this phase M.O. continued to work, often, however, destroyed

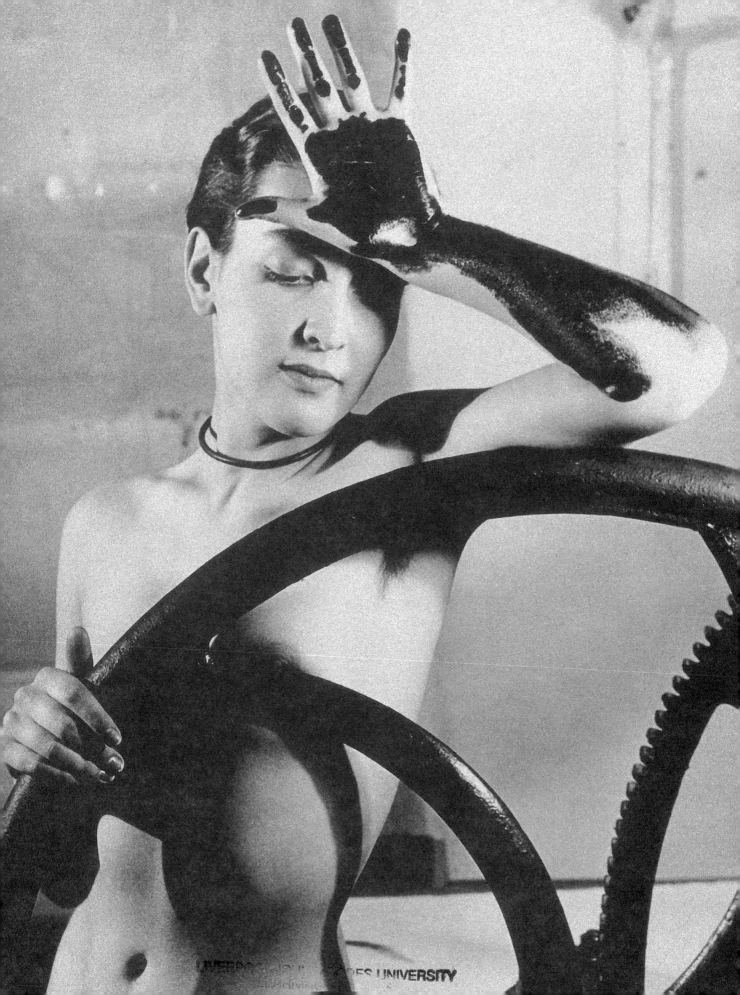

projects or did not complete them. She kept in touch with 'Gruppe 33' and later took part in the exhibitions of 'Allianz', another Swiss artists' association. In 1938 she travelled with Leonor Fini and André Pieyre de Mandiargues through Northern Italy. In 1939, she went back to Paris to take part in an exhibition of fantastic furniture together with Max Ernst, Leonor Fini, and others at the gallery of René Drouin and Leo Castelli at Place Vendôme. She presented some objects and a table with bird's feet. In Switzerland she first lived with her family in her grandparent's residence in the Klingenthal. When for financial reasons the house was sublet, her family moved to Carona, while M.O. remained there, living in a room above the garage.[2] The Kunstmuseum Basle purchased the painting *Krieg und Frieden* ('War and Peace') in 1943. In 1945 Meret Oppenheim met Wolfgang La Roche, whom she married in 1949; M.O. and La Roche lived in Bern, Thun, and Oberhofen. It took a long time for M.O. to make connections to the art scene in Bern. The director of the Bern Kunsthalle, Arnold Rüdlinger, was a supportive mentor and friend. In the 1950's Bern was very open to art, and many artists were drawn to the city. Among others, M.O. met Daniel Spoerri and Diter Rot where.

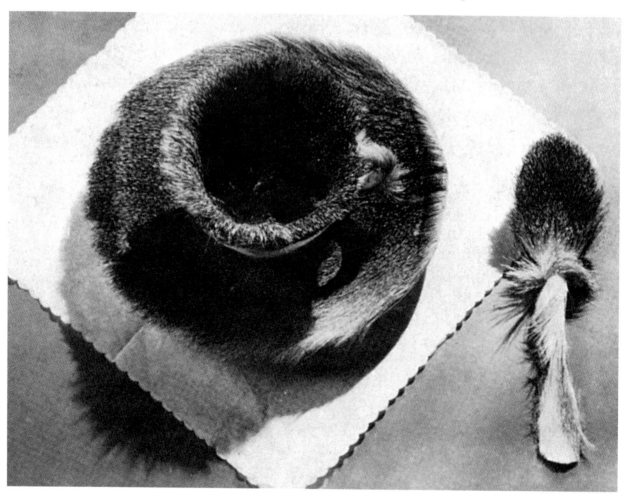

Breakfast in Fur – Pelztasse, 1936; Photo: Dora Maar

The Oppenheim-La Roche household was very hospitable. The reciprocally open marriage ended in 1967 with the death of Wolfgang La Roche.

After a break of ten years, M.O. went back to Paris again in 1950; but was disappointed when she realized that some of her old friends had remained rooted in the 'jargon' of Surrealism. In 1954 she moved into a studio in Bern – her crisis was finally over. In 1956 she designed costumes and masks for Daniel Spoerri's production of *Le Désir Attrapé par la Queue* ('Desire Caught by the Tale') by Picasso. The production was staged at a small theater in Bern. M.O. created the object *Le couple* ('The Couple'), a pair of laced lady's boots joined at the tips, for an exhibition that took place parallel to the theater performance. In 1959 M.O. organized a *Spring Banquet* in Bern, where the meal was served on the body of a nude woman. Three couples took part in the event. André Breton persuaded M.O. to repeat the *Banquet* in Paris for the *Exposition InteRnatiOnal du Surréalisme*, which took place some months later at the Cordier gallery. It was to be her last exhibition with the Surrealist group.

In the following years, she had many solo exhibitions and also participated in a number of group exhibitions, for example, in Basle, Paris, Milan, New York, Zurich, Bern, Stockholm, Oslo, and Geneva. In 1967 a retrospective of her work was shown at the Moderna Museet in Stockholm. In addition to her flat in Bern, M.O. from 1972 onward also once more rented a studio in Paris. A travelling retrospective was exhibited in 1974/75 at the museums of Solothurn, Winterthur, and Duisburg. On January 16, 1975, she received the Art Award of the City of Basle. Her speech, where she presented her position on the situation of the *female artist*, received much acclaim. In 1981, her

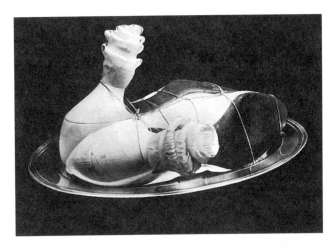

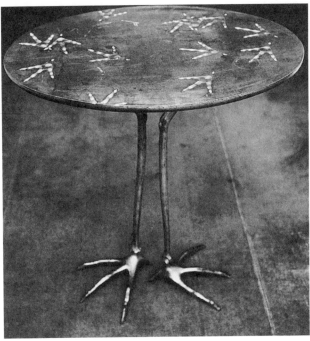

Ma gouvernante – My Nurse – Mein Kindermädchen, 1936

Table with Bird's Legs – Tisch mit Vogelfüssen, 1939/1983

poems (1933-1957) were published together with serigraphs in a book with the title of *Sansibar* by Edition Fanal in Basle. In 1982 she received the Art Award of the City of Berlin and was invited to take part in *documenta 7* in Kassel. In 1983, among other works, Meret Oppenheim created two paintings after reading the correspondence between Bettina Brentano and Karoline von Günderode (1802-1806). The Goethe Institute in Genoa organised a touring exhibition that was also shown in Milan and Naples. A fountain sculpture based on sketches by M.O. was formally opened at the Waisenhausplatz, the central square in Bern. A fur-

ther retrospective took place in 1984 at the Kunsthalle in Bern and the ARC, Musée d'Art Moderne de la Ville de Paris. The Suhrkamp Verlag in Frankfurt/Main published Meret Oppenheim's poems in the same year, and in 1985 she worked on a fountain sculpture for the Jardins de l'ancienne École Polytechnique in Paris. On November 15, 1985, Meret Oppenheim died in Basle, on the day her book *Caroline* was presented to the public.

1 Bice Curiger, *Spuren durchstandener Freiheit*, Zürich, 1989 (1982).
2 As a German citizen Meret Oppenheim's father was not allowed to work as a doctor in Switzerland.

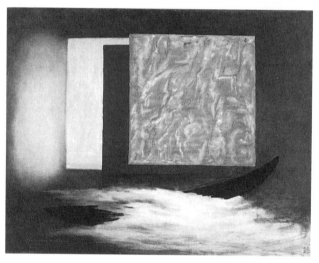

Spring banquet – Frühlingsfest, Bern, 1959

For Karoline von Günderode, 1983

Biografie

Meret Oppenheim wird am 6. Oktober 1913 als erstes Kind des Arztes Erich Alphons Oppenheim und seiner Frau Eva Oppenheim-Wenger in Berlin-Charlottenburg geboren. Als der Vater 1914 zum Kriegsdienst eingezogen wird, zieht M.O. mit ihrer Schweizer Mutter zu ihren Großeltern in die Schweiz nach Delémont. Hier im Berner Jura verbringt M.O. zusammen mit ihren Geschwistern Kristin und Burkhard ihre frühe Kindheit und fährt später oft in den Ferien zu den Großeltern. Der Vater eröffnet nach dem Krieg eine Praxis im süddeutschen Steinen. M.O. besucht unter anderem Schulen in Steinen, Basel und Lörrach.

Großen Einfluss nahm ihre Großmutter Lisa Wenger-Ruutz, die als eine der wenigen Schülerinnen die Kunstakademie in Düsseldorf besucht hatte und als Schriftstellerin bekannt wurde. Lisa Wenger-Ruutz illustrierte auch eines der populärsten Schweizer Kinderbücher, „Joggeli söll go Birli schüttle". Die Großeltern besaßen ein Haus in Carona, in dem viele Künstler und Literaten verkehrten, unter anderem Hermann Hesse, der kurz mit Meret Oppenheims Tante Ruth Wenger verheiratet war. Mit 16 Jahren verfertigt M.O. 1930 ihre Collage „Das Schulheft" mit der Gleichung „x = Hase", die 1957 in der Zeitschrift „Le Surrèalisme même", Nr. 2, mit dem Titel „Le cahier d'une écolière" abgebildet wird.

Nachdem M.O. den Entschluss fasst, Malerin zu werden, verlässt sie 1931 das Gymnasium. In Basel begegnet sie dem Maler Walter Kurt Wiemken und der Malerin Irène Zurkinden, mit der sie 1932 im Alter von 18 Jahren nach Paris fährt, um dort Kunst zu studieren. Sie besucht nur sporadisch die „Académie de la Grande Chaumière", da sie es vorzieht, allein in ihrem Hotelzimmer im Hotel Odessa am Montparnasse zu arbeiten. Es entstehen Gedichte und Zeichnungen, zum Teil mit aufgeklebten Gegenständen, sowie die Projektskizze „Einer der zuschaut, wie ein anderer stirbt", Basis der Plastik „Le spectateur vert" – „Der grüne Zuschauer". Die erste Version von 1959 wird in bemaltem Holz und Kupfer ausgeführt (Kunstmuseum Bern), eine weitere 1976 in Serpentin mit Gold (Wilhelm-Lehmbruck-Museum, Duisburg).

Alberto Giacometti und Hans Arp besuchen M.O. 1933 in ihrem Atelier an der Avenue de Châtillon 44 und fordern sie auf, zusammen mit den Surrealisten im „Salon des Surindépendants" auszustellen. M.O. hält sich häufig im Atelier von Alberto Giacometti auf und schaut ihm bei der Arbeit zu. Hier zeichnet sie ebenfalls im Jahr 1933

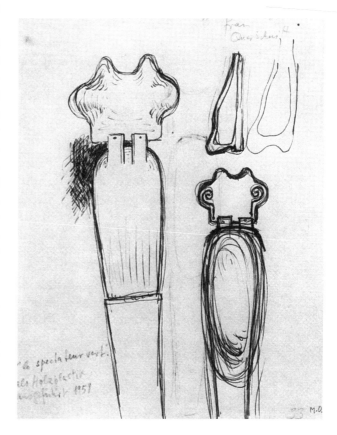

The Green Spectator – Der grüne Zuschauer, 1933

Plan for the Primeval Venus – Plan für die Urzeitvenus, 1933

„L'oreille de Giacometti" – „Das Ohr von Giacometti", das sie später 1959 in Wachs modelliert und in Bronze gießen lässt. 1977 erscheint das Objekt als Multiple für ihre Ausstellung in der Galerie Thomas Levy (1978). Die Zeichnung „Plan für die Urzeitvenus" sowie das Modell zur „Urzeitvenus" realisiert sie ebenfalls 1933. Von diesem werden 1962 einige Exemplare gegossen, gefolgt 1977 von einer Edition. M.O. schließt sich dem Kreis um André Breton an und nimmt bis 1937 regelmäßig an den Gruppenausstellungen der Surrealisten teil. Im Winter 1933/34 lernt Meret Oppenheim Man Ray kennen, der sie bittet, für eine Serie von Fotografien zu posieren. Im Atelier von Louis Marcoussis entsteht die weltberühmt gewordene Aufnahme von M.O. an der Druckerpresse, die 1934 mit ihrem Einverständnis in der Zeitschrift „Minotaure" Nr. 5 veröffentlicht wird.

In weiteren Fotografien hat Man Ray M.O. unter anderem mit Badekappe festgehalten. 1934 trifft Meret Oppenheim auf einem Atelierfest des Malers Kurt Seligmann Max Ernst, mit dem sie eine leidenschaftliche Affäre beginnt. Nach einem knappen Jahr beendet M.O. dieses Verhältnis, weil sie sich von dem Älteren und Berühmteren in ihrer künstlerischen Freiheit eingeschränkt fühlt.

Meret Oppenheims Vater muss 1936 seine Praxis in Steinen aufgeben, da er aufgrund seines jüdisch klingenden Namens von den Nationalsozialisten sanktioniert wird. Damit hört auch die finanzielle Unterstützung für M.O. auf. In diesem Jahr entsteht ihr bekanntestes Werk, das Objekt „Le déjeuner en fourrure", das von Alfred H. Barr für das Museum of Modern Art in New York in der Galerie Charles Ratton erworben wird.

Im selben Jahr hat sie in Basel, in der Galerie Schulthess, ihre erste Einzelausstellung. Max Ernst schreibt den Text für die Einladungskarte. Das Objekt „Ma gouvernante – My Nurse – Mein Kindermädchen", das in dieser Ausstellung zu sehen ist, befindet sich heute in der Sammlung des Moderna Museet in Stockholm. Aus finanzieller Not unternimmt M.O. den Versuch, mit Entwürfen für Mode und Schmuck Geld zu verdienen. Bice Curiger bemerkt dazu: „[...] selbst den extravagantesten Couturiers sind die Vorschläge oft eine Spur zu verrückt. Ihrem Selbstverständnis gemäß entwickelt sie die Vorschläge nicht aus dem gängigen Modekodex heraus, sondern stellt ihren eigenen kulturellen Bezug her [...]".[1]

1937 kehrt M.O. nach Basel zurück und besucht dort zwei Jahre die Kunstgewerbeschule. Um diese Zeit bricht ihre Schaffenskrise aus, die 18 Jahre andauern wird. In dieser Phase arbeitet M.O. zwar weiter, zerstört aber vieles oder stellt es als unfertig auf die Seite. Sie pflegt Kontakt zur „Gruppe 33" und beteiligt sich später an Ausstellungen der „Allianz", einer weiteren Schweizer Künstlervereinigung. 1938 reist M.O. mit Leonor Fini und André Pieyre de Mandiargues durch Oberitalien. 1939 fährt sie noch einmal nach Paris und beteiligt sich mit Objekten

und einem Tisch mit Vogelfüßen an einer Ausstellung phantastischer Möbel mit Max Ernst, Leonor Fini und anderen in der Galerie René Drouin und Leo Castelli am Place Vendôme. Sie wohnt zuerst in dem Haus der Großeltern im Klingenthal. Als die Familie nach Carona zieht, da das Haus aus wirtschaftlichen Gründen vermietet wird, bezieht M.O. ein Zimmer über der Garage.[2] Das Kunstmuseum Basel kauft 1943 das Bild „Krieg und Frieden" an. 1945 lernt M.O. den Kaufmann Wolfgang La Roche kennen, den sie 1949 heiratet. Das Ehepaar lebt in Bern, Thun und Oberhofen. Nur langsam findet M.O. Zugang zum Berner Künstlerkreis. Wichtiger Mentor und Freund ist der Leiter der Berner Kunsthalle, Arnold Rüdlinger. In Bern herrscht in den 1950er-Jahren ein offenes Klima, das viele Künstler anzieht. Hier lernt Meret Oppenheim unter anderem Daniel Spoerri und Diter Rot kennen. Die Eheleute La Roche-Oppenheim führen ein sehr gastfreundliches Haus. Die gegenseitig freiheitliche Ehe dauert bis zum Tod von Wolfgang La Roche im Jahr 1967.

Nach einer zehnjährigen Pause reist M.O. 1950 erstmals wieder nach Paris; sie trifft Freunde aus den 1930er-Jahren, ist aber zugleich darüber enttäuscht, dass sie teils im „Jargon" des Surrealismus verhaftet geblieben sind. 1954 bezieht sie ein Atelier in Bern, ihre Krise ist endlich beendet. 1956 entwirft sie Kostüme und Masken für Daniel Spoerris Inszenierung von Picassos „Wie man Wünsche am Schwanz packt", das in einem kleiner Berner Theater aufgeführt wird. Für die gleichzeitig stattfindende Ausstellung entsteht das Objekt „Le couple", ein Paar Damen-Schnürstiefel mit zusammengewachsenen Spitzen. 1959 organisiert M.O. in Bern ein „Frühlingsfest", das auf dem Körper einer nackten Frau zelebriert wird. Am Mahl nehmen drei Paare teil. Breton drängt sie zu einer Wieder-

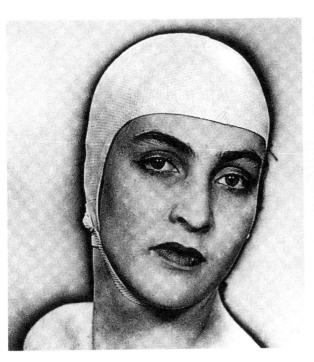

M.O. Paris, 1933/34. Photos: Man Ray

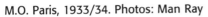

(Fortsetzung)

mit der üblichen Frische und Anmut, die
wir an ihr so bewundern. Ihre Farbgebung
dagegen ist voller Pflanzen- und Tierreste. Da-
rum verwahren sich ihre Bilder am besten in
bleiernen Dosen und steinernen Brücken.
Ein Komma wird in ihrer Hand zum Zauber-
stab. Beispiel:

EIN STUHL VON SEIDE, BEDECKT.
Mit fünfzehn Jahren verläßt sie Vater und
Mutter, um den halbwüchsigen Eisenbah-
nen und den ihr wichtigsten Seezungen nach-
zujagen. Mit zwanzig verschließt sie sich
vornehm in eine Luftspalte und ver-
schluckt den Schlüssel. Nach vierzigtägigem
Fasten bricht sie plötzlich aus und
spielt seitdem gerne – warum wohl? –
mit den Griffelfortsätzen der Küstenländer
und Vorgebirge. Die Schiffbrüchigen und
die Gichtbrüchigen ... Mit einem Wort, sie
ist ein lebendes Exemplar für den uralten Lehrsatz:

DAS WEIB IST EIN MIT WEISSEM MAR-
MOR BELEGTES BRÖDCHEN.
Wer überzieht die Suppenlöffel mit kostbarem
Pelzwerk? Das Meretlein. Wer ist uns über
den Kopf gewachsen? Das Meretlein. Die bessern De-
(Fortsetzung folgt)

Max Ernst.

Invitation card for the exhibition at Galerie Schulthess,
Basle, 1936, text by Max Ernst
Einladungskarte zur Ausstellung in der Galerie Schulthess,
Basel, 1936, Text von Max Ernst

holung des „Fests" in Paris anlässlich der einige
Monate später stattfindenden Ausstellung „Exposi-
tion inteRnatiOnal du Surréalisme" in der Galerie
Cordier. Es ist ihre letzte Ausstellung im Kreis der
Surrealisten.

In den folgenden Jahren hat M.O. etliche Ein-
zelausstellungen und nimmt darüber hinaus an
Gruppenausstellungen teil, unter anderem in Basel,
Paris, Mailand, New York, Zürich, Bern, Stockholm,
Oslo und Genf. 1967 findet ihre erste umfassende
Retrospektive im Moderna Museet Stockholm statt.
Zusätzlich zu ihrem Berner Domizil mietet M.O. ab
1972 wieder ein Atelier in Paris an. 1974/75 zeigen
die Museen Solothurn, Winterthur und Duisburg
eine große Übersichtsschau ihres Werks. Am 16.
Januar 1975 wird Meret Oppenheim der Kunst-
preis der Stadt Basel verliehen. Sie hält eine viel
beachtete Rede, in welcher sie Stellung nimmt zum
Problem des „weiblichen Künstlers". 1981 erscheint
in der Edition Fanal, Basel, eine Publikation mit
Gedichten (1933-1957) und Serigraphien unter
dem Titel „Sansibar". 1982 erhält sie den Großen
Preis der Stadt Berlin und wird eingeladen, an der
documenta 7 in Kassel teilzunehmen. 1983 entste-
hen unter anderem zwei größere Werke, inspiriert
durch die Lektüre des Briefwechsels zwischen Betti-
na Brentano und Karoline von Günderode (1802-
1806). Das Goethe-Institut in Genua veranstaltet
eine Wanderausstellung mit Stationen in Mailand
und Neapel. In Bern wird auf dem Waisenhausplatz
eine Brunnenskulptur nach Entwürfen von M.O.
eingeweiht. Eine weitere Retrospektive findet 1984
in der Kunsthalle Bern und im ARC, Musée d'Art Moderne de la Ville de Paris
statt. Der Suhrkamp Verlag in Frankfurt/Main publiziert im selben Jahr die Ge-
dichte von Meret Oppenheim. 1985 arbeitet sie an einer Brunnenskulptur für die
„Jardins de l'ancienne école Polytechnique" in Paris. Am 15. November 1985
stirbt Meret Oppenheim in Basel, am Tag der Präsentation ihres Buchs „Caroline".

1 Vgl. Bice Curiger: Spuren durchstandener Freiheit, Zürich 1989 (1982).
2 Der Vater durfte als Deutscher in der Schweiz seinen Beruf als Arzt nicht ausüben.

Appendix – Anhang

Solo Exhibitions – Einzelausstellungen

1936	Galerie Schulthess, Basel
1952	Galerie d'Art Moderne, Basel
1956	A l'étoile Scellée, Paris
1957	Galerie Riehentor, Basel
1959	Galerie Riehentor, Basel
1960	Galleria Arturo Schwarz, Milan
	Casa Serodine, Ascona
1965	Galerie Gimpel und Hanover, Zurich
1967	Retrospective, Moderna Museet, Stockholm
1968	Galerie Krebs, Bern
1969	Galerie der Spiegel, Cologne
	Galleria La Medusa, Rome
	Editions Claude Givaudan, Paris
1970	Galleria Il Fauno, Turin
1971	Caché-Trouvé, Galerie Bonnier, Geneva
1972	Wilhelm-Lehmbruck-Museum, Duisburg
	Galerie d'Art Moderne, Basel
1973	Solitudes mariée, Galerie Bonnier, Geneva
1974	Galerie Renée Ziegler, Zurich
	Galerie Ziegler S.A., Geneva
	Galerie Müller, Stuttgart
	Jeux d'été, Galerie Arman Zerbib, Paris
1974-75	Museum der Stadt, Solothurn
	Kunstmuseum, Winterthur
	Wilhelm-Lehmbruck-Museum, Duisburg
1975	Galleria San Lucca, Bologna
	Galerie 57, Biel
1977	Galerie Elisabeth Kaufmann, Basel
	Galerie Loeb, Bern
	Galerie Nothelfer, Berlin
	Galerie Gerhild Grolitsch, Munich
	Galerie Boulakia, Paris
1978	Eugenia Cucalon Gallery, New York
	Galerie Levy, Hamburg
1979	Kunstverein Wolfsburg
1980	Galerie 57, Biel
	Marian Goodman Gallery, New York
1981	Galerie Edition Claude Givaudan, Geneva
	Galerie Nächst St. Stephan, Vienna
1982	Galerie Krinzinger, Innsbruck
	Kärtner Landesgalerie, Klagenfurt
	Salzburger Kunstverein, Salzburg
	Galleria Pieroni, Rome
	Akademie der Künste, Berlin
	Galerie Littmann, Basel
	Galerie Hans Huber, Bern
	Galerie Krebs, Bern
1983	Schloß Ebenrrain, Sissach
	Galerie Le Roi des Aulnes, Paris (Erlkönig)
1983-84	Goethe Institute: PalazzoBiancho, Genoa, Padiglione d'Arte
	Contemporanea, Milan, Museo Diego Aragona Pignatelli, Naples and Turin
1984	Nantenshi Gallery, Tokyo
	Kunsthalle, Bern
	ARC-Musée d'Art Moderne de la Ville de Paris
	Farideh Cadot, Paris
	Broida Museum, New York

1985	Galerie Susan Wyss, Zurich
	Galerie Oestermalm, Stockholm
	Galerie Beatrix Wilhelm, Stuttgart
	Kunstverein, Frankfurt
	Haus am Waldsee, Berlin
	Kunstverein, Munich
	Galerie Stemmle-Adler, Heidelberg
	Atelier Fanal, Basel
	Galerie Stahlberger, Weil am Rhein
1986	Kunsthalle, Winterthur
	Galleria Gamarra y Garrigues, Madrid
1987	Galerie Krebs, Bern
	Kunstmuseum, Bern
	Galerie Renée Ziegler, Zurich
1988	Kent Gallery, New York
1989	ICA, London
	Bilderstreit, Cologne
	Rooseum, Malmö
	Galerie des Bastions, Geneva
	Galerie Pudelko, Bonn
1990	Palau de la Virreina, ICA, Barcelona
1991	M.O. Masken, Freitagsgalerie Imhof, Solothurn
	Un moment agréable sur une planète, Centre Culturel Suisse, Paris
1993	Hommage á Meret Oppenheim, Galerie Schön + Nalepa, Berlin
1994	Aktionsforum Praterinsel, Munich
1995	Museo d'Arte, Mendrisio
	Galerie A. von Scholz, Berlin
	Kunstverein Ulm
1996/97	Meret Oppenheim. Beyond the teacup, Guggenheim Museum, New York
	Museum of Contemporary Art, Chicago, Illinois
	Bass Museum of Art Miami Beach, Florida
	Joslyn Art Museum, Omaha, Nebraska
	Galerie Hirschmann, Frankfurt
1997	Instituto Léones de Cultura Léon
	Meret Oppenheim. Eine andere Retrospektive, Galerie Krinzinger, Vienna
	Museum voor Moderne Kunst, Arnhem
	Upplands Konstmuseum, Uppland
	Helsinki City Art Museum, Helsinki

Catalogues of Solo Exhibitions – Kataloge von Einzelausstellungen

1956	Meret Oppenheim, Galerie A L'étoile scellée, Paris
1960	Meret Oppenheim, Galleria Schwarz, Mailand
1965	Meret Oppenheim, Galerie Gimpel & Hanover, Zürich
1967	Meret Oppenheim, Moderna Museet, Stockholm
1969	Meret Oppenheim (Prima mostra personale in Italia), Rom
	Galleria La Medusa, Rom
1970	Meret Oppenheim, Galleria Il Fauno, Turin
1971	Meret Oppenheim "Caché – Trouvé", Galerie Bonnier, Genf
1971/72	Meret Oppenhiem, Galerie d'art moderne (Suzanne Feigel), Basel
1973	Meret Oppenheim "Solitudes mariées", Dessins, Objets, Peintures 1930/1973,
	Galerie Suzanne Visat, Paris
1973/74	Meret Oppenheim, Galerie Renée Ziegler, Zürich
1974	Meret Oppenheim, Museum der Stadt Solothurn
	(anschließend in Winterthur, Kunstmuseum und in
	Duisburg, Wilhelm-Lehmbruck-Museum)
1978	Meret Oppenheim, Arbeiten von 1930-1978, Galerie Levy, Hamburg
1981	Meret Oppenheim, Disegni, Galleria Pieroni, Rom
1981	Meret Oppenheim, Galerie Nächst St. Stephan, Wien
	anschließend Galerie Krinzinger, Innsbruck, Kärtner Landesgalerie,
	Klagenfurt und Kunstverein Salzburg

1982	Meret Oppenheim, Arbeiten von 1930-1982, Galerie Orangerie-Reinz, Köln
	Meret Oppenheim, Pavillon d'Europe II, Mouvements dans l'Art Europeen
	Contemporain, Galerie de Séoul, Seoul
1983	Meret Oppenheim, Palazzo Biancho (Goethe-Institut), Genua
	anschl. in Mailand, Padiglione d'Art Contemporanea und in Neapel, Museo
	Diego Aragona Pignatelli
	Meret Oppenheim, Schloss Ebenrain, Sissach
1984	Meret Oppenheim, Kunsthalle, Bern
	Meret Oppenheim, ARC Musée d'art Moderne de la Ville de Paris, Paris
1985	Meret Oppenheim, Galerie Beatrix Wilhelm, Stuttgart
1987	Meret Oppenheim, Legat an das Kunstmuseum Bern, Bern
	Meret Oppenheim, "Zwei-Vier-Sechs-Acht and Forever", Galerie Levy, Hamburg
1988	Meret Oppenheim, Kent Fine Art Gallery, New York
1989	Meret Oppenheim, Institute of Contemporary Art, London, "Defiance in the
	Face of Freedom" (engl. Ausgabe der Monographie von Bice Curiger)
	Meret Oppenheim, Galerie Pudelko, Bonn
1990	Meret Oppenheim Retrospectiva, Palau de la Virreina, ICA, Barcelona
1991	Meret Oppenheim, "Un Moment Agréable sur une Planète", Centre Culturel Suisse, Paris
1993	Hommage à Meret Oppenheim, Galerie Schön + Nalepa, Berlin
1994	Meret Oppenheim, Aktionsforum Praterinsel, München
1995	Meret Oppenheim, Museo d'Arte, Mendrisio
1996	Meret Oppenheim: Beyond the teacup, Guggenheim Museum, New York
	Museum of Contemporary Art, Chicago
	Bass Museum of Art, Miami Beach, Florida
	Joslyn Art Museum, Omaha, Nebraska
1997	Meret Oppenheim. Eine andere Retrospektive, Galerie Krinzinger, Wien

Group Exhibitions – Gruppenausstellungen

1933	Salon des Surindépandants, Paris
1934	Surrealist Exhibition, Galerie des Quatre Chemins, Paris
1935	Kubisme = Surréalisme, The International Surrealist Exhibition,
	New Burlington Galleries, London
	Fantastic Art Dada Surrealism, Museum of Modern Art, New York
	Exposition Surréaliste d'objets, Galerie Charles Ratton, Paris
	Galerie Cahier d'Art, Paris
1938	Kunsthaus, Zurich
	Galerie Robert, Amsterdam
1939	Exhibition of Fantastic Furniture, Galerie René Drouin et Leo Castelli, Paris
1941	Ateliers Boesiger & Indermauer, Zurich
1942	Allianz, Kunsthaus, Zurich
	Julia Ris and Meret Oppenheim, Galerie d'Art Moderne, Basel
1944	Weihnachtsausstellung, Kunsthalle, Basel
1947	Galerie d'Art Moderne, Basel
	Konkrete, Abstrakte, Surrealistische Malerei in der Schweiz, Kunstverein,
	St. Gallen
	Allianz, Kunsthaus, Zurich
1948	Réalites Nouvelles No 2, Paris
	Parallèles, Galerie d'Art Moderne, Basel
1949	Réalites Nouvelles No 3, Paris
	Noir et Blanc, Kunsthaus, Zurich
1950	Gruppe 33, Galerie Kléber, Paris
1952	Phantastische Kunst des 20. Jahrhunderts, Kunsthalle, Bern
1953	20 Jahre Gruppe 33, Kunsthalle, Basel
1956	Nationale Kunstausstellung, Mustermesse, Basel
	Antikunst-Ausstellung, Theater der unteren Stadt, Basel
1957	Die Zeichnung im Schaffen jüngerer Schweizer Maler und Bildhauer,
	Kunsthalle, Bern
	Galerie Iris Clert, Paris – Rome
1959	Exposition InteRnatiOnale du Surréalisme, Galerie Daniel Cordier, Paris
1960	d'Arcy Gallery, New York

	Weihnachtsausstellung, Thunerhof, Thun
	Atelier Riehentor, Basel
	Il Canale, Venice
	Studio d'Arte Contemporanea Rusconi, Venice
1961	Galerie Riehentor, Basel
	Galleria Arturo Schwarz, Milan
	Anti-Processo 3, Galleria Brera, Milan
	The Art of Assemblage, The Museum of Moderne Art, New York
	Der Surrealismus und verwandte Strömungen in der Schweiz, Thunerhof, Thun
	Künstler aus Thun, Städtisches Museum, Brunswick
1962	Galleria Bevilacqua, Venice
	Galerie Riehentor, Basel
	L'Objet, Musée des Arts Décoratifs, Paris
	Weihnachtsausstellung, Basel
	Collages et Objets, Galerie du Cercle, Paris
1963	La Boîte, Galerie Henriette Le Gendre, Paris
	Galerie Kornfeld & Klipstein, Bern
	Gruppe 33, Kunsthalle, Basel
1964	Galerie Handschin, Basel
	25 Bernr und Bieler Künstler, Städtische Galerie, Biel
	Phantastische Kunst, Galerie Obere Zäune, Zurich
	Le Surréalisme, Sources - Histoire - Affinités, Galerie Charpentier, Paris
1965	Weihnachtsausstellung, Thun
	Surrealismo e arte fantastica, Sao Paulo
	Aspekte des Surrealismus 1924. 1965, Galerie d'Art Moderne, Basel
	Weihnachtsausstellung, Kunsthalle, Basel
1966	Museo de arte moderna, Rio de Janeiro
	Cordier-Ekström Gallery, New York
	Dorothée Hofmann, Meret Oppenheim, K.R.K. Sonderborg, Galerie Handschin, Basel
	Bernr Künstler, Berner Galerie, Bern
	Meret Oppenheim und Peter von Wattenwyl, Berner Galerie, Bern
	Games without Rules, Fischbach Gallery, New York
	Gewerbemuseum, Bern
	Salon de Mai, Musée d'Art Moderne, Paris
	165 tableaux du Salon de Mai, Skopje, Belgrad
	Zeichnungen schweizer Künstler, Kunstverein, Solothurn
	Weihnachtsausstellung, Thunerhof, Thun
	Phantastische Kunst - Surrealismus, Kunsthalle, Bern
	Kunstmuseum, Basel
	Le Surréalisme, Tel Aviv
	Berner Künstler auf der Lueg, Bern
	Chess Foundation von Marcel Duchamp, New York
1967	Chair Fun, organized by the Schweizerische Werkbund, Bern
	Fetisch-Formen, Haus am Waldsee, Berlin, Städtisches Museum, Leverkusen
	Salon de Mayo, Havana
	Aspekte, Sissach, Schloss Ebenrain
	Weihnachtsausstellung bernischer Maler und Bildhauer, Kunsthalle, Bern,
	Helmhaus, Zurich
	Sammlung Marguerite Arp-Hagenbach, Kunstmuseum, Basel
	Weihnachtsausstellung, Thunerhof, Thun
1968	Horizonte 2, Galerie Gimpel und Hanover, Zurich
	Salon de Mai, Musée d'Art Moderne, Paris
	The Obsessive Image 1960-1968, Carlton House Terrace, London
	Dada, Surrealism and Their Heritage, Museum of Modern Art, New York
	Berner Galerie, Bern
	Trésors du Surréalisme, Casino, Knokke
1969	Salon de Mai, Musée d'Art Moderne, Paris
	Napoléon 1969, Landesmuseum, Schloss Gottorf, Schleswig
	Vier Freunde, Kunsthalle, Bern, Kunsthalle, Düsseldorf
	Surrealismus in Europa, Baukunst-Galerie, Cologne
	650 Minis, Galerie Krebs, Bern
	Weihnachtsausstellung, Kunsthalle, Basel

1970	5. Schweizerische Plastikausstellung, Biel
	Berner Galerie, Bern
	Surrealism, Moderna Museet, Stockholm; Konsthall, Göteborg
	Museum, Sundsvall; Museum, Malmö; Kunsthalle, Nuremberg
	Das Ding als Objekt, Museum, Oslo
1971	11 Schweizer, Galerie Vontobel, Feldmeilen
	Salon de Mai, Musée d'Art Moderne, Paris
	Métamorphoses de l'objet, Palais des Beaux-Arts, Brussels
	Rotterdam – Berlin – Milan
	Multiples, Kunstgewerbeschule, Basel
	Sturmkonstnärer och Schweizisk Kukonst, Museum, Landskrona
	Ich mich, Berner Galerie, Bern
	Baukunst, Der Geist des Surrealismus, Cologne
	9 Schweizer Künstler, Galerie S-Press, Hattingen
	Galerie Alphonse Chave, Vence
	Alfred Hofkunst, Meret Oppenheim, Peter von Wattenwyl, Galerie Krebs, Bern
1972	Art Suisse contemporain, Bochum, Tel Aviv
	Artistes Suisses contemporains, Grand Palais, Paris
	Le Surréalisme 1922-1942, Musée des Arts Décoratifs, Paris
	Die andere Realität, Kunstmuseum, Bern
	Berner Galerie, Bern
	Schweizer Zeichnungen im 20. Jahrhundert, Staatliche Graphische
	Sammlung, Munich;
	Kunstmuseum, Winterthur; Kunstmuseum, Bern; Musée Rath, Geneva
	Der Surrealismus, Haus der Kunst, Munich and Musée des Art Décoratifs, Paris
	Gchribelet + Gchrizelet, Galerie 57, Biel
	La table de Diane, Galerie Cristofle, Paris
	31 artistes Suisses, Grand Palais, Paris
	Salon de Mai, Paris
	Profile X, Schweizer Kunst Heute, Museum, Bochum
	L'estampe et le surréalisme, Galerie Vision Nouvelle, Paris
1973	Galerie Krebs, Bern
	Art Boxes, Kunsthandel Brinkmann, Amsterdam
	Les Masques, Galerie Germain, Paris
	Tell 73, Zurich – Basel – Lugano – Bern – Lausanne
	Weisser Saal, Bern
	Galerie Fred Lanzenberg, Brussels
	Moderne Schweizer Künstler, Warsaw
	Katakombe, Idole, Basel
1974	Micro-Salon, Galerie Christofle, Paris
	Lapopie, Galerie Francoise Tournier, Château de Saint-Cirq
	Aspects du Surréalisme, Galerie Francoise Tournier, Paris
	Moderne Schweizer Künstler, Budapest - Bucharest
	Accrochage, Galerie Luise Krohn, Badenweiler
	Salon de Mai, Paris
1975	Magna – Feminismus und Kreativität, Galerie Nächst St. Stephan, Vienna
	Machines Célibataires, Edition 999, Düsseldorf; Bern-Venice-Brussels-
	Le Creusot-Paris-Malmö-Amsterdam-Vienna
	Siège-Poème, Paris-Créteil-Montreal, Quebec; Weisser Saal, Bern
	Aspekte aus neuen Solothurner Sammlungen, Museum der Stadt, Solothurn
1976	Studio du Passagé, Brussels; Fondation Maeght, St. Paul-de- Vence
	Daily Bul & Co., Musèe d'Art Moderne, Paris; Neue Galerie, Aix-La Chapelle
	Graphik, Berner Galerie, Bern; Galerie Loeb, Bern
	Collages, Galerie Krebs, Bern
	Galerie Stevenson & Palluel, Paris
	Demeures d'Hypnos, Galerie Lucie Weill, Paris
	Boîtes, Galerie Brinkmann, Amsterdam; Galerie 57, Biel
	Tatort Bern, Bochum
	Objekte - Subjekte, Galerie Aktuell, Bern
	DIN A4, Galerie Aktuell, Bern
	Hommage à Adolf Wölfli, Kunstmuseum, Bern
	Musée d'Art, Rennes

	La boîte, Musèe d'Art Moderne, Paris
	Landschaft, Galerie Krebs, Bern
1977	Galerie Lara Vincy, Agence Argilia-Presse, Paris
	Orangerie, Berlin-Charlottenburg
	Künstlerinnen International, Kunstverein, Frankfurt a.M.
1978	Dada and Surrealism, Hayward Gallery, London
	Imagination 78, Museum, Bochum, Germany
1979	Berner Galerien und ihre Sammler, Kunstmuseum, Bern
	Galerie Krebs, Bern
	Das Schubladenmuseum, Kunstmuseum, Bern
1980	L'Altra Metà dell'Avanguardia 1910-40, Milan-Rome -Stockholm
	Maitres du XXe Siecle, ARTCURIAL, Paris
	FARBER, Bruxelles
1981	Permanance du regard Surréaliste, ELAC, Lyon
1982	Pavillon d'Europe, Galerie de Seoul, Korea
	documenta 7, Kassel
	Kunsthalle, Bern
	Dessins fantastiques, Galerie S. Steiner, Bern
	ARTEDER '82, Bilbao
1983	Reine Fabiola, Brussels
	Edition Claude Givaudan at ASHER/FAURE, Los Angeles
1985	Akademie der Künste, Berlin
	Meret Oppenheim/Mariann Grunder, Nola – Naples
	Galerie Krebs, Bern
	Festival se l'Erotisme, Paris
	Galerie Michele Zeller, Bern
1986	Collagen, Zuger Kunstgesellschaft, Zug
	Biennale, Venice
	Centre Georges Pompidou, Paris
1986-88	The Success of Failure, USA
1987	Museum Moderner Kunst, Vienna
	Musée des Beaux Arts, Lausanne
	Gallerie Dabbeni, Lugano
	Galerie Beyeler, Basel
1988	Exhibition of jewelry by Jean Arp, Max Ernst, Meret Oppenheim, Man Ray, Lugano
1989	4. Triennale, Lausanne and Fellbach
1991	Anxious Visions - Surrealist Art, University Art Museum, Berkeley
1992	Al(L) Ready Made, Net Kruithuis, 's Hertogenbosch
	Man Ray - Meret Oppenheim, Paintings and Works on Paper, Kent Gallery, New York
	Galleria Martini & Ronchetti, Genoa
	Sonderfall? Die Schweiz zwischen Réduit und Europa, Steinen, Schulzentrum;
	Schweizerisches Landesmuseum, Zurich
1993	The Return of the Cadavre Exquis, The Drawing Center, New York
1994	Die Erfindung der Natur, Museum Sprengel, Hannover
	Badischer Kunstverein, Karlsruhe
	Rupertinum, Salzburg
	Meret Oppenheim und ihre Freunde zum 80. Geburtstag, Galerie Renée Ziegler, Zurich
1994-95	Worlds in a Box, The South Bank Centre, London; City Arts Centre, Edinburgh
	Graves Art Gallery, Sheffield; Sainsbury Centre, Norwich
	Whitechappel Art Gallery, London
1997	ART/FASHION, Guggenheim Museum, New York

Publications by Meret Oppenheim – Publikationen von Meret Oppenheim

1954/55	Gedichte und Illustrationen für Carl Lazlos "La lune en rodage" Basel
1954	"Selle de bicyclette couverte d'abeilles" (Document communiqué par Meret Oppenheim), in: Médium, Hg. André Breton, Neue Serie, Nr. 3, Mai 1954, S. 49
1957	Fotoreproduktion des "Cahier d'une écolière" von 1930, in: Le surréalisme, même, Nr. 2, Frühjahr, S. 80/81. Im selben Heft, S. 2: Porträtfoto mit kleinem

Text über die Künstlerin.

1957 Enquêtes (über ein Bild von Gabriel Max und ein anonymes Gemälde), in: Le surréalisme, même, Nr. 3, Herbst, Paris, S. 77 und 82

1959 Enquêtes (le Striptease), in: Le surréalisme, même, Nr. 5, Frühjahr, Paris, S. 58 (Fragen dazu befinden sich in Heft Nr.4, 1958, S. 56f.)

1959 Monotypie (Handabdruck), Beilage in: hortulus, Illusttrierte Zweimonatsschrift für neue Dichtung, Hg. Hans-Rudolf Hilty, Heft 40, August

1966 A Portfolio, in: The Paris Review, Nr. 36, Winter 1966, S. 81-90 Meret Oppenheim spricht Meret Oppenheim, "Man könnte sagen, etwas stimmer nicht" – Gedichte 1933-1969, S-Press-Tonband, Köln (2. Auflage 1986)

1974 The Tinguely-Objekt, in: Leonardo Bezzola, Jean Tinguely, Zürich 1974, S. 187

1975 Rede anläßlich der Übergabe des Kunstpreises der Stadt Basel 1974, am 16.1.1975. Erstmalig abgedruckt in: Kunst-Bulletin des Schweizerischen Kunstvereins, 8. Jg., Nr. 2, Februar 1975, S. 1-3. (Auch in: Bice Curiger(Hg.), Meret Oppenheim, Zürich, 1989, S. 130f. Und in: Orte, Schweizer Literaturzeitschrift, 29, Juli/August 1980, S. 36ff.)

1976 Entretien avec Danièle Boone, in: L'Humidité, Nr. 23, Paris, Herbst 1986, S. 26.27

1977 Weibliche Kunst, in: Die Schwarze Botin, Nr. 4, Juli 1977, Berlin, s: 35f. (Auch in: Tageszeitung, Berlin, 19. März 1982)

1977 Wie eine Maske (Leserbrief zu einer Rezension von Ernst Bornemanns Buch "Abtreibung der Frauenfrage") in: Weltwoche, Zürich, 6. April (Auf Italienisch in: Kat. Meret Oppenheim, Genua 1983, Palazzo Biancho, S. 112f.)

1978 Es gibt keine "weibliche Kunst", in: Brückenbauer (Wochenblatt des sozialen Kapitals, Organ des Migros-Genossenschafts-Bundes), Nr. 4, 27. Januar 1978, Zürich

1980 Überlegung zur Kunst auf öffentlichen Plätzen, in: Kat. Bern, 6. Berner Kunstausstellung in Zusammenarbeit mir der GSMBA-Sektion Bern, Kunsthalle, o.S.

1980 Gedichte, in: Orte, Schweizer Literaturzeitschrift, 29, Juli/August 1980, S. 19-33

1980 Io, Meret. (Rede Basel 1975, "Selbstporträt seit 60.000 v. Chr. Bis X" in italienisch), in: (Bolaffi-) Arte, Nr. 103, 1980, S. 44-48

1981 Sansibar, 16 Gedichte und Serigraphien, Atelier Fanal, Basel 1981

1982 Mit Lys Wiedmer-Zingg "Mir Fraue", in: Schweizer Frauenblatt, März

1982/89 Gedichte von Meret Oppenheim, in: Hg. Bice Curiger, Meret Oppenheim, Zürich, 1989, S. 110-113

1983 A Projekt by Meret Oppenheim (Drei Zeichnungen) in: Artforum, New York, Oktober, S. 47-50

1984 Husch, husch, der schönste Vokal entleert sich. Gedichte, Zeichnungen, Hg. Christiane Meyer-Thoss, Frankfurt a.M. 1984

1984 Caroline, 23 Gedichte, 21 farbige Radierungen, 2 Prägedrucke, Atelier Fanal, Basel 1984

1984 Kunst kann nur in der Stille entstehen, Gespräch mit Werner Krüger, in: Documenta. Künstler im Gespräch, Köln, 1984

1984 Das Ende kann nur der Anfang sein, in: Kunst und Wissenschaft, Hg. Paul Feyerabend und Christian Thomas, Zürich 1984, S. 243-250

1984 Meret Oppenheim. Aus einem Gespräch mit Walo von Fellenberg, Francois Grundbacher und Jean-Hubert Martin, in: Kat. Meret Oppenheim, Bern 1984, Kunsthalle, S. 13-16

1985 Meret Oppenheim: Texte, Zeichnungen und ein Handschuh für Parkett, in: Parkett Nr. 4, 1985, S. 46-49

1985 "Caroline. Gedichte und Radierungen von Meret Oppenheim", Edition Fanal, Basel

1986 Aufzeichnungen 1928-1985. Träume, Hg. Christiane Meyer-Thoss, Bern/Berlin 1986

1987 Kaspar Hauser oder Die Goldene Freiheit. Textvorlage für ein Drehbuch, Bern/Berlin 1987

1987 Theonanacatle-Psilosibin-Cy. (4 Tabletten). Persönliches Protokoll des Rauschmittel-Versuchs vom 10.4.1965, in: Kat. Meret Oppenheim, Kunstmuseum Bern 1987, S. 82-89

1987 Gedichte, in: Eau de Cologne, Monika Sprüth Galerie, Köln, Nr. 2, S. 4-9

Bibliography – Bibliographie

„Allianz" (Hg.): Almanach neuer Kunst in der Schweiz, Vereinigung moderner Schweizer Künstler, Zürich 1940

Ammann, Jean-Christophe: Für Meret Oppenheim, in: Bice Curiger, Meret Oppenheim, Zürich 1989, S. 116f

Ders.: Liebe Meret, in: Basler Zeitung, 16.11.1985

Amodel-Mebel, A.: Meret Oppenheim, Diss., Rom 1884-85

Arici, Laura: Der Hermaphroditische Engel. „Imago" ein Film über Meret Oppenheim, in:
 Neue Zürcher Zeitung, 16.12.1988

Dies.: Meret Oppenheim als Graphikerin, in: Neue Zürcher Zeitung, 21.3.1988

Auffermann, Verena: Neue Kleider für neue Ideen. Die Meret Oppenheim, Retrospektive im
 Kunstverein, in: Frankfurter Rundschau, 3.1.1984

Dies.: Liebe zum Skandal als Liebe zur Freiheit. Meret Oppenheim – eine Künstlerische Sphinx, in:
 Westermanns Monatshefte, Jan. 1985, S. 112ff

Auregli, Dede: Oppenheim, il sogno delle cose, in: L'Unià, 21.11.1985

Baatsch Henri-Alexis: Entretien entre Meret Oppenheim et Henri-Alexis Baatsch, in: Kat. Meret
 Oppenheim, Seoul 1982, o.S.

Barletta, Riccardo: Oppenheim. Più fine di Duchamp, in: Corriere della sera, 12.10.1983

Barr, Alfred H.: Fantastic Art Dada Surrealism, The Museum of Moderne Art, New York 1936

Baumer, Dorothea: Poetisches von einer Rebellin, in: Süddeutsche Zeitung, 1.7.1985

Baumgartner, Marcel: L'Art pour l'Art. Bernische Kunst im 20. Jahrhundert, Bern 1984

Belton, Robert J.: Androgyny: Interview with Meret Oppenheim, in: Mary Ann Caws u.a. (Hg.),
 Surrealism and Women, London 1991, S. 63-75

Besio, Armando: Meret Oppenheim, 70 anni portati bene, in: (Bolaffi-)Arte, Mailang, Nr. 134, Okt. 1983, S. 22

Bezzola, Leonardo: Objekte von Meret Oppenheim. Photographie, in: Werk Nr. 4, Zürich 1971

Billeter, Erika: Eine Säge wird Vogel, in Züri Leu, 23.11.1973

Billeter, Fritz: Wie leicht, wie schwer fiel ihr dies Leben, in: Tages-Anzeiger, Zürich, 16.11.1985

Bischof, Rita: Das Geistige in der Kunst von Meret Oppenheim, Rede anlässlich der Trauerfeier am
 20. Nov. 1985 (Privatdruck), o.S.

Dies.: Formen poetischer Abstraktion im Werk von Meret Oppenheim, in: Konkursbuch 20,
 Das Sexuelle, die Frauen und die Kunst, o.J., S. 39ff

Boone, Danièle: Meret Oppenheim (Entretien), in:L'humidité, 1976

Borrini, Catherine-France: Les folies Oppenheim, in:L'Hebdo, 13.9.1984

Breton, André: Magie quotidienne, La tour Saint Jacques, Nov./Dez. 1955

Ders., Paul Eluard, Man Ray: Meret Oppenheim, Editions de Cahiers d'Arts, Paris 1934

Bürgi, Christoph A.: Freuen wir uns, dass sie gelebt hat. Rede anlässlich der Trauerfeier zum Tod von
 Meret Oppenheim am 20. Nov. 1985 in Basel, (Privatdruck), o.S.

Burckhardt, Jacqueline: Vokale und Bilder im Zauber der Reize, in Parkett, Nr. 4, 198, S. 22-23

Burri, Peter: Freiheit wird nicht gegeben, man muß sie nehmen, in: Die Weltwoche, Nr. 47, 21.11.1985

Butler, Sheila: Psychoanalysis, Ageny and Androgyny, Diplomarbeit, Univ. Of Western Ontario,
 London, Ontario, 1993

Calas, Nicolas: Meret Oppenheim: Confrontations, in: Artforum, Nr. 10, Sommer 1978, S. 24f

Calzolari, Ginestra: Se „Man Ray dipinge per essere amato" Meret Oppenheim dipinge per amare e
 essere amata, in: Acrobat Mime Parfait, Nr. 1, 1981

Cameron, Dan: What is Contemporary Art?, in: Kat. Rooseum, Malmö, Schweden 1989

Casciani, Stefano: Diviano occidentale-orientale, in: Domus, Nr. 645, Dez. 1983, S. 42-50

Catoir, Barbara: Der Geruch, Das Geräusch, Die Zeit. Zu den Gedichten von Meret Oppenheim, in: Akzente,
 Zeitschrift für Literatur, Heft 1, Feb. 1975, S. 78-80

Chadwick, Whitney: Women Artist and the Surrealist Movement, Boston 1963

Christ, Dorothea: Die Übergabe des Basler Kunstpreises an Meret Oppenheim, in: Kunst-Bulletin,
 Februar 1975

Corà, Bruno: M.O. – quando l'artista è musa di se stessa, in: Napoli Oggi, 12.4.1984

Curiger, Bice: Meret Oppenheim „Ich bin noch kein Denkmal", in: Tagesanzeiger Zürich, 16. Sept. 1983

Dies.: Trauerrede für Meret Oppenheim anläßlich der Trauerfeier am 20. Nov. 1985 (Privatdruck), o.S.
 (unter dem Titel „Abschied von Meret Oppenheim" abgedruckt in Emma, Nr. 1, 1986, S. 6)

Dies.: Una storia cominciata con alcune foto di Man Ray e una coalizione in Pellicia, in:
 Bolaffiarte, Nr. 103, 1980

Dies.: Ein Werk voller Offenbarungen und Geheimnisse, in: Tages-Anzeiger, 18.3.1982
 „Curiger 1989" = Bice Curiger: Meret Oppenheim, Spuren durchstandener Freiheit. Darin:
 Werkverzeichnis bearbeitet von Dominique Bürgi, Zürich, 1989 (1982, 1984)

Dies.: Meret Oppenheim: Tracce di una libertà sofferta, con indice delle opere di Meret Oppenheim
 e Dominique Bürgi, Lugano 1995

D'Amico, Fabrizio: Brillano le lacrime di Meret, in: La Repubblica, 28.2.1982

Ders.: Quando una tazza indossa la pelliccia, in: La Repubblica, 14.10.1983

Ditzen, Lore: Die Dame mit der Pelztasse. Eine Begegnung mit Meret Oppenheim, in:
Süddeutsche Zeitung, Nr. 72, 27./28. März 1982, S. 15

Du, Zeitschrift für Kunst und Kultur, Heft 2/1986, Thema Basel, „Gesichter" (Fotoporträts von Meret
Oppenheim, und Christian Vogt, S. 62-69)

Ernst, Max: Meret Oppenheim, Text auf Einladungskarte zu ihrer Ausstellung in der Galerie Schulthess,
Basel 1936, reproduziert u.a. in: Bice Curiger, Meret Oppenheim, Zürich 1989, S. 29

Export, Valie: Mögliche Fragen an Meret Oppenheim (Briefinterview) in: Kat. Wien 1975, Feminismus,
Kunst und Kreativität, Galerie nächst St. Stephan, S. 4-6

Faeh, Gabi: Meret Oppenheim, Es ist eine Frechheit, alt zu werden (Fotobericht über das Haus der Familie
von Meret Oppenheim in Carona), in: Ideales Heim, Das Schweizer Wohnmagazin, März 1986, S. 30-37

Florence, Penny, Dee Reynolds: Feminist Subjects Multi Media, Manchester University Press, 1995

Feugas, Jean-Claude de: Conversation avec Meret Oppenheim, in: Créatis, La photographie au présent,
Nr. 5, 1977, Paris, o.S.

Frey, Patrick: Die Antilope mit Sonne auf dem Rücken, in: Die Wochenzeitung, Nr.36, 7.9.1984

Frossard, Denise: Meret Oppenheim, L'espiègel de la conscience, in: „Voir", Lettres, arts,spectacles,
Nr. 26, Jan. 1986, S. 36f

Gachnang, Johannes: „Verwandlung schmerzt, Veränderung ergötzt, Veredelung langweilt" (Meret
Oppenheim) und für Meret Oppenheim, in: Ders., Reisebilder, Berichte zur zeitgenössischen Kunst,
Hg. Troels Andersen, Wien 1985, S. 24-30 und 162f

Ders.: Für Meret Oppenheim – Ein letzter Gruß, Rede zur Trauerfeier am 20. Nov. 1985 in Basel
(Privatdruck), o.S.

Gauville, Hervé: Meret Oppenheim meurt en Suisse, in: Libération, 18.11.1985

Gensicke, Andrea: Meret Oppenheim. Die surrealistische Künstlerin, unveröffentlichte Seminararbeit,
Universität München, 1986

Gianelli, Ida: Intervista a Meret Oppenheim, in: Kat. Meret Oppenheim, Genua 1983, Palazzo
Biancho, S. 114-119

Gibson, Michael: The Fantasy and Wit of Meret Oppenheim, in: International Herald Tribune, 24./25.11.1984

Glaesmer, Jürgen: Meret Oppenheim. Rede anlässlich der Übergabefeier des
Kunstpreises des Stadt Basel, in Kat. Galerie Levy, Hamburg 1978

Glozer, Laszlo: Schöne Respektlosigkeit, in: Süddeutscher Zeitung, 19.10.1977

Großkopf, Annegret: Die eigenwillige Lady, in: Stern, Nov. 1982, S. 160-178

Grut, Mario: Madame! Har ni nonsin durckitur den här pälsen?, in: Vecko Journalen, 28.4.1967

Häsli, Richard: Fährtenleserin des Unbewußten. Meret Oppenheim zum 70. Geburtstag, in:
Neue Zürcher Zeitung, 6.10.1983

Ders.: Auf den Spuren des Unbewussten, in: Neue Zürcher Zeitung, 16./17.11.1985

Hecht, Axel: Ideenblitze vom poetischen Irrlicht, in : art. Kunstmagazin, Juni 1982

Heissenbüttel, Helmut: Kleiner Klappentext für Meret Oppenheim, in: Kat. Meret Oppenheim,
Solothurn 1974, Museum der Stadt, o.S.

Ders.: Großer Klappentext für Meret Oppenheim, in: Bice Curiger, Meret Oppenheim, Zürich 1989, S. 126-128

Helfenstein, Josef: Androgynität als Bildthema und Persönlichkeitsmodell. Zu einem Grundmotiv im
Werk von Meret Oppenheim, in: Kat. Meret Oppenheim, Bern 1987, Kunstmuseum, S. 13-30

Ders.: Meret Oppenheim und der Surrealismus, Stuttgart 1993

Helmot, Christa von: Die Zeit ist ihre treue Verbündete, in: Frankfurter Allgemeine Zeitung, 3.1.1985

Henry, Maurice: Meret Oppenheim, in: Antologia grafica del Surrealismo, Album 3, Mailand 1972, S. 188-195

Henry, Ruth: Interview mit Meret Oppenheim, in: Du, Die Kunstzeitschrift, 10/1983, S.82-84

Dies.: Träume vom Kosmos, in: Publik, 14.2.1969

Hofmann, Werner: Laudatio auf Meret Oppenheim, in: Kunstpreis Berlin, Akademie der Künste, 1982, S. 7f

Hollenstein, Roman: Auf der Suche nach dem Ideal der Kunst, in: Neue Zürcher Zeitung, Nr. 210, 2.9.1984

Huber, Jörg: Man muß sich die Freiheit nehmen, in: Der schweizerische Beobachter, Nr. 12, 1987

Hubert, Renée Riese: From Déjeuner en fourrure to Caroline: Meret Oppenheim's Chronicle of
Surrealism, in: Mary Ann Caws u.a. (Hg.), Surrealism and Women, London 1991, S. 37-49

Isler, Ursula: Mit der Kraft der Stille, in: Neue Zürcher Zeitung, 27.3.1982, S. 47

Dies.: Meret Oppenheim, in: Neue Zürcher Zeitung, 4.12.1973

Jouffroy, Alan: Meret Oppenheim, in: Opus international (Surrealismus-Heft), 19/20, Okt. 1970, S. 112-114

Ders.: 23 questions à Meret Oppenheim, 1973, unveröffentl. Manuskript, Kunstwissenschaftliches
Institut Zürich

Ders.: A l'improviste, in: Bice Curiger, Meret Oppenheim, Zürich 1989, S. 119 (zuerst auf der
Einladungskarte zur Meret Oppenheim-Ausstellung in der Galerie Suzanne Visat, Paris 1973)

Kamber, André u.a.: Vorwort im Kat. Meret Oppenheim, Solothurn 1974, Museum der Stadt, o.S.

Ders.: Eröffnungsrede anlässlich der Ausstellung in Wien 1981, veröffentlicht in: Kat. Meret Oppenheim,
Hamburg 1987, Galerie Levy, o.S.

Keller, Renate: ... und lasst die Wände los. Ein offener Brief an Meret Oppenheim, in: Jahresbericht
 Kunstverein Winterthur, 55, 1975, S. 35-43
Kipphoff, Petra: Kunst ist Interpretation. Zeit-Gespräch mit Meret Oppenheim, in: Die Zeit,
 Nr. 47, 19.11.1982
Dies.: Zauberin in den Lagunen. Zum Tod von Meret Oppenheim, in: Die Zeit, 22.11.1985
Klüver, A., J. Martin: Kiki's Paris, New York, 1989
Liebmann, Lisa: Progress of the Enigma, in: Bice Curiger, Meret Oppenheim, Defiance in the Face
 of Freedom, London 1989, S. 126-128
Lüscher, Helen: Meret Oppenheim, in: Kunst Nachrichten, Nr. 5, 1970, o.S.
Martin, Jean-Hubert: Vorwort, in: Kat. Meret Oppenheim, Bern 1984, Kunsthalle, S.3f
Mathews, Henry: Meret Oppenheim, in: The Paris Review, Nr. 36, Paris 1950
Mendini, Alessandro: Cara Meret Oppenheim, in: Domus, Nr. 605, 1980, S. 1
Meyer-Thoss, Christiane: Wer Heu im Arm hat, darf es verspeisen! Zu den Gedichten von Meret Oppenheim,
 in: Bice Curiger, Meret Oppenheim, Zürich 1989, S. 114f
Dies.: Insgeheim. Insgesamt. Nachwort in: Meret Oppenheim, Husch, husch, der schönste Vokal entleert
 sich ..., Frankfurt a. M. 1984, S. 109-124 (Auch abgedruckt in: Eau de Cologne (Monika Sprüth
 Galerie, Köln), Nr.2, 1987, S.7f)
Dies.: Poesie am Werk, in: Parkett, Nr. 4, 1985, S. 34-35
Dies.: Protokoll der Gespräche mit Meret Oppenheim über den Briefwechsel zwischen Bettine Brentano und
 Karoline von Günderode, in, Kat. Bilderstreit, Köln 1989, S. 195-208
Dies. (Hg.): Meret Oppenheim. Buch der Ideen. Frühe Zeichnungen, Skizzen und Entwürfe für Mode,
 Schmuck und Design, Bern 1996
Monteil, Annemarie: Träume zeigen an, wo man steht, in: National-Zeitung Basel, Nr. 325, 18.10.1974
Dies.: Meret Oppenheim, in: Kunst und Frau, Club Hrotsvit, Sonderheft, Schweizer. Verein für künstlerische
 Tätigkeit, Luzern 1975, S. 45-48
Dies.: Meret Oppenheim: Die Idee mit dem Brunnen, in: Du, Die Kunstzeitschrift, Nr. 10 , 1980, S. 68f
Dies.: Meret Oppenheim. Die Weisheit aus dem Federverlies, in: Künstler, Kritisches Lexikon der
 Gegenwartskunst, München 1988
Dies.: Die alte Schlange Natur, in: Weltwoche, 9.10.1974
Moos-Kaminski, Gisela von: Meret Oppenheim, in: Artefactum, Feb./März 1985
Morgan, Stuart: Meret Oppenheim. An Essay, London 1989 (Text zusammen mit 16 Postkarten von Meret
 Oppenheim in einem Samtetui, erschienen anlässlich der Ausstellung im ICA London)
Morschel, Jürgen: Meret Oppenheim – die Dame mit der Pelztasse, in: Kunstforum, Nr. 10, 1974, S. 162-170
Orenstein, Gloria: Meret Oppenheim, in: Obliques, Nr. 14/15, o.J., S. 193-199
Pagé, Suzanne/Parent, Béatrice: Interview de Meret Oppenheim, in: Kat. Meret Oppenheim, Paris 1984,
 Musée d'art Moderne de la Ville, S. 11-22
Picon, Gaetan: Der Surrealismus in Wort und Bild, Genf 1976
Platschek, Hans: Zur Meret Oppenheim Ausstellung in der Galerie Levy, Hamburg, in: Das Kunstwerk,
 Okt. 1978, S. 63f
Prerost, Irene: Eine junge alte Dame, in: Schweizer Illustrierte Zeitung, 3.9.1984
Radziewsky, Elke von: Die Schliche des David (Zur Ausstellung „Zimmersskulptur" in Berlin) in: Die Zeit,
 Nr. 13, 24.3.1989, S. 73
Reuterswärd, Carl F.: Le Cas Meret Oppenheim, in: Kat. Meret Oppenheim, Stockholm 1967,
 Moderna Museet, o.S.
Rotzler, Willy: Objekt-Kunst, von Duchamp bis Kienholz, Köln 1972
Salerno, Giovan Battista: Una tazzina di cafè in pelliccia dall'incantevole Meret Oppenheim, in:
 Manifesto, 2.2.1982
Sauré, Wolfgang: Rezension der Meret Oppenheim-Ausstellung in der Galerie Bulakia, Paris, in:
 Das Kunstwerk, Feb. 1978, S. 44f
Schierle, Barbara: „Die Freiheit muß man nehmen", in: Tip, Nr. 8, April 1982
Schlocker, Georges: Sie ist doch längst über die Pelztasse hinaus, in: Saarbrücker Zeitung, 18.3.1982
Schloss, Edith: Galleries in Rome, in: International Herald Tribune, 16./17.1.1982
Schmidt, Doris: Auf andern Sternen weiterleben ... Nachruf für Meret Oppenheim, in: Süddeutsche Zeitung,
 München, 16./17.11. 1985
Schmitz, Rudolf: Meret Oppenheim im Gespräch mit Rudolf Schmitz, in: Wolkenkratzer Art Journal, Nr. 5,
 Nov./Dez. 1984, S. 108f
Ders. Und Meyer-Thoss, Christiane: Landschaft aus „Titan" (Zeichnung von 1974), in: Bice Curiger, Meret
 Oppenheim, Zürich 1989, S. 121
Schneede, Uwe W.: Malerei des Surrealismis, Köln 1973
Schuhmann, Sarah: Fragen und Assoziationen zu den Arbeiten von Meret Oppenheim, in: Kat. Berlin 1977,
 Künstlerinnen International 1877–1977, S. 72-79
Schulz, Isabel: Qui êtes-vous? Who are you? Wer sind Sie? Gedanken zu den Selbstporträts von Meret

Oppenheim, in: Kat. Meret Oppenheim, Bern 1987, Kunstmuseum, S. 53-66

Dies.: Edelfuchs im Morgenrot, Studien zum Werk von Meret Oppenheim, München 1993

Sello, Gottfried: Meret Oppenheim, in: Brigitte, Nr. 4, 1980

Smith, Roberta: Meret Oppenheim, in: The New York Times, 18.3.1988

Strasse, Catharine: Entretien avec Meret Oppenheim, in: Arte Factum, Zeitschrift für aktuelle Kunst in Europa, Nr. 7, Feb./März 1985, S.16-19

Stobl, Ingrid: Meret Oppenheim: Die Schöne und das Biest, in: Emma Nr. 7, 1981, S. 54-61

Tavel, Hans-Christoph von: Meret Oppenheim.Spuren zu einer Biographie, in: Kat. Meret Oppenheim, Solothurn 1974, Museum der Stadt, o.S.

Ders.: Meret Oppenheim: „Der grüne Zuschauer", in: Ders., Wege zur Kunst im Kunstmuseum Bern, Bern 1983, S. 86f

Ders.: Meret Oppenheim und ihre Biographie, in: Berner Kunstmitteilung, Nr. 254, Juni/Juli 1987, S. 1-6

Ders.: Das Vermächtnis von Meret Oppenheim im Kunstmuseum, in: Kat. Meret Oppenheim, Bern 1987, Kunstmuseum, S. 7-10

Thorn-Petit, Liliane: Meret Oppenheim, in: Dies., Portraits D'Artistes, o.O. (RTL) 1987

Thorson, Victoria: Great Drawings of the 20th Century, New York 1982

Tillmann, Lynne M.: Don't cry... work: conversation with Meret Oppenheim, in: Art and Artist, Bd. 8, Okt. 1973, S. 22-27

Touraine, Liliane: Meret Oppenheim, in: Opus International, Nr. 53, Nov./Dez. 1974, S. 104

Vachtova, Ludmila: „Ohne mich ohnehin ohne Weg kam ich dahin", in: Tages-Anzeiger Zürich, 14.9.1984

Vergine, Lea: Der Weg zur anderen Hälfte der Avantgarde, in: Transatlantik, März 1981

Wächter-Böhm, Liesbeth: Pelztasse mit Zukunft. Anstelle einer Einleitung: 14 angelesene und/oder ausgedachte Fragmente, in: Design ist unsichtbar, Hg. Helmuth Gsöllpointner, Wien 1981, S. 377-384

Waldberg, Patrick: Meret Oppenheim. Le Coeur en Fourrure, in: Ders., Les Demeures d'Hynos, Paris 1976, S. 367f (zuerst in: Kat. Paris 1974, Jeux d'Eté, Galerie Armand Zerbib)

Walser, Paul: Frisches Lüftchen im Römer Kunstleben, in: Tages-Anzeiger Zürich, 31.13.1981

Wechsler, Max: Paradise Gained, in: Artforum, Sept 1985, S. 94-97

Wehrli, Peter K.: Wort in giftige Buchstaben eingepackt ... (wird durchsichtig), in: Orte, Schweizer Literaturzeitschrift, 29, Juli/August 1980

Whiters, Josephine: Famous fur-lined teacup and the anonymous Meret Oppenheim, in: Arts Magazine, Nr. 52, Nov. 1977, S. 88-93

Winter, Peter: Kein mit weißem Marmor belegtes Brötchen, in: Du, Nov. 1978

Wirth, Günther: Meret Oppenheim in der Galerie Müller, Stuttgart, in: Das Kunstwerk, Mai 1974, S. 79

Wittek, Bernhard: Meret Oppenheim e l'Italia, in: Kat. Meret Oppenheim Genua 1983, Palazzo Biancho, S. 3-5

Zacharopoulus, Denys: Meret Oppenheim, inAcrobat Mime Parfait, Nr.1, 1981

Zaug, Fred: Zum Tode von Meret Oppenheim – am Ziel des Menschseins, in: Der Bund, Bern, 16.11.1985, S.2

Zimmermann, Marie-Luise: Zu Besuch bei Meret Oppenheim. Die Freiheit nehmen, in: Brückenbauer, Nr. 7, Feb. 1982, S. 15

Dies.: Große Ehre für eine große Künstlerin, in: Bund, 4.2.1982

Dies.: Sie war mehr als nur eine große Surrealistin, in: Berner Zeitung, 16.11.1985

Filmography – Filmographie

1978	Christina von Braun: Frühstück im Pelz, TV-film, 45 min., NDR, 1.Oktober
1983	Vis-à-Vis: Meret Oppenheim im Gespräch mit Frank A. Meyer, TV film, 60 min., DRS. 31. August
1983	Jana Markovà: Zu Besuch bei Meret Oppenheim in Paris, TV-film, 50 min., Telefilm Saar, Saarbrücken, ausgestrahlt im ZDF, Dezember
1984	J. Canobbi, D. Bürgi: Einige Blicke auf Meret Oppenheim, Video, 60 min., Südwestfunk, Dezember
1984	L. Thorn: Porträt der Künstlerin Meret Oppenheim, Video, 60 min., RTL, Nov., ARC - Musée d'Art Moderne de la Ville de Paris, 27.10. - 10.12.
1984	Deidi von Schaewen, Heinz Schwerfel: Man Ray,Video, 52 min., Centre Georges Pompidou, Paris
1985	Susanne Offenbach: Zum Tod von Meret Oppenheim. Mit Interview, TV-film, 15 min., SW 3, November
1988	Pamela Robertson-Pearce, Anselm Spoerri (Directors, Producers): Imago. Meret Oppenheim, Film, 90 min., England
1997	Lucie Herrmann: Rückblende - Meret Oppenheim, WDR, Köln

247

Index of Works –
Abbildungsverzeichnis

page – Seite

65
Sketch for fabric pattern
Entwurf für Stoffmuster
Watercolor, ink / Aquarell, Tinte
20.4 x 18.1

66
Sketches and notes for rings and bracelets –
Skizzen und Notizen für Ringe und
Armreifen, 1935
Ink, pencil, leather fur /
Tusche,Bleistift, Leder, Pelz
21.9 x 16.9 cm

67
Bracelet – Armband, 1935
Brass, overt with fur / Messing mit Pelz
bezogen, 6.5 x 2 cm
Collection Clo Fleiss, Paris

68
Covered wooden rings –
Bezogene Holzringe 1935/2003
Ebony covered with leather or fabric
Ebenholz mit Leder oder Stoff bezogen
Each 2.5 x 1.5 cm
Produced by Ortrun Heinrich, Hamburg

68
Covered metal rings –
Bezogene Metallringe 1935/2003
Gilded brass, covered with leather or fabric
Messing vergoldet mit Leder oder Stoff
bezogen, 2 x 1 cm/2 x 1.3 cm/2 x 1.3 cm
Produced by Ortrun Heinrich, Hamburg

69
Metal and wooden rings covered with fur –
Metallringe mit Fell bezogen 1935/2003
Gilded brass, ebony, artificial fur /
Messing vergoldet, Ebenholz, Kunstpelz
1 x 4 cm/1.5 x 4 cm/1 x 3.5 cm/1.5 x 4.5 m
Produced by Ortrun Heinrich, Hamburg

70
Choker – Halsband, 1934-36/2003
Plastic material, cord, gold
Plastik, Korder, Gold
36 x 7 x 1 cm – Prototype
Edition 12 + 2
Produced by Ortrun Heinrich, Hamburg

71
Sketch for a choker –
Entwurf für ein Halsband, 1934-36
Gouache, watercolor / Gouache, Aquarell
19.4 x 20.3 cm

72
Bone Necklace with Mouth –
Knochenkette mit Mund, 1935-36/2003
Gilded silver / Silber veroldet
18.5 x 6.5 x 0,1 cm
Prototype (gildet brass)
Edition 12 + 2
Produced by Ortrun Heinrich, Hamburg

73
Sketch for Bone Necklace with Mouth –
Entwurf für Knochenkette mit Mund,
1935-36
Pencil / Bleistift
21 x 27 cm

74
Sketches for earings –
Ideen für Ohrschmuck, 1936
Gouache, Pencil, gold color /
Gouache, Bleistift, Goldfarbe
23.1 x 27.2 cm

75
Choker – Halsband, 1936/2003
Painted plastic material / Plastik bemalt
21 x 19 x 2 cm
Produced by Constanze Schuster, Hamburg

75
Sketch for choker –
Entwurf für Halsband, 1936
Ink, pencil, watercolor / Bleistift, Tusche,
Aquarell
16 x 13.5 cm

76
Ring with Sugar Cube –
Ring mit Zuckerwürfel, 1936-37/2003
Gilded 925 silver, sugar cube /
925 Silber vergoldet, Zuckerwürfel
3 x 2 x 1.5 cm – Prototype
Edition 12 + 2
Produced by Ortrun Heinrich, Hamburg

77
Sketches for accessories –
Entwürfe für Accessoires, 1936-37
Ink, watercolor, pencil /
Tusche,Tinte, Bleistift
29.7 x 20.8 cm

78
Pendant – Anhänger, 1937/1985
Gold, stag-beetle's nipper inside of
transparent material
Gold, Zange vom Hirschkäfer in
transparentem Material
5.5 x 3.5 x 1.7 cm
Produced by Otrun Heinrich, Hamburg
Traute Fischer-Levy, Hamburg

79
Sketch for pendant –
Skizze für einen Anhänger, 1937
Pencil / Bleistift
27 x 20.9 cm

80
Sketch for a leg choker –
Skizze für ein Beinband, 1937
Ink / Tinte
15.7 x 9 cm

80
Leg choker – Beinband, 1937/2003
Gilded brass, cord / Messing vergoldet,
Kordel
61 x 1.8 x 1.8 cm
Produced by Ortrun Heinrich, Hamburg

81
Sketch for Clip Tournant –
Skizze für Clip Tournant, 1937
Pencil / Bleistift
21 x 27 cm

81
Clip Tournant, 1937/2003
Gilded brass / Messing vergoldet
5.5 x 4 x 0.2 cm – Prototype
Edition 12 + 2
Produced by Otrun Heinrich, Hamburg

82
Sketch for a pendent –
Entwurf für einen Anhänger, 1937
Gouache
6.7 x 10.5 cm

82
Pendent – Anhänger, 1937/2003
Eboney, plastic material, gilded silver
Ebenholz, Kunststoff, Silber vergoldet
6 x 3.4 x 3.8 cm – Prototype
Edition 12 + 2
Produced by Otrun Heinrich, Hamburg

83
Sketch for a necklace –
Entwurf für eine Halskette
Ink, Pencil / Tinte, Bleistift, 14 x 21.9 cm

83
Necklace – Halskette
Plastic, gilded silver /
Kunststoff silber vergoldet
26 x 2.5 x 4 cm – Prototype 2003
Produced by Constanze Schuster, Hamburg

84
Sketch for earring –
Entwurf für Ohrring, 1942
Pencil, watercolor / Bleistift, Aquarell
22.1 x 16.8 cm

85
Sketch for a brooch –
Skizze für eine Brosche, ca. 1936-40
Pencil, watercolor / Bleistift und Aquarell
17.4 x 21.2 cm

85
'Laid Table', brooch –
"Gedeckter Tisch", Brosche,
ca. 1936-40 /1985
Silver, gold / Silber, Gold
5 x 4 x 0.4 cm – Prototype
Traute Fischer-Levy, Hamburg
Edition 12 + 2
Produced by Otrun Heinrich, Hamburg

86
The Poet – Der Dichter, 1966
Gold, enamel / Gold, Emaille
10 x 8 x 0.3 cm
Produced by Gian Carlo Montebello
Museum for Contemprary Art,
's-Hertogenbosch, the Netherlands

87
Necklace 'Husch-Husch' –
Halskette "Husch-Husch" 1985
Gold, Stones / Gold , Steine
16 x 4 cm
Privat collection, Basle

88
Sketch for pendant watch –
Entwurf für Anhängeruhr, 1940 - 45
Gouache, Pencil / Gouache, Bleistift
17.5 x 11 cm

88
Pendant watch – Anhängeruhr, 1985
Gold, silver, pearl, watch /
Gold, Silber, Perle, Uhr
6.6 x 2.5 x 0.8 cm Prototype
Produced by Ortrun Heinrich, Hamburg
Traute Fischer-Levy, Hamburg

90
Sketch for glove –
Entwurf für Handschuh 1936
Ink, pencil, watercolor /
Tusche, Bleistift, Aquarell
16 x 22 cm

91
Fur Gloves with Wooden fingers –
Pelzhandschuhe mit Holzfingern, 1936
Painted wood, fur/Holz bemalt, Pelz
each 21 x 10 x 5 cm
Collection Galerie Hauser & Wirth AG,
Zürich

91
Sketch for Shoe with Fur –
Skizze für Schuh mit Pelz, 1936
Pencil, watercolor / Bleistift, Aquarell
18.5 x 27.3 cm

91
Shoe with Fur –
Schuh mit Pelz, 1936/2003
Shoe, fur, painted china /
Schuh, Pelz, bemaltes Porzellan
24 x 12 x 13.5 cm
Pruduced by Theaterkunst, Hamburg

92
Template for gloves –
Schablone für Handschuhe, 1936
Collage
34 x 24.8 cm

93
Skeleton-Hand Gloves –
Knochenhandschuhe, 1936/2003
Painted leather / Bemaltes Leder
28 x 12.5 cm – Prototype
Produced by Theaterkunst, Hamburg

94
Sketch for glove –
Skizze für Handschuh, 1942-45
Ink / Tusche
27 x 17.5 cm

94
Sketch for glove –
Skizze für Handschuh, 1942-45
Ink / Tusche
27 x 17.3 cm

95
Glove with Snake –
Handschuh mit Schlange, 1940-45/2003
Glove, gilded wire / Handschuh, Golddraht
28 x 13 cm – Prototype
Produced by Theaterkunst, Hamburg

95
Projects for gloves and other accessories –
Skizzen für Handschuhe und andere
Accessoires, 1940-45
Pencil / Bleistift
20.9 x 15.3 cm

96
Sketch for Gloves with Veins –
Entwurf für Handschue mit Adern, 1942-45
Pencil / Bleistift
19 x 11 cm
97
Pair of Gloves with Veins –
Handschuhe mit Adern (Paar), 1985
Leather, silkscreen / Leder, Serigraphie
22 x 8.5 cm – WN AI 12
150 copies 1/150 – 150/150 and 12 e.a.
For Parkett No 4, 1985
Thomas Levy, Hamburg

98
Projects for belts, shoes and hats –
Entwürfe für Gürtel, Schuhe und Hüte,
1934-36
Ink / Tinte
29.7 x 20.8 cm

99
Hat with Halo –
Hut mit Heiligenschein, 1934-36/2003
Felt hat with foam rubber/
Filzhut mit Schaumgummi
26 x 24 x 23 cm
Produced by Theaterkunst, Hamburg

100
Sketch for Hat for Three Persons –
Chapeau pour trois personnes –
Skizze für "Hut für drei Personen", 1936-42
Pencil / Bleistift
20.8 x 29.7 cm

100
Hat for Three Persons –
Hut für drei Personen, 1936-42/2003
Felt hats with feathers and tulle /
Filzhüte mit Federn und Tüll
Each 97 x 66 x 28 cm
Produced by Theaterkunst, Hamburg

101
Girl, Wearing on her Head a Cloud with
Rabbit – Mädchen, auf dem Kopf eine
Wolke mit Hasen tragend, 1941
Pencil, watercolor / Bleistift, Aquarell
26 x 18 cm

101
Rabbit Hat –
Hasenhut, 1941/2003
Felt hat, tulle, rabbit / Filz, Tüll, Hase
70 x 70 x 56
Produced by Theaterkunst, Hamburg

102
Sketches for cape, hat and
varieté undergarments –
Entwürfe für Cape, Hut und
Varieté-Unterwäsche, ca. 1942
Pencil, colored pencil / Bleistift, Farbstift
29.7 x 20.8 cm

103
Dog's Snout Hat –
Hundeschnauzenhut, 1942/2003
Fur, felt, velvet, and artifical dog snout /
Fell, Filz, Samt und künstliche
Hundeschnauze
26 x 24 x 23 cm
Priduced by Theaterkunst, Hamburg

104
Red Hat – Roter Hut, ca 1942/2003
Felt, mask / Filz, Maske
24 x 23 x 19 cm
Produced by Theaterkunst, Hamburg

104
Cylinder – Zylinder, 2003
Black buckskin / schwarzes Wildleder
30 x 30 x 17 cm
Produced by Theaterkunst, Hamburg

105
Sketches for costumes –
Kostümentwürfe, ca. 1942
Pencil / Bleistift
29.7 x 20.8 cm

106
Sketches for buttons –
Skizze für Knöpfe, 1944
Ink, pencil / Bleistift, Bleistift
29.7 x 21 cm

107
Sketch for a belt –
Entwurf für einen Gürtel
Ink, Gouache / Tusche, Gouache
8.4 x 14.9 cm

108
Buttons for an evening jacket –
Knöpfe für eine Abendjacke, 1942-45
Gouache on velvet paper /
Gouache auf Samtpapier
28.9 x 16.8 cm

109
Evening Jacket – Abendjacke, 1942-45/2003
Silk, embroidery, mother-of-perls- buttons /
Seide, Stickerei, Perlmutknöpfe
73 x 60 x 20 cm
Produced by Theaterkunst, Hamburg

110
'Slip Mandrill' varieté undergarments –
„Slip Mandrill" Varietéunterwäsche,
ca. 1940/2003
Torso with fur, sequins, tulle /
Torso mit Pelz, Pailletten, Tüll
36 x 34 x 24 cm
Produced by Theaterkunst, Hamburg

110
Pullover with 'Brest Pousches' –
Pullover mit „Brusttaschen", ca 1942/2003
Wool / Wolle
57 x 50 x 15 cm
Produced by Theaterkunst, Hamburg

111-113
Notes and sketches for paper dresses –
Notizen und Skizzen für Papierkleider, 1967
Ink, pencil, ball-point pen /
Tinte, Bleistift, Kugelschreiber
Each 29.7 x 20.8 cm

114
Robe Simple 1942-45/2003
Painted cardboard / Karton bemalt
90 x 40 cm
Produed by Theaterkunst, Hamburg

114
Robe Simple 1942-45/2003
Cardboard covered with paper gras
and plastic flower/
Karton mit Papiergras bezogen
und Plastikblume
90 x 40 cm
Produced by Theaterkunst, Hamburg

114
Robe de Diner, 1942-45/2003
Cardbord, paper plates, knives, forks
Karton, Papierteller, Messer, Gabeln
129 x 49 cm
Produced by Theaterkunst, Hamburg

115
Sketch for Robe Simple, Robe de Diner,
1942-45 – Skizze für Robe Simple,
Robe de Diner, 1942-45
Pencil / Bleistift
29.7 x 20.8 cm

116
Design for the cover of the Swiss Magazin
"Annabelle" –
Entwurf für die Schweizer Frauenzeitschrift
„Annabelle" 1940-45
Pencil, gouache / Bleistift, Gouache
31.7 x 24.4 cm

117
M.O. at her Crystal Table for Ten Place
Settings – M.O. an ihrem Glastisch für
zehn Gedecke, 1985
197 x 155 x 70 cm – Prototype, 20 copies
Produced by Michael Burckhardt, Zürich

118
Table with Three Legs, model –
Tisch mit drei Beinen, Modell, 1938/2003
Gilded wood, Plexiglass, hair /
Holz vergoldet, Plexiglas, Haar
24.5 x 9 x 8 cm
Produced by Thomas Börner, Hamburg

119
Sketch for Table with Three Legs –
Entwurf für einen Tisch mit drei Beinen,
1938
Ink, gouache / Tusche, Gouache
20 x 14 cm

120
Sketch for tabletop of Table with Bird's
Legs – Skizze für die Platte des Tisches mit
Vogelfüssen, 1983
Ink, pencil / Tusche, Bleistift
79 x 50 cm
Thomas Levy, Hamburg

121
Table with Bird's Legs –
Tisch mit Vogelfüssen, 1939/1983
Bronze, wood / Bronze, Holz
65 x 70 x 50 cm – WN B8
30 copies 1/30 – 30/30 and 2 e.a. and 2 H.C.
Tabletop produced by Helmut Sasse,
Hamburg
Museum für Kunst und Gewerbe, Hamburg

122
Sketch for an illuminated garden table
Entwurf für einen Gartentisch mit Licht
Ink, pencil, colored pencil / Tusche,
Bleistift, Farbstift
13.9 x 12.5 cm

122
Sketch for a garden chair of wrought iron –
Entwurf für einen Gartenstuhl aus
Schmiedeeisen
Pencil, colored pencil / Bleistift, Farbstift
13.5 x 16 cm

123
Sketch for a table –
Skizze für einen Tisch, 1940 – 45
Pencil / Bleistift
6.8 x 7.8 cm

123
Table, model –
Tisch, Modell, 1940 – 45/2003
Wood, Plexiglass / Holz, Plexiglas
23 x 23 x 18 cm
Produced by Thomas Börner, Hamburg

124
Sketch for a console –
Skizze für eine Konsole, 1940 –45
Pencil / Bleistift
17.5 x 22.8 cm

124
Console, model –
Konsole, Modell, 1940-45/2003
Wood, painted plastic material /
Holz, Kunststoff bemalt
21 x 21 x 9.5 cm
Produced by Thomas Börner, Hamburg

125
Sketch for a chair –
Entwurf für einen Stuhl, 1940–45
Pencil / Bleistift
14.5 x 7.5 cm

125
Chair, model –
Stuhl, Modell, 1940 – 45/2003
Wood, metal / Holz, Metall
24.5 x 9 x 8 cm
Produced by Thomas Börner, Hamburg

126
Sketch for a hearth chair –
Skizze für einen Kaminstuhl, 1967
Pencil / Bleistift
11.5 x 19.5 cm

126
Armchair and footstool, model –
Sessel und Fußbank, Modell, 1972
Painted cardboard / Karton bemalt
16 x 6 x 3 cm

127
Sketch for Läbchuechegluschti –
Skizze für Läbchuechegluschti, 1967
11.5 x 10.8 cm
Pencil, colored pencil / Bleistift, Farbstift

127
Läbchuechegluschti, 1967
Wood, velvet, cushion /
Holz, Samt, Sitzkissen
93 x 45 x 45 cm – WN Q123a
Kunstmuseum, Bern

128
Cadavres Exquis –
Chair in a Waterfall –
Stuhl in einem Wasserfall, 1975
Pencil / Bleistift – WN Y 264o
41.5 x 29 cm

128
Cadavres Exquis – Chair for Singers –
Stuhl für Sänger, 1975
Gouache / Gouache
41.5 x 29 cm – WN Y264b

128
Cadavres Exquis – Flitting Chair –
Flitzender Stuhl, 1975
Goauche / Gouache
41.5 x 29 cm – WN Y264g

128
Cadavres Exquis –
The Fairy Queen's Throne –
Der Thron der Feenkönigin, 1975
Gouache / Gouache
41.5 x 29 cm – WN Y 264d

129
Cadavres Exquis –
Chair for the Year 2000 –
Stuhl für das Jahr 2000, 1975
Gouache / Gouache
41.5 x 29 cm – WN 264i

130
Sketch for perfume flask
Entwurf für Parfümflakon, 1936
Ink / Tusche
17.2 x 10.3cm

130
Sketch for perfume flask
Entwurf für Parfümflakon, 1936
Ink, watercolor, gold color /
Tusche, Aquarell, Goldfarbe
16 x 9.9 cm

131
Sketch for perfume flask
Entwurf für Parfümflakon, 1936
Ink / Tusche
13.8 x 12.5 cm

131
Wooden model for perfume flask
Holzmodell für einen Parfümflakon,
1936/1984-85
Ebony / Ebenholz
11 x 6.5 x 6.5 cm
Produced by Helmut Sasse, Hamburg

131
Wooden models for perfume flasks
Holzmodelle für Parfümflakons,
1936/1984-85
Ebony / Ebenholz
9.5 x 5 x 5 cm/9 x 4.5 x 4.5 cm
Produced by Helmut Sasse, Hamburg

132
Three sketches for perfume flasks
Drei Entwürfe für Parfümflakons, 1936
Ink / Tusche
22.2 x 8.5 cm , 15.3 x 12.7 cm, 13 x 9 cm

133
Wooden models for perfume flasks –
Holzmodelle für Parfümflakons,
1936/1984-85
Ebony / Ebenholz
9 x 3.7 x 3.7 cm/15 x 4.5 x 4.5 cm/
9.5 x 6 x 6 cm
Produced by Helmut Sasse, Hamburg

134
Two sketches for perfume flasks
Zwei Entwürfe für Parfümflakons, 1936
Ink / Tusche
21.6 x 11 cm , 20.8 x 14 cm

135
Three wooden models for perfume flask
Drei Holzmodelle für Parfümflakons,
1936/1984-85
Ebony / Ebenholz
9.5 x 8 x 3.5 cm/10 x 4.5 x 4.5 cm/
14.5 x 4.3 x 4.3 cm
Produced by Helmut Sasse, Hamburg

135
Four sketches for glass perfume flasks
Vier Entwürfe für Parfümflakons aus Glas
Pencil, colored pencil, ink/
Bleistift, Farbstift, Tusche
10.5 x 6.3 cm/10 x 4.8 cm/
9.8 x 5 cm/10 x 5 cm

251

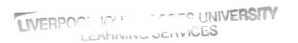

136
Sketch for a carpet –
Entwurf für einen Teppich
Ink, colored pencil, pencil/
Tusche, Farbstift, Bleistift
20.4 x 15.5 cm

137
Hermes Fountain –
Merkursbrunnen, 1966/2000
Bronze
220 x 180 x 180 cm
6 copies and 2 H.C.
Photo Roman März
in 'Il Giardino di Daniel Spoerri'

138
Sketch for Wind Trees –
Skizze für Windbäume, 1976
Ink, pencil, colored pencil
Tusche, Bleistift, Farbstift
52 x 23 cm – WN Z302

138
Model for Wind Trees –
Modell für Windbäume, 1976/2003
Metal, wood, Plexiglass /
Metal, Holz, Plexiglas
104 x 30 x 30 cm
Pruduced by Thomas Börner, Hamburg

139
'Crystal', model for fountain –
„Kristall", Modell für Brunnen, 1979
Metallic paper, cardboard / Metallfolie,
Karton
28.5 x 33 cm – WN AC 98

139
'Blossom', model for fountain –
„Blüte", Modell für Brunnen, 1979
Painted modeling material, brass, Plexiglass
Bemalte Modelliermasse, Messing, Plexiglas
30 x 20 x 20 cm – WN AC 96

140
Yellow Mask –
Gelbe Maske, 1936
Painted paper mâché, fur
Papiermaché bemalt, Pelz
21 x 21 x 10 cm

140
Child's Face
Kindergesicht,
Plastic material, painted like porcelain
Kunstoff, bemalt wie Porcellan
6 x 15 x 14 cm

141
Pink Wire Eyes –
Rosarote Drahtaugen
Various materials / verschiedene Materialien
10 x 21 x 23 cm

141
Red and Black Wire Eyes –
Rote und schwarze Drahtaugen
Various materials /verschiedene Materialien
21 x 18 x 21 cm

*Unless otherwise indicated, works listed on
page 65-141, Private Collection, Basle.
Wenn nicht anders angegeben, alle Werke
Seite 65-141, Privatsammlung, Basel.*

144
Autumn – Herbst, 1930
Watercolor / Aquarell
25 x 31 cm – WN A2
Thomas Levy, Hamburg

145
Votive Picture (Destroying Angel) –
Votivbild (Würgeengel), 1931
Watercolor, ink / Aquarell, Tusche
34 x 17.4 cm – WN A2
Private Collection, Basle

146
Trunked Animal at the Beach –
Rüsseltier am Strand, 1932
Watercolor, ink / Aquarell, Tusche
21 x 16 cm – WN A3
Private Collection, Basle

147
Half-length Portrait of a Woman –
Brustbild einer Frau, 1932
Pencil / Bleistift
27 x 21.5 cm WN A3

148
La chimère de Notre Dame et
Jeanne d'Arc, 1932
Watercolor, gouache / Aquarell, Gouache
25 x 26 cm – WN A2
Private Collection, Basle

149
Portrait of Irène Zurkinden, 1933
Gouache
25.5 x 16.6 cm – WN A 2
Private Collection, Basle

150
White Porcelain, Little Red Bricks –
Weisses Porzellan, rote Ziegelchen, 1933
Ink / Tusche
21 x 27 cm – WN A4
Thomas Levy, Hamburg

150
Architectural Fragment with
Rays of Light, 1933
Architektonisches Gebilde
mit Lichtstrahlen, 1933
Ink / Tusche
17 x 21 cm – WN A4
Private Collection, Basle

151
Detail from the End of the World –
Detail aus Weltuntergang, 1933
Ink / Tusche
21 x 29.5 – WN A4
Thomas Levy, Hamburg

152
Dream – Traum, 1937
Watercolor, ink / Aquarell, Tusche
27 x 21 cm – WN B1e
Private Collection, Basle

153
The Woman of the Woods –
Die Waldfrau, 1939
Oil on fibreboard / Öl auf Pavatex
28 x 37.5 cm – WN B9c
Private Collection, Zurich

154
Sophistry – Sophisterei, 1942
Ink / Tusche
14 x 27 cm – WN C3e

155
The Paradise is Under the Earth –
Das Paradies ist unter der Erde, 1940
Collage, gouache
22 x 16.5 cm – B 11
Private Collection, Hamburg

156
Unicorn Witch – Einhornhexe, 1943
Ink / Tusche
21 x 29.5 cm – WN C 3k
Thomas Levy, Hamburg

156
Note for mask – Notiz für die Maske, 1943
Pencil / Bleistift
15 x 18 cm

157
The Tragicomical –
Das Tragischkomische, 1944
Oil on fibreboard / Öl auf Pavatex
39 x 70 cm – WN C 10
Private Collection, Basle

158
Garibaldina, 1952
Aluminum / Aluminium
52 x 44.5 x 2 cm – WV C31
Edition 1978 1/6 - 6/6 and two E.A:
Three of the six are painted white.
Drei der Sechs sind weiss bemalt.
Edition: Thomas Levy, Hamburg

159
Phalène-Moth – Nachtfalter, 1954
Oil on canvas / Öl auf Leinwand
23.2 x 40 cm - WN D6e
Private Collection, Hamburg

160
Gu-gugg (How He Stares, the Old Fellow!) -
Gu-gugg (Wie er schaut, der Alte!), 1954
Oil on wood / Öl auf Holz
71 x 42 cm – WN D2
Private Collection, Bremen

161
Summer Brushwood (Pan is Hiding) –
Sommergestrüpp (Pan verbirgt sich), 1955
Oil on wood / Öl auf Holz
67.5 x 97 cm – WN D8c

162
One Will See – On va voir –
Man wird sehen, 1955
Gouache on fibreboard /
Gouache auf Pavatex
70 x 49 cm – WN AR 14

162
Cat with Candle on It's Head,
Illustration for a Poem, 1957
Katze mit Kerze auf dem Kopf,
Illustration zu einem Gedicht, 1957
Ink / Tusche
15 x 18 cm – WN F 24a
Traute Fischer-Levy, Hamburg

163
Cat with Candle on It's Head, 1957
Katze mit Kerze auf dem Kopf, 1957
Offset – 29.5 x 18.5 cm – WN F24b, Levy 7
150 copies and 65 copies
Thomas Levy, Hamburg

164
Tower with Arched Entrance –
Turm mit gewölbtem Eingang, 1958
Woodcut / Holzschnitt
29.5 x 21 cm – WN G34aIII, Levy 11
Thomas Levy, Hamburg

165
Bushes – Gebüsch, 1958
Woodcut / Holzschnitt
30 x 21 cm – WN G34aII, Levy 12
Thomas Levy, Hamburg

166
Wallowing Horse –
Sich wälzendes Pferd, 1958
Ink / Tusche
32 x 43 cm – WN G25b

167
Spring Sky – Frühlingshimmel, 1958
Oil on cardboard / Öl auf Karton
64 x 49 cm – WN G30

168
Demon with Animal Head –
Tierköpfiger Dämon, 1961
Object: clock case, wood, ceramic buttons
Objekt: Uhrenkasten, Holz, Keramikknöpfe
59 x 35 x 45 cm – K33
Collection Onasch, Berlin

169
Source – Quelle, 1958
Object-painting: box, gouache, cardboard
Objektbild: Schachte, Gouache, Karton
41 x 33 cm WN H 46
Galerie Ziegler, Zürich

170
Clouds over Continent –
Wolken über Kontinent, 1964
Etching / Radierung
15 x 11 cm – WN N91a , Levy 26
100 copies and 20 E.A.copies
Thomas Levy, Hamburg

171
The Black Snake Knows the Path of the
Islands – Le Serpent Noir Connait le
Chemin de Îls – Die schwarze Schlange
kennt den Weg der Inseln, 1963
Object: wood, glass / Objekt: Holz,Glas
30 x 30 x 8.5 cm
Galerie de France, Paris

172
Gray Cloud Dressed –
Graue Wolke bekleidet, 1965
Oil on wood and wooden frame
Öl auf Holz und Holzrahmen
43 x 58 cm – WN 0106
Galerie Ziegler, Zürich

173
Black Chimney –
Schwarzer Kamin, 1966
Oil on wood / Öl auf Holz
27.5 x 18.5 cm – WN P113
Private collection, Basle

174
Bon Appétit, Marcel, 1966
Object: various materials
Objekt: diverse Materialien
32 x 32 x 3 cm – WN P109
Forster Goldstrom, San Francisco

175
November, 1967
Crayon / Ölkreide
49 x 65 cm – WN Q123e
Private collection, Bale

176
Collage from the "Gallery of Voyage" –
Collage aus „Reisegalerie", 1969
Collage
20 x 20 cm – WN S133
Thomas Levy, Hamburg

177
Squirrel – Eichhörnchen, 1969
Object, various materials /
Objekt, diverse Materialien
23 x 17.5 x 8 – WN S 126
Thomas Levy, Hamburg

178/179
Avena Oathflow 4884 - Fleur Bluemay -
Ode - AFFAIRE HALF-ERE - Haberflair,
o/Watt'a – Hafer - Blume, 1969
Plastic flower with oats /
Plastikblume mit Haferfloken
50 cm h. – WN S 134
300 copies 1/300 - 300/300
Thomas Levy, Hamburg

180
Small Jura Landscape –
Kleine Juralandschaft, 1970
Aluminum / Aluminium
30 x 30 x 2 cm – WN T135
6 copies 1/6 - 6/6 and 2 E.A. 1978
Thomas Levy, Hamburg

181
Irma la Douce, 1970
Oil on wood with objects /
Öl auf Holz mit Objekten
168.5 x 42.5 cm – WN T 148a
Private colletion, Basle

182
Whip Snakes – Peitschenschlangen, 1970
Object, wood, paint, leather /
Objekt, Holz, Farbe, Leder
164 and 156 x 3 x3 cm – WN 145 and 146
Private collection, Basle/Zürich

183
Star-Studded Sky and Sunset –
Gestirnter Himmel und Sonnenuntergang,
1971
Gouache, collage / Gouache, Collage
100 x 70 cm – WN U167

184
The Delicate Assassin – L'Assassin Delicat –
Der empfindliche Meuchelmörder, 1971
Cadavre exquis, pencil / Bleistift
22 x 17.5 cm
Thomas Levy, Hamburg

184
God is Tolerant – Dieu est ouvert –
Gott ist tolerant , 1971
Cadavre exquis, pencil / Bleistift
22 x 16.5 cm
Thomas Levy, Hamburg

184
He Looks Around – Il se Retourne –
Er sieht sich um, 1971
Cadavre exquis, various materials /
diverse Materialien
29 x 5.5 x 5.5 cm – WN U 177i
Thomas Levy, Hamburg

185
The Embarrassing End –
La Fin Embarrassée –
Ende und Verwirrung, 1971
Oil on canvas / Öl auf Leinwand
110 x 84 – WN U 177

186
Night-Sky with Agates –
Nachthimmel mit Achaten, 1971
Colored lithograph / Farblithographie
64 x 49 cm – WN U178, Levy 40
Thomas Levy, Hamburg

187
Poster Fur Cup –
Poster Pelztasse, 1971
Offset after Photo of Man Ray
Offset nach Photo von Man Ray
53 x 76 cm – WN U153, Levy 37
190 copies 1/190 - 190/190 + 30 H.C.
Private collection, Basle

188
Laden Table, Dog Underneath –
Beladener Tisch, darunter Hund, 1972
Crayon, ink / Ölkreide, Tusche
34,5 x 48 cm – WV 186b

189
Writing Paper for a Black Swan –
Briefpapier für einen schwarzen
Schwan, 1972
Oil on wood with plastic set / Öl auf Holz
mit Plastikset
55 x 42 cm – WN V 189

190
Dragonfly Campoformio –
Libelle Campoformio, 1972
Ink / Tusche
15.5 x 24 cm WN V 190
Private collection, Basle

190
New Year's Card for Atelier 5, Bern –
Neujahrskarte für Atelier 5, Bern, 1982
Offset
10.5 x 14.5 cm – WN AF140
Private collection, Basle

191
The Exercise Book –
Das Schulheft, 1973
Embossed etching /
Radierung mit Prägedruck
28 x 44 cm – WN W201a, Levy 45
100 copies 1/100 -100/100 and
15 not bounded
100 Exemplare und 15 ungebunden
Thomas Levy, Hamburg

192
They are Dancing –
Sie tanzen, 1973
Colored pencil / Farbstift
50 x 32,5 cm – WN W 199

193
The Cocoon (It's Alive) –Le cocon (il vit) –
Der Kokon (er lebt), 1974
Object, wooden box, satin cushion
with quicksilver inlay, branches.
Objekt, Holzkasten, Satin-Kissen mit
Quecksilber Einlage, Äste
9 x 17 x 9 cm – WN X 232

194
My Flag – Meine Fahne, 1974
Colored silkscreen / Farbiger Serigraphie
50 x 36 cm – WN X231 a, Levy 48
150 copies 1/150 –150/150 and 25 e.a.
Thomas Levy, Hamburg

194
Stones - Black Drops, Disappearing
towards the White Center –
Steine - schwarze Tropfen, die zur
weißen Mitte hin verschwinden, 1974
Colored etching – Farbradierung
35 x 29.5 cm – WN X220a, Levy 47
100 copies 1/100 – 100/100 and 10 e.a.
Thomas Levy, Hamburg

195
Lagoons – Lagunes – Lagunen, 1974
Watercolor, ink, colored crayon
Aquarell, Tusche, Farbkreide
35 x 50 cm – WN X 228

196
Polypheme in Love –
Der verliebte Polyphem, 1974
Colored silkscreen on plexiglas mirror
Farbiger Siebdruck auf verspiegeltem
Plexiglas
19 x 8 x 0.4 cm – WN X238a, Levy 49
100 copies 1/100 – 100/100
Thomas Levy, Hamburg

196
Polypheme in Love –
Der verliebte Polyphem, 1974
Pencil,colored pencil / Bleistift, Farbstift
50 x 32.5 cm – WN X 238
Private collection, Basle

197
Giacometti's Ear –
Das Ohr von Giacometti, 1974
Etching / Radierung
30 x 21 cm – WN X239a, Levy 51
132 copies 1/132 –132/132 and 13 e.a.
Private collection, Hamburg

198
Porter in the Fog –
Der Träger im Nebel, 1975
Colored silkscreen / Farbige Serigraphie
32 x 48.5 cm WN Y 249b, Levy 53
150 copies 1/150 – 150/150 and 25 e.a.
Thomas Levy, Hamburg

199
Reddish Moon and Cypresses
against Black Sky –
Rötlicher Mond und Zypressen
vor schwarzem Himmel, 1975
Ink / Tinte
32.5 x 50 cm – WN Y 274
Private collection, Basle

200
Parapapillonneries –
The Cypress Sphinx Moth –
Der Zypressenschwärmer, 1975
Colored lithograph / Farblithographie
46 x 61 cm – WN Y298b, Levy 58b
99 copies 1/99 – 99/99 and 20 e.a.
Thomas Levy, Hamburg

200
Parapapillonneries –
The Silk Moth and Proud Rosamunde –
Seidenmotte und die stolze
Rosamunde, 1975
Colored lithograph / Farblithogrphie
46 x 61 xm – WN Y298e, Levy 58e
99 copies 1/99 – 99/99 and 20 e.a.
Thomas Levy, Hamburg

200
Parapapillonneries – The Silverbottom
Der Silberschwanz, 1975
Colored lithograph / Farblithographie
46 x 61 cm – WN Y 298d, Levy 58d
99 copies 1/99 – 99 /99 and 20 e.a.
Thomas Levy, Hamburg

201
Queen of Termites –
Termitenkönigin, 1975
Object, painted exhaust pipe
Objekt, bemaltes Auspuffrohr
70 x 10 x 20 cm – WN Y 271
Private collection, Basle

202
Little Red Man in a Mussel Shell–
Kleines rotes Männchen in einer
Muschel, 1975
Print handcolored – Druck handcoloriert
22.5 x 16 cm – WN Y 252, Levy 54
40 copies 1/40 - 40/40
Thomas Levy, Hamburg

202
Agate – Achat, 1976
Colored lithograph / Farblithografie
32 x 23 cm – WN Z 307, Levy 59
100 copies 1/100 – 100/100 and 10 e.a.
Thomas Levy, Hamburg

202
Japanese Garden – Japanischer Garten, 1976
Colored lithograph / Farblithographie
40 x 25 cm – WN Z 308, Levy 60
100 copies 1/100 – 100/100 and 20 e.a.
Thomas Levy, Hamburg

203
Giacometti's Ear –
Das Ohr von Giacometti, 1977
Bronze objekt after plaster model 1933
Bronze nach Gips von 1933
10 x 7.5 x 1.5 cm – WN AA 17b
1/500 – 100/500 after Bronze
101/500 – 500/500 after plaster
Thomas Levy, Hamburg

204
New Stars – Neue Sterne, 1977
Oil on wood / Öl auf Holz
32.5 x 37.5 cm WN AA 34
Galerie Ziegler, Zürich

205
Cloud on Bridge –
Wolke auf Brücke, 1977
Oil on polyelstomer / Öl auf Polyestomer
48 x 23 x 13 cm – WN AA 49a
7 copies and 3 e.a.
Private colletion, Hamburg

206
Lying Profile with Butterfly –
Liegendes Profil mit Schmetterling, 1977
Colored lithograph / Farblithographie
59 x 45 cm – WN AA 37a, Levy 61
100 copies 1/100 – 100/100 and 10 e.a.
Thomas Levy, Hamburg

206
Young Man in Profile (Call Me as You Like)
Jüngling im Profil
(nenne mich wie Du willst), 1977
Ink / Tusche
48.5 x 32 cm – WN AA 52
Thomas Levy, Hamburg

207
Snail – Schnecke, 1977
Watercolor, ink / Aquarell und Tusche
32 x 48.5 cm – WN AA 48

208
Subterranean Bow –
Unterirdische Schleife, 1977
Bronze objekt after plaster model, 1960
Bronze nach Gips von 1960
12.5 x 6.5 x 1 cm – WN AA 17a
100 copies 1/100 –100/100 and 10 e.a.
Thomas Levy, Hamburg

209
Primeval Venus – Urzeitvenus, 1977
Bronze objekt after plaster model, 1933
Bronze nah Gips von 1933
10 x 6 x 4 cm – WN AA 17c
100 copies 1/100 – 100/100 and 10 e.a.
Thomas Levy, Hamburg

210
Green Mirror before Desert –
Grüner Spiegel vor Wüste, 1978
Colored crayon / Ölkreide
48 x 63 cm – WN AB 56

211
Six Little Primeval Animals
and a Sea Snail's Shell –
Sechs Urtierchen und ein
Meerschneckenhaus, 1978
Objects, painted and glazed terra cotta
Objekt, Terracotta bemalt, glasiert
19 x 29.5 x 24 cm – WN AB 59b
7 copies, Atelier Sabine Baumgartner, Berne
Thomas Levy, Hamburg

212
Stones – Steine, 1978
Three colored lithographs and three
'Snakepoems'
Drei Farblithographien und drei
„Schlangengedichte"
Each 46 x 37 – WN AB 58 I-III, Levy 63
Thomas Levy, Hamburg

213
Project for X-Ray ,1964 / 1978
Photo 34.5 x 27.5
Edition, 1981 25.5 x 20.5 cm
20 copies 1/20 – 20/20 – WN N92b
Thomas Levy, Hamburg

214
Shadow Multiplication –
Schatteneinmaleins, 1979
Pattern, spray / Schablone, Spray
30 x 21 cm – WN AC 97, Levy 66
20 copies 1/20 – 20/20 and 3 e.a.
Thomas Levy, Hamburg

214
White Bird over Water –
Weisser Vogel über Wasser, 1980
Gouache, colored crayon /
Gouache, Ölkreide
12.5 x 50 cm – WN AD106a

215
Little Sun Head – Sonnenköpfchen, 1978
Bronze 100 copies 1/100 –100/100 and
10 e.a., in Silver 10 e.a.
Bronze 100 Exemplare und 10 e.a.
10 Exemplare in Silber e.a.
5 x 5.3 x 0.7 – WN AB 75b
Thomas Levy, Hamburg
Eva und Carl Großhaus

216
The Old man from the Mountain –
Der Alte vom Berg, 1979
Slap of slate with pieces of slate glued on
Schiefertafel, aufgeklebte Schieferstückchen
29.5 x 21.5 cm – WN AC 97a
Private collection, Basle

217
Eternal Calender 'Even Days , Uneven Days'
– Ewiger Kalender „Gerade Tage,
ungerade Tage", 1980
Colored lithograph / Farblithographie
21.5 x 31.5 cm – WN AD 111, Levy 68
125 copies 1/125 – 125/125 and 5 e.a.
Thomas Levy, Hamburg

218
Sansibar, 1981
15 colored silkscreens, embossed,
with 16 poems by M.O.
15 Farbserigraphien mit Prägung
und 16 Gedichten von M.O.
28 x 28 cm – WN AE 115a, Levy 69
Thomas Levy, Hamburg

219
Portrait with Tattoo –
Portrait mit Tätowierung, 1980
Stencil and spray paint on a photograph
Schablone und Spray auf Photo
29.5 x 21 cm – WN AC 109, Levy 67
Foto: Heinz Günter Mebusch
50 copies 1/50 – 50/50 and 3 e.a.

220
For Traute Fischer for her Birthday –
Für Traute Fischer zum Geburtstag, 1983
Ink / Tusche
18 x 17 cm – WN AG 147
Traute Fischer-Levy, Hamburg

220
Megalithikum, 1983
Crayon / Ölkreide
32 x 48.5 cm – WN AG 145

221
Caroline, 1984
21 coloured etchings, two embossed
and 23 poems by M.O.
21 Farbradierungen, zwei Pägedrucke
und 23 Gedichte von M.O.
28 x 28 cm – WN AH 163, Levy 76
89 copies 1/89 – 89/89 and 12 H.C.
Thomas Levy, Hamburg

222
I'm a Child in Swaddling Clothes
Swaddled with an Iron Hand –
Ich bin ein Wickelkind, gewickelt
mit eisernem Griff, 1985
Etching / Radierung
14 x 11.5 cm – WN AI 26, Levy 77
90 copies 1/90 – 90/90 and 10 e.a.
Private collection, Basle

222
Creakingly Steps the Violet –
Knarrend tritt das Veilchen – 1985
Etching, gouache / Radierung, Gouache
35.8 x 24.6 cm – WN AI 48
25 copies 1/25 – 25/25

223
Roma, 1985
Pencil / Bleistift
20.5 x 15 cm

224
Wooden Log Jumping Jack –
Baumstamm-Hampelmann, 2001
After the original from 1940 /
Nach dem Original von 1940
19 x 5 x 0.5 cm – WN B10b
Colored Silkscreen on wood
Farbige Serigraphie auf Holz
100 copies 1/100 – 100/100
Thomas Levy Galerie, Hamburg

224
Project for Mine Ha Ha
Projekt für Mine Ha Ha, 1973/1984/2004
Jumping Jack and two letters
Hampelmann und zwei Briefe
70 x 100 cm
Thomas Levy, Hamburg